'*Electric Sheep* writes about film for people who like film: a classic approach.'
— Norman Lebrecht, *The New Statesman*

'*Electric Sheep* is a refreshing and original magazine that explores the world of film from myriad angles with wit and imagination.'
— Jennifer Higgie, *Frieze*

'*Electric Sheep* is idiosyncratic, intelligent, informed and it really knows and cares about cinema. Long may it prosper.'
— Tony Herrington, *The Wire*

'With its distinctly quirky eye on the arts in all forms, *Electric Sheep* offers new perspectives on all media that broadens established demographics.'
— Alan Jones, *FrightFest*

'The coolest magazine in town.'
— Suzanne Ballantyne, *Raindance Film Festival*

ACKNOWLEDGEMENTS

Thanks to everyone who has contributed material to this anthology and has helped in making it happen. We would particularly like to thank Bill Morrison, Bich Quân Tran at Dissidenz, Candy Vincent-Smith at Optimum Releasing, Faith Taylor at Soda Pictures, Park Circus, Bounty Films and Axiom Films as well as all the directors who kindly agreed to contribute to our Closing Shots piece: the Brothers Quay, Asiel Norton, Vincenzo Natali, Michael Almereyda, Scott McGehee and David Siegel, Debra Granik, Greg McLeod, Stephanie Barber, David OReilly, Marc Price, Asif Kapadia and Peter Whitehead.

First Published by Strange Attractor Press 2011

A CIP catalogue record for this book is available from the British Library

Strange Attractor Press
BM SAP, London, WC1N 3XX, UK

www.strangeattractor.co.uk
www.electricsheepmagazine.com

Printed in the UK

THE END:
An *Electric Sheep* anthology

EDITED BY VIRGINIE SÉLAVY

ART DIRECTOR: **EMERALD MOSLEY**
ASSISTANT EDITORS: **SARAH CRONIN & ALEX FITCH**
SUB EDITORS: **RICHARD BANCROFT, ALEXANDER GODFREY, ELEANOR MCKEOWN & ALEXANDER PASHBY**

Contents

Still from Decasia | BILL MORRISON

Introduction

This is the end. But you won't find ceiling-mounted fans obsessively whipping the sweaty tropical air and leading you into the heart of darkness. We have found our terminal pleasures elsewhere, in the apocalyptic truth revealed when the mist finally lifts, in Scandinavian tales of self-dissolution and grand Japanese gestures of destruction, and in the extremities of a multi-footed human beast.

Of course, the end doesn't always mean the end. We have all witnessed the dead rise again, spreading chaos among the living or threatening the return of bloodthirsty oppressors. Running from the carnage, we find refuge in abstract patterns, loops and circles, aspiring to serene eternity or prisoners of an inescapable recurrence.

An obsessive dream of blue lips and golden skin remains unfinished, leading to further kaleidoscopic dreams. Barely awake, we play games with multiple endings and wonder whether to be good or evil. But no matter what path we choose, some will be punished, starting with wayward girls, child witches and unredeemed sinners, while melancholy drifters will find only disillusion at the end of the road.

As dusk falls on the Manitoban prairie, we mourn the death of a salesman and the passing of a heroic age, but look with lucid eyes at cinema's affinity with decay. Admiring the silver swirls of its decomposing beauty, touched by the poignant transience of the matter of film and sound, we pause for a moment. But soon we remember that all you can ever do is see your madness through to the end.

VIRGINIE SÉLAVY

1

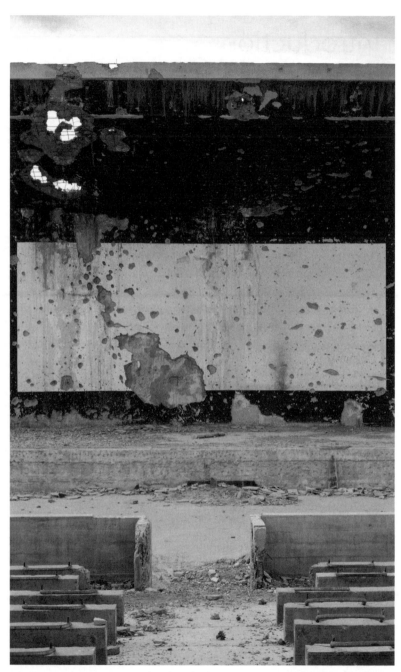

Bullet-scarred outdoor cinema at the Palace of Culture in Karte Char, Kabul | SIMON NORFOLK

A FEAST OF SKELETONS
Cinema's ongoing love affair with its own demise

IAN FRANCIS

Quinlan: Come on, read my future for me.
Tanya: You haven't got any.
Quinlan: What do you mean?
Tanya: Your future is all used up.
—*Touch of Evil* (Orson Welles, 1958)

My guess is that the final disappearance of cinemas will take place around the year 2020.
—Jean-Pierre Melville, 1971[1]

Traditionally, anti-piracy campaigns have played on our sense of guilt by likening illegal downloads to car theft, or by revealing the shadowy web that links the sale of bootleg DVDs with international terrorism. Perhaps registering that this finger-pointing approach was misdirected – when those watching have more than likely paid for their ticket – the copyright lobby has adopted a change of tack in recent ads,

FEATURING

Faded phantoms
Magic lanterns
Hoarders
A Hitchcock doppelgänger

3

1 Rui Nogueira ed. and trans., *Melville on Melville* (Viking Press, 1971), p.167.

thanking the viewer for helping to keep the industry alive with their custom. This leaves a very odd taste in the mouth. When we kneel at the multiplex altar we expect to submit ourselves to swagger and noise, but not to feel as if we have made a donation towards repairing the church roof.

to dazzle and transport audiences, while also promising to record and store lived reality

Having survived television and the VCR, gaming and DVD, cinema is now haunted by the spectre of seeders and leechers, rippers and burners, a world where plasma screens fill living-room walls and everyone pillages their movies online. Since the medium marked its hundredth birthday academia has done a roaring trade in 'death of cinema' conferences, and as we approach the centenary of its 'second birth' (as a cultural form and not just a technology), the exhibitors too seem to be grappling with the prospect of their own mortality.

It was ever thus, according to historian Tom Gunning. Returning to cinema's infancy in '"Animated Pictures": Tales of Cinema's Forgotten Future, After 100 Years of Film', he argues that instability has always been written into film's DNA. Not only was the celluloid itself fragile and prone to bursting into flames, but the medium's mixed parentage in theatre, photography and optical trickery has created for it 'a mercurial and ambiguous mission': to dazzle and transport audiences, while also promising to record and store lived reality in amazing detail.[2] Cinema conquered the world by selling the former, with an emphasis on spectacle and novelty; in 1914 a colleague of Thomas Edison likened the limited shelf-life of films to the ice trade.[3] Even as the picture palaces outdid each other in size and grandeur this sense of transitoriness could still be found. 'A romance of finance' was the phrase used to describe the dizzying growth of Oscar Deutsch's Odeon circuit, and it's an apt summary of a business that has frequently defied logic with studios that

4

2 Tom Gunning, '"Animated Pictures": Tales of Cinema's Forgotten Future, After 100 Years of Film' in *Reinventing Film Studies*, Christine Gledhill and Linda Williams eds. (Arnold, 2000), p.327.

3 Frank Dyer, testifying during the 1914 government anti-trust suit. *United States v. Motion Picture Patents Company.* 225 F. 800 (E.D. Pa., 1915) Record 1627. Quoted in Gunning (2000), p.317.

produce more flops than hits and theatres that are virtually empty for half of the week.[4] For Gunning the slipperiness of the medium is directly related to its disorientating effect on the viewer, creating an uncanny illusion of life reflecting tensions beyond the screen:

'The crisis of cinema does not consist in the passing away of a century-long fashion in popular entertainment but embodies a crisis in our way of life, in the age of information. It was as a harbinger of this crisis that film emerged about a century ago; now it once again focuses our understanding of the situation with greater clarity. Cinema has long been a skeleton at a feast, but at the same time, as in a fantasmagoria program, a Méliès trick film or a Disney cartoon, cinema is also a feast of skeletons, a carnival which simultaneously acknowledges our progressive loss of shared realities and provides a festive ground on which this loss can be anticipated, celebrated, mourned and perhaps even transcended.'[5]

Still from Le Château hanté *(Georges Méliès, 1897, Lobster Films)*

5

Before exploring some more recent manifestations of cinema's death-wish I'd like to look at its roots. The popularity of the pre-cinema fantasmagoria, a smoke-and-mirrors show offering communion with the spirit world, and the prancing skeletons in early work by Georges Méliès and R.W. Paul stem from a 19th-century fascination with death; a fascination that has itself been seen as a reassertion of loyalty to the past in the face of massive social and

4 The Mayor of Bury St Edmunds at a 1937 Odeon opening, quoted in Allen Eyles, *Odeon Cinemas: Oscar Deutsch Entertains Our Nation* (Cinema Theatre Association, 2002), p.208.

5 Gunning (2000), p.328.

technological change. Then as now, new technology provided a means of expressing this allegiance with tradition. The arrival of the daguerreotype, for instance, spawned a Victorian craze for photographs of deceased relatives, often propped up next to their loved ones with posthumously applied rouge or pupils painted on the eyelids. André Bazin described this impulse to embalm, to arrest time, as the 'mummy complex', and situated it as a founding principle of art, which was given its most powerful tool with the arrival of cinema.[6] In 1912, a critic from *The Bioscope* visited the Scala Theatre in London to see Charles Urban's *The Coronation Durbar at Delhi* (1911), an early colour film that inspired the following rhapsody:

> 'Man has conquered most things; now he has vanquished Time. With the cinematograph and the gramophone he can "pot" the centuries as they roll past him, letting them loose at will, as he would a tame animal, to exhibit themselves for his edification and delight. The cinematograph, in short, is the modern Elixir of Life – at any rate, that part of life which is visible to the eye. It will preserve our bodies against the ravages of age, and the beauty, which was once for but a day, will now be for all time.'[7]

It's a vision of immortality given extra pathos by our awareness of the war just around the corner; and you have to wonder whether observers a century hence will sift through our own grand proclamations on the digital revolution in a similar light. There is no great leap from 'elixir of life' to 'feast of skeletons', and the connection between the two had already been cemented in the popular imagination by the Gothic horror of Mary Shelley (*The Mortal Immortal*, 1833) and Oscar Wilde (*The Picture of Dorian Gray*, 1890). Notions of life in death and the torment of agelessness were given extra potency by the coming of film. In

6 André Bazin, *What Is Cinema?* vol.1, Hugh Gray ed. and trans. (University of California Press, 1967), p.9.

7 'The Durbar in Kinemacolor', *The Bioscope*, 8 February 1912.

The Haunted Gallery, Lynda Nead has explored how the painting or statue magically sprung to life became one of the images that defined the turn of the century as scientific discoveries and the accelerating pace of life made the idea of stasis look like a fairy tale.[8]

We might see the early film exhibitors as bottlers of mercury, attempting to harness terrifying new velocities unleashed on the world. The years leading up to 1914 are littered with countless tales of rise-and-fall, heroic failures grappling with the potential of the new medium and hunting for a viable living. Among them, Waller Jeffs was a lantern lecturer turned film showman whose seasons at the Curzon Hall became a fixture in Birmingham's cultural calendar. In his heyday during the mid-1900s Jeffs more than matched the triumphalism of our *Bioscope* reviewer, drafting in endorsements from civic dignitaries and extolling the improving qualities of the cinematograph in order to win over a wary middle-class audience. He played a part in making the medium respectable, but his role in its future became increasingly uncertain as the decade went on and formidable competition arrived in the shape of purpose-built cinemas. Having enjoyed years of enthusiastic puff-pieces in the local press, Jeffs's struggles could only be concealed for so long, and you can see the cracks starting to appear in the listings paper *Midlands Amusements*:

> 'New and up-to-date methods will be introduced. The latest pictures as soon as published will find a place in his lengthy repertoire and we can only trust that an adequate measure of support will be accorded the enterprise displayed.'[9]

A once-mighty enterprise is reduced to calling on its customers' sense of compassion, with a pleading tone that echoes today's anti-piracy campaigns. With hindsight it is hard to miss the fatal flaw in Waller Jeffs's business model, conceived before the days of film rentals when exhibitors bought prints outright and hired their

8 Lynda Nead, *The Haunted Gallery: Painting, Photography and Film Around 1900* (Yale University Press, 2008).

9 *Midlands Amusements*, 18 February 1911, p.14.

venues. This led to over-reliance on a limited slate of titles when the curiosity factor of moving pictures was no longer sufficient to hold an audience; they had begun to expect a much more rapid turnover in the programme. The model that won out was a mirror image of this one: exhibitors renting a fresh batch of films every week or two and investing their capital in bricks and mortar. While such dead ends and wrong turns might reassure us that cinema took the correct path for survival, they are also a reminder that other options were available.

archivists have
always had a
touch of this
apocalyptic
thinking

Since the Cinematograph Act came into force in 1910 the template has been set, and the basic characteristics of distribution and exhibition have remained pretty much the same. Odeon's dogged fight with Disney over the theatrical window for *Alice in Wonderland* (Tim Burton, 2010)[10] gives us some idea of how highly cinemas prize the status quo, and perhaps how little faith they have in their own product. In the same way, digital projection has not automatically ushered in more varied programming because all the major players continue to insist on business as usual. Sticking with tradition may be a defence against an inherently risky business, but it also speaks of an identity crisis for the film-going experience. What used to be known as ancillary sales now provide the lion's share of a film's revenue while its theatrical run increasingly takes on the role of a smartly-bound hardback book, an elaborate shop-window conferring prestige on the contents.

8

It is this process, along with the phasing out of celluloid and the growth of multi-platform media conglomerates, that has led Janet Harbord to claim that the Hollywood system actually died in the 1990s.[11] When this harbinger of modernity comes to suspect – like theatre, the respectable elder sibling it came to destroy – that it might have more past than future, so the perceived value of its

10 Odeon cinemas refused to screen the film in the UK in response to Disney's plan to release the DVD before the end of the standard 17-week theatrical window.

11 Janet Harbord, *The Evolution of Film: Rethinking Film Studies* (Polity Press, 2007).

back catalogue grows; not just as a source of revenue and re-useable stories, but also of cultural capital. An origin myth to keep the whole wagon rolling along. As policy-makers and entrepreneurs with no previous interest in old films attempt to figure out a formula whereby digital + archive will equal money, we might detect a certain peak oil mentality, a vision of film as a finite resource with limited prospects. Engaged in a continual struggle against entropy and destruction, archivists have always had a touch of this apocalyptic thinking; whether official institutions or self-appointed keepers of the flame. Talk to one of the hoarders, the obsessives who fill their houses with rusty reels and projector parts, and it's easy to see how cinema and death have snuggled up with each other for so long. A retired projectionist I know is fond of quipping: 'My wife says when I go she's ordering five skips, and I'll be in the first one.'

One of cinema's defining marvels has always been its ability to capture time and rerun it, and its acolytes can be susceptible to nostalgia and sentiment. When celluloid enters its final days in the sheltered accommodation of museums and archives our fetishism of the material itself will only intensify, but so often it is the digital world that provides both the inspiration and the vehicle for this yearning. On Vimeo there is a film called *Facts about Projection* (Temujin Doran, 2010). Made by a projectionist at the Screen on the Green cinema in London, it's a three-minute elegy for the ancient craft of print-handling guaranteed to get film-nerds sobbing into their laptops. 'When they have finally replaced all the reels, towers and rollers with digital computers and computer keyboards, then I'll have to find a new job.' The film was shot on a DV camera, edited on a home computer and reached its audience of 40,000 thanks to free online distribution.[12]

I'm writing this from the Edinburgh film festival, having just seen a feature called *Obselidia* (Diane Bell, 2010) about another hoarder who turns his home into a Museum of Obsolete Things; transistors and turntables, Viewmasters and Polaroids. Our hero

9

12 *Facts about Projection*, www.vimeo.com/8972758.

falls for a projectionist[13] at a silent movie theatre who shares his love of forgotten detritus but has reconciled herself to the modern world, and ultimately she persuades him to turn his museum into a website. Continuing the analogue/digital two-step, the film has

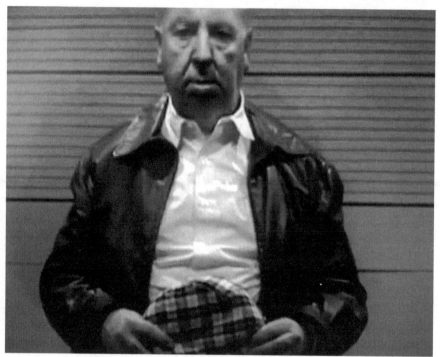

Still from Double Take *(Universal)*

picked up a Sundance prize for its HD cinematography, and rather than watching it in a cinema I saw it hunched at a monitor in the basement of the festival delegate centre, alongside 30 other cubicles. Later as I picked up my tickets from the Filmhouse, the man behind

13 Why have projectionists become such totemic figures? Because they're an endangered species, symbolising the passing of an era as musical accompanists and usherettes once did. Japanese cinema was so wedded to its *benshi* tradition of live narration that talkies didn't catch on until well into the 1930s, the striking *benshi* enshrined as defenders of an ancient order.

the box-office was saying to his colleague, 'people are always going to want that shared experience', while the venue's toilet walls carried adverts for the local Home Cinema Centre: 'we can capture all that is magical with the cinema and recreate it in your home.'

By sliding from forgotten technologies to environmental meltdown *Obselidia* suggests that our pre-emptive mourning for cinema may just be a rehearsal for a much bigger ending. This parallel is also drawn in a different way by artist Johan Grimonprez in the recent *Double Take* (2009), which deftly stitches together archive footage from the late 50s and early 60s to explore how television brought the very real possibility of apocalypse into living-rooms during that period while leaving cinema lumbering in its wake. At the heart of the film is an imaginary encounter between Alfred Hitchcock, in the midst of shooting *The Birds* (1963), and a version of himself on the verge of death, returned from 1980 to warn that it's all downhill from here. 'Half the movie theatres in the country have closed down. TV has killed cinema, broken it down into bite-sized chunks and swallowed it... It is the destiny of every medium to be swallowed by its offspring.' Five years after he made *Vertigo* (1958), one of film's boldest statements of its own necrophiliac tendencies, *Double Take* has the director confronting his own mortality as well as that of his medium. (It also floats the idea that – like the USA – cinema has always needed an enemy.)

Double Take is available on DVD from Soda Pictures.

The fictional Hitchcock recounts a dream of being alone in a huge auditorium, and it is at moments of crisis and transition that empty or abandoned cinemas take on the same resonance as disused churches. During the long, slow death of the 1970s, movies like *The Last Picture Show* (Peter Bogdanovich, 1971) and *Kings of the Road* (Wim Wenders, 1976) used cinema closures as signifiers for a loss of youth or community, and today the internet is awash with images of crumbling picture-houses, glorying in the sight of flaked gold paint, mouldy velvet and dismantled seating. The image of cinema as a body bearing the ravages of a long, painful century recurs frequently in its obituaries; for Susan Sontag, 'Cinema's 100 years seem to have the shape of a life cycle: an inevitable birth, the steady accumulation of glories and the onset in the last decade of

11

an ignominious, irreversible decline.'[14] Jean-Luc Godard has sung a similar tune, predicting that the medium will last about as long as he does. Beyond nostalgia for a particular era of engaged cinephilia, why do so many critics find it impossible to imagine film outliving them?

In Ali Smith's novel *The Accidental,* the life-cycle of cinema underpins the story of a family on holiday in Norfolk, emotionally and sexually capsized by the arrival of a stranger. She is named Alhambra after the provincial one-screen cinema where she was conceived in 1968, a cinema torched by a disgruntled projectionist with a lit cigarette and a tin of creosote at the close of chapter one. A mercurial, ambiguous con artist, Alhambra becomes a blank screen upon which each member of the family projects their own fantasies, and part of Smith's project is to explore how these fantasies are shaped by film-watching while probing the gap between lived experience and the public narratives offered by cinema. In classical movie fashion, the book is structured into three acts, and the beginning of the end is heralded by an exhilarating chapter that describes the medium's first hundred years in seven pages, as if it were flashing before its own eyes.

After shooting through fairgrounds, talkies, Cinerama, a Martian history of film in fast forward, we reach a familiar litany. 'Demolished. Demolished. Bingo club. Demolished. Bingo club. Seventh-day Adventist's Church. Demolished. Demolished. Open-air car sales. Demolished. Supermarket. Demolished...' And so it goes on, each one a nail in the coffin. Then a series of visions, born from a life watching movies: 'Fade to circle. Fade to black. They knock down the walls and all the films stand up out of their dead selves, transparent as the superimposed souls of the dead getting up out of their corpses. Burt Lancaster kisses Gina Lollobrigida on the trapeze high above the crowd... The dead on all the battlefields get up and walk. They walk and walk, they become a great crowd. Limping, bandaged, pale, carrying each other, not like zombies, like

14 Susan Sontag, 'The Decay of Cinema', *New York Times Magazine*, 25 February 1996, p.60.

real shattered people, they walk to the houses of the living and they stare in through the windows.'[15]

What becomes of our movie dreams when the buildings that nurtured them disappear? Smith's father was an electrician at the local cinema, and in part this is her elegy to the Inverness picture-going of her childhood; but by describing the endless mutations and shape-shifting of one venue she undercuts the finality of the chapter's last line ('It's the end of the long, long day.'). It's also worth noting that her death-rattle comes not at the end of the century but during the 1970s, when the industry seemed to be on its last legs and soft porn was the only thing propping it up. Was the multiplex era simply artificial life-support, postponing the inevitable? Or just another manifestation of cinema's travelling light? Unlike the picture of 'irreversible decline' painted by soothsayers like Godard and Sontag, the festive ground invoked by *The Accidental* seems to leave room for further miraculous rebirths in the future. As Tom Gunning puts it, 'Film culture is based less on objects than on the intangible effects of memory and shared experiences (...) There is no single identity to guard, and cinema in its origins was founded in the transformation of sacred rituals into irreverent entertainments.'[16]

The challenges that cinema faces are not phantoms. We cannot conjure up a happy ending by liberating the medium from messy commerce into a realm of pure memory. But for film, the threat of oblivion is nothing new; just part of the package that comes with the promise of immortality, and history suggests that its survival will not depend on one particular funding body, studio system or delivery format. The shape of our anxieties for its future illuminates our own relationship with the past, and the things we most fear to lose. ■

13

15 Ali Smith, *The Accidental* (Penguin, 2006), p.210.

16 Gunning (2000), p.327.

14

'It's the End of Days.' | JAMES STRINGER

A GOOD MAN, DREADFULLY PUNISHED:
Frank Darabont's *The Mist*

JAMES ROSE

The end of this story begins with a single gunshot. A murder in a supermarket, by the checkouts. There is a calling out for blood, holy justice through sacrifice. A child, blond and innocent, is first singled out and then the woman who holds him close to her. A fevered mob descends upon them both as others try to defend them. There is a lashing out with fists and makeshift weapons. As fights break out, the only armed man in the supermarket takes his pistol out from

FEATURING

Creatures

Preachers

Heroes

the waistband of his trousers, takes careful aim and slowly squeezes the trigger. The dull thud of the single shot echoes along the aisles. The bullet breaks through the milk bottle that a woman holds and enters her stomach. The fighting stops. Silence as the woman falls to her knees. Her blood spills out, a deep copper red blossom that soaks into the floral pattern of her dress.

In truth, the end of this story really starts, as it should, near the beginning. Following a violent storm, the people of a small Maine town gather to survey the damage: uprooted trees have crushed cars and houses, the road twisted and the bridge across the river buckled, mundane instances of modern life destroyed by nature. As they stare at the wreckage, military vehicles rumble past in a convoy. Soldiers, young and frightened, sit in the back of the trucks, both hands holding tightly onto their machine guns. No one thinks anything of their presence as a military base is situated high up in the cliffs above the town. The destruction soon loses its appeal and townspeople wander into the supermarket to gather supplies and equipment for repair. Among them are painter David and his young son Billy, his neighbour Norton, the deeply religious Mrs Carmody and deputy manager Oliver Weeks. Standing in the shop together they are only of casual acquaintance. David mentions to Norton that he cannot get a mobile phone signal and that he could not pick up the local radio stations on the way into town. This

succession of occurrences is subtle enough, appearing as they do in the background, their detail softened by the distance. But it steadily constructs a growing sense of isolation, quickly establishing that if something were to happen then those inside the supermarket would be left to fend for themselves. As David and Norton take their place in the queue, police cars and fire trucks hurtle past the supermarket, compounding the indications that something is wrong. And then, suddenly, the siren begins.

It's a horrific sound; a dull and cold wail that renders all in the supermarket silent and still. It is the sound of gas flooding the trenches, of bombs obliterating homes, of a brilliant bright white light that blinds and then burns. It is the sound of the end of all things. A man appears, running towards the supermarket, blood

running from his nose and mouth, red splashed across his bright blue shirt. 'Something in the mist,' he shouts, 'Something in the mist took John Lee'. The siren continues to repeat its singular warning: the mist, nothing more than tiny water droplets suspended in air, is no different to the poison in the trenches, to the falling ashes from all those bombs. 'It's the End of Days,' murmurs Mrs Carmody. The mist, dreadful in its density, rolls against the glass frontage, pressing against it as if it were a solid mass, sealing off the customers' view and stranding them in the supermarket. The large panes, reinforced, may later bow, crack, splinter and break but for now, at least, they hold.

This story has been told many times before. The narrative's origins lie in the Western in films such as *Rio Bravo* (Howard Hawks, 1959) and *The Alamo* (John Wayne, 1960), and it was later incorporated into war films (*Zulu* [Cy Endfield, 1964] being a prime example) and then horror films by notable directors such as Alfred Hitchcock (*The Birds*, 1963), George A. Romero (*Night of the Living Dead*, 1968) and John Carpenter (*The Thing*, 1982). With each telling the story is reworked in a different genre or perspective, but it essentially remains the same: a small group of people, from various parts of the community, are trapped inside a confined space by an unknown threat. They attempt to survive their situation through group work and put their trust in a nominal leader but soon the need for self-preservation emerges, quickly followed by prejudice, resulting in violent and often deathly conflict. In the supermarket, the disparate customers are at first unified by mutual guilt: moments after the mist has rolled against the plate glass windows, a mother stands before the others and begs for their assistance in getting back to her young children. As no one will help, the woman walks out into the mist, alone. Her heels click sharp against the concrete and she disappears, soon to be presumed dead. Much later, one of those who refused to help her will, perhaps as a punishing justice, see her again.

This first act of self-preservation is followed by many more, each time resulting in the death of two or three members of the group. David witnesses nearly all these deaths, the most harrowing being

17

the assault upon Norm in the storeroom: with the delivery shutter partially open, the mist seeps in and, with it, a thick, single tentacle, the first manifestation of the monstrous threats that lie outside. The thing coils itself around the teenager, and although David tries to help, more tentacles reach inward, tearing strips of flesh from Norm's legs and chest, finally dragging him outside. David sits in shock, Norm's blood smeared across his face and hands. Norm. Normal. Being trapped by unfathomable creatures and an ever-thickening mist in a supermarket is a long way from normal. The supermarket, of all the places they could have been trapped within the most mundane and everyday of locations, makes that sudden shift away from normality all the more shocking. Its aisles are filled with brightly coloured packets, dried food, exotic vegetables, its cabinet refrigerators and freezers steadily humming below the numbing music. It was a consumer heaven, but now the consumer has become the consumed.

for this lack of vision, he will be punished

The mist is transformative or, despite its concealing nature, revealing. As this blanket of grey settles over the supermarket, some people change. At first it's a communal shift for all feel fear and all deny the single parent the help that she needs. But as events slowly unfold and the mist thickens – obscuring further but revealing more – the true nature of those trapped becomes apparent. Norton, the slick city lawyer, adamantly grounds himself in fact and denies the fiction of the supernatural potential of the mist. His logical world view will not tolerate the possibility of the fantastical. For this lack of vision, he will be punished when he and a number of others finally decide to leave the supermarket.

Norton's decision is dominated by a strong sense of rationality, but there is also an underlying reason. Early scenes refer to a past conflict between Norton and David and there is a palpable sense that Norton, in some way, feels as though he is being mocked by the locals. This suggests a sense of suppressed paranoia within Norton, a paranoia that is compounded by his status as an outsider: although he owns a house on the lake, it is a weekend/holiday retreat. Fully aware that he is 'from the city', Norton perceives the locals' rising belief in the supernatural or biblical possibilities of the mist as a

means to further conspire against him, to directly challenge his rationality and to mock him because he is not 'one of them'. As he says when David attempts to convince him not to leave the supermarket, if there is something in the mist then: 'the joke will be on me after all.'

Norton is played by black actor Andre Braugher. Although there is never any mention of his ethnicity, nor is there any blatant racial conflict within the film, it is hard not to acknowledge that Norton, the black male, is forced to stand up against a group of white people for what he believes to be right. This almost unconscious conflict exacerbates the more obvious oppositions of social class and religious belief, with each conflict in turn eliminating certain characters while pitching neighbour against neighbour, friend against friend, in what steadily becomes a sort of localised civil war: personal belief against rationality, religious belief against the known and observed incidents.

In sharp contrast to Norton is Mrs Carmody. Secretly losing her faith, she finds it again as she marks the shifting shadows in the mist as Cain. They empower her by providing her with the evidence of Otherworldly existence, fuelling her interpretations of prophecy. In these terrible interpretations she finds an authority over the confused and the frightened, a power she wields un-tempered, and so while she may preach for the greater good she is instead only aligning herself with that which threatens: she is a religious hysteria, vengeful and violent, the threat coming not from outside the supermarket but from within it.

And then there is David. Whereas Norton, the rationalist, sees nothing but mist and Carmody the machinations of a vengeful God, David, the artist, sees what the film is telling us is there: monsters. He has witnessed their flesh and the spilling of their blood, their tentacular nature, the rows of teeth, the blank eyes and terrible claws. Accepting what he has seen, no matter how improbable it may seem, David copes with it, emerging out of the mist as a Common Man who through dreadful circumstance becomes an unwilling leader. In this role he tries to do what is right. He tries to fortify and defend the supermarket; he works hard to keep the group together; convinces

19

20

'Better to die by the bullet than by tooth and by claw.' | JAMES STRINGER

some to stay but helps the ones who want to leave; attempts to rescue others and risks his life to get medical supplies. He negotiates and comforts and saves. He is a good man, but that is precisely why he will make the wrong decision at a fateful moment.

As the death toll mounts, the ever decreasing group becomes fractured, each with their own understanding of what is happening and how the situation should be dealt with. The first signs of the group splintering come right after the mist has engulfed the supermarket, when to Mrs Carmody's 'It's the End of Days' an old man replies that it is the result of a chemical accident at the mill. It is religion against science, a juxtaposition that at first positions Mrs Carmody as a mentally unbalanced, weak and ineffectual individual who is not taken seriously by the others. But, as more people are devoured and torn apart by the apocalyptic creatures, Carmody's religious preaching gains in ferocity and her ranks of believers increase, culminating in the sacrifice of a soldier.

In the besieged supermarket, fear – unfounded or not – breeds religious conversion and possible extremism. Stockroom worker Jim is a perfect example of this: he is, at first, very much against Carmody's sermons, all the more so as he was one of those who witnessed Norman's death and, during the early part of the film, threatens to beat her. But, as the death toll mounts and the number of unworldly creatures increases, Jim falls under her hypnotic spell. His fear of dying (no doubt in part amplified by Carmody's rhetoric) and an overwhelming sense of guilt for Norm's death create a significant shift in his belief system to such an extent that he not only prays at Carmody's feet but actively arms himself to protect her from David's small collective. Jim begins the narrative as a seemingly rational and open-minded individual, one who, like many others in the supermarket, considers Mrs Carmody to be nothing more than the local, slightly crazed (but harmless) religious spinster. But as the deathly events unfold, his fear, guilt and paranoia provide a weakness for Carmody to prey upon and, through her Old Testament oratory, she causes a significant polarisation within him: instead of remaining rational he becomes fearful of that which he mocked.

21

The balance of power slowly shifts from the rational to the supernatural. Carmody's preaching turns from religious mania into a powerful weapon of fear, one that can stand up to the only actual firearm in the film, Ollie Weeks's hand gun. While at the start of the film this weapon (quite literally) loads him (and those he chooses to align himself with) with the most power within the supermarket, Mrs Carmody soon proves that guns and bullets are no match for the power of language, fearful rhetoric and the (lynch) mob. While Ollie stands with his revolver, Carmody's flock stand united, their weapons both an unfailing belief in Judgement Day and anything that has come to hand within the shop. The contrast between the two is perhaps all the more exaggerated because of Mrs Carmody's gender: as a female who uses speech as a weapon, she appears to successfully undermine the phallic power of the gun. That is, until she tries to prevent Ollie, David and the small group of remaining rational thinkers from leaving the supermarket now controlled by her fanatic supporters. As the mob descends at her request, Ollie draws his revolver and shoots Mrs Carmody, once in the stomach, once in the head.

bodies are cocooned to car seats

Few of David's group survive the gauntlet across the creature-infested parking lot and into his car. The five remaining characters are like a family, bound by the blood spilt in their recent experience. An elderly couple sit in the back, Grandma and Grandad, while David, the father, sits at the wheel. His 'wife' sits next to him, his son sleeping on her lap. Outside their slow-moving vehicle the world has forever changed: the landscape of overturned cars and toppled pylons is covered in a soft white material, light and thin, like the web of those terrible spiders. Bodies are cocooned to car seats or the corners of their houses. Nothing moves. As they drive down the motorway, David stops the car. A dull thudding can be heard, the car jumping with each sound. Towering above them, a creature of horrific proportion strides across the road. Its six thick, bone-like legs move in slow unison, its great underbelly writhing with thousands of tentacles. The terrifying beast, a dreadful confirmation that the world as they knew it has ended, disappears into the mist. They drive on until the fuel runs out. There is no one else, only this new

world in which they are now nothing more than prey. Hope, like the fuel, has finally run out. They have little choice for in this alien world their chances of survival are null. There are five survivors but only four bullets. David makes a decision.

Outside, the creatures roar, their moans drifting through the mist. Then, out of that thick white curtain rolls a tank. A rescue. Behind it, soldiers burn away the webbing and the monsters it conceals with flame-throwers, revealing the old, familiar world underneath. David, the only survivor from his group, watches, unable to speak.

Killing them, only a few moments ago, seemed like the right thing to do because survival in the soft white landscape appeared impossible. Better to die by the bullet than by tooth and by claw. Now, as more military personnel appear, it seems like such a dreadful act. Killing his son, surviving himself. There was, at that point, no choice. He, the rational, moderate good man, just like Mrs Carmody, the religious maniac, chose to sacrifice. This decent man, this unassuming hero, this indefatigable helper of others, who, throughout the film always seemed right, could not have done more wrong. Then David sees her again, that single parent that no one would help. She stands in one of the passing trucks, both her children, safe and well, at her side. She looks down at him as she passes by but says nothing. David drops to his knees, just like Mrs Carmody did with Ollie Weeks's bullet burning in her gut, and screams. When threatened by the end of the world, it seems that no one, whether rationalist or realist, religious extremist or moderate, good or bad man, has the right answer. ■

23

End of the Wicked | LIBERTY FILMS

CARELESSLY KEPT:
End of the Wicked

NICOLA WOODHAM

In 1999, Nigerian evangelist Helen Ukpabio worked with director Teco Benson to capitalise on the wave of popularity of low-budget Nollywood melodramas. Nollywood was just beginning and has since grown to be a huge independent film industry in Nigeria, where privately funded filmmakers turn around thousands of films each year. The result of the collaboration was the unusual and extreme film *End of the Wicked: A Witchcraft Movie.* I have previously

FEATURING

Child witches

Occultists

Evangelists

Beelzebub

Nollywood

25

described the subgenre it belongs to as African horror-trash but it has also been seen as part of the Nigerian evangelist horror genre. When I first saw the film, like most horror cinephiles, I was delighted to find a film that covers familiar ground: witches, native doctors, animal metamorphosis, cheap special effects and Christianity battling it out with occult forces. The style is high camp, and as a Western viewer it is hard to take the film seriously, but when one understands the context of its production and its meaning for an African viewer it appears in a completely different light.

The plot of *End of the Wicked* revolves around a coven of adults and children converted to witchcraft, who are incited to refill the empty blood bank by Beelzebub, master of the 'Land of Torture'. Over a few days, they deliberately use magic to cause pain and misery to their families: people die unexpectedly, businesses and marriages fail, homes are repossessed, people are electrocuted. A mother-in-law nicknamed 'Lady Destroyer' causes the most trouble and wants to ruin her family, but she is no match for the powers of a pastor, played by Helen Ukpabio, who comes to the rescue. Lady Destroyer loses the battle of spiritual wills. She confesses and is publicly beaten by a mob. Witches and witchcraft practice are manifested with makeshift props and make-up. Scenes are thrown together and embroidered with unsophisticated computer-generated images and repetitive library sound effects to suggest the power of a spell or magical transformation. The acting and sound quality is shaky, but the overall impression is of a vibrant new kind of filmmaking. It was long-awaited: African people telling African stories in a Nigerian setting – but the disturbing message of the film and the way it was received in Nigeria cannot be ignored.

When speaking to Teco Benson last year, I learnt that the function of many Nollywood films is to morally educate African people. These widely distributed, often pirated movies reach thousands of viewers. Ukpabio, who wrote and produced the film, founded the Liberty Foundation Gospel Ministries in 1992 in the city of Calabar, Cross River State. With *End of the Wicked*, Ukpabio aimed to show that trust in Jesus will prevent all ills, from unhappiness, poverty and illness to childlessness. She uses drama and the easily

accessible medium of video to
spread her radical Pentecostal beliefs
and to reach out to 'the lost and the
ignorant'. As her website indicates, a
prime motivation of her church is to
eradicate witchcraft.[1] Ukpabio has
written widely on how to identify a
witch and the harm they can cause.
One of the services she offers is
'witchcraft deliverance', claiming
that she can 'deliver' thousands
of witches simultaneously. When

Still from End of the Wicked *(Liberty Films)*

Ukpabio portrays a child as a witch in *End of the Wicked*, she is not
using witches as the fantasy figures of Western popular culture, but
rather she is reflecting Nigerian cultural and spiritual beliefs. For
Ukpabio, child witches are a real danger and need to be found and
brought to her for exorcism. Her viewpoint echoes a genuine fear
among some people in Nigeria, where belief in child witches has
become more prevalent this century.

This problematic aspect of the film was outlined by filmmakers
Mags Gavan and Joost van der Valk in their documentary *Saving
Africa's Witch Children*.[2] They make the connection between the
release of *End of the Wicked* and the rise in maltreatment of children
believed to be witches across Nigeria, especially in the state of Akwa
Ibom (part of the Niger Delta and next to Cross River State, where
Ukpabio resides). They argue that although films like *End of the
Wicked* are not the sole motivator for belief in child witches, or
brutality to children, they are a contributing factor. The accusations
of the filmmakers did not sit lightly with Ukpabio, who has since
tried to sue them and leaders of featured Nigerian charities Child
Rights and Rehabilitation Network (CRARN) and Stepping
Stones, disrupting their conferences by sending her supporters to
violently sabotage them. In July 2009, for instance, a conference

27

1 www.libertyfoundationgospelministries.org.

2 *Dispatches*, Channel 4, 12 November 2008.

organised by the Nigerian Humanist Movement on child rights and witchcraft in Calabar was raided by around 150 members of the Liberty Foundation Gospel Ministries, who caused a temporary but aggressive disruption.

Ukpabio's cause is inherently complex and multifaceted. On the one hand, she supports belief in witchcraft, advocates deliverance from its evil and makes a film that portrays the violent beating to death of a 'witch'; but on the other, she detaches herself from any incidences of torture or injury to individuals suspected of demonic possession. She ardently defends herself against her critics' accusations. Her exorcisms, she claims on her website, work without laying her hands on the suspected witch: 'Unlike other ministries where witches and wizards are beaten or stoned to death, Liberty is the only Ministry that shows mercy to witches.'[3] She also claims that because she does not charge for 'deliverance' she cannot be accused of exploiting her congregation. She resolutely maintains that she has no part in the child abuse that happens in Nigeria as a result of the extreme beliefs she has helped disseminate by way of books, films and services.

ways of recognising witches are purely intuitive and variable

The figures are staggering. There are thousands of homeless children across the Niger Delta, abandoned because they are thought to be witches. On the Stepping Stones website, the list of reported violent treatment of supposed witches includes: being buried alive, bathed in acid, chained and tortured in churches to extract a confession and being outcast. Pushing these beliefs can mean big money for some evangelist church leaders. Akwa Ibom has more Christian churches per square metre than anywhere in the world. There, parents pay sums of money they can ill afford for pastors to perform cleansing rituals on their children. In the *Dispatches* documentary, one woman pays the equivalent of £130, when the average wage is less than $1 a day. The tactics are terrifying. Ways of recognising witches are purely intuitive and variable; a child can be identified just for being a child, it seems. Ukpabio writes in her book *Unveiling the Mysteries of Witchcraft* that,

28

3 www.libertyfoundationgospelministries.org/downloads.html.

'if a child under the age of two screams in the night, cries and is always feverish with deteriorating health, he or she is a servant of Satan'.[4] Many children may exhibit this behaviour given that the area is rife with disease such as HIV/AIDS, typhoid, hepatitis and malaria. If any misfortune befalls a family, a child may become a scapegoat. They are targeted, stigmatised and often exiled. Even though a Child Rights Act was passed into law in Nigeria in 2003 to protect children, *Saving Africa's Witch Children* makes clear that the Akwa Ibom government had not actually signed the Act at the time of filming, five years later. Nevertheless, the power of the media and further protest from Stepping Stones and CRARN pressurised the state governor, Godswill Akpabio, into enacting the Child Rights Act in December 2008.[5]

It has to be said that the Nigerian authorities are not entirely comfortable with Helen Ukpabio, and the National Film and Video Censors Board started legal action against her six years ago for illegally distributing her films, including *End of the Wicked*, although she has recently won the case. Her film *The Rapture* had previously been banned by the Nigerian censors for 'anti-Catholicism'. Ukpabio is under obligation to present her films to the NFVCB for classification before their release but in these instances she did not. Ukpabio's case highlights a recent surge in the legislation of Nollywood filmmaking. The government has attempted to crack down on the uncensored release of films and their piracy. Nollywood films are usually released straight to video; they are produced and can be reproduced illegally in the VCD (video compact disc) format. The aim of the government is to enforce a more organised form of distribution so that filmmakers can see some of the profits for their hard work and personal financial investment in the production of films. However, it's worth noting that, problematic as Ukpabio's

29

4 Chapter 8, quoted in *Saving Africa's Witch Children*.

5 In the *Dispatches* follow-up documentary *Return to Africa's Witch Children* (Channel 4, 23 November 2009) Godswill Akpabio is heard stating to his officials that five million people viewed *Saving Africa's Witch Children* on the first day it was available online. His embarrassment was clear. More details on the governor's position can be found on the state website www.aksgonline com.

Still from End of the Wicked *(Liberty Films)*

vigilante approach may be, the spirit of independence is what has made Nollywood so popular. As an industry it has thrived without government intervention and gained from operating outside the law. While the industry is unsustainable with the current level of piracy, it can be argued that piracy made Nollywood films cheap and accessible to thousands of African people, people who have created a demand for more films, with higher production values. In some ways, Ukpabio has been made an example of by the NFVCB. Yet, this has had an adverse effect. She can now claim that she is being persecuted and denied freedom of speech, which gives her even more ammunition to fight her cause.

This law suit also indicates the extreme lengths to which Ukpabio will go to uphold her right to practise her belief in witchcraft and to defend her name. This fighting spirit carries over into the content of her cinematic output. Ukpabio's films are controversial and inherent

in them is a sense of warfare, of different belief systems battling for precedence. Her films belittle native beliefs and ancestor worship. True evil, they suggest, is in the form of the Christian idea of Satan, and they end with a final 'showdown' where evil oppression is combated with prayer. Indeed, her own background puts her in a good position to claim authority about different religious 'powers'. She alleges that she was initiated into occultism (the Olumba Olumba Obu cult) herself in her youth and also attended a Catholic school before entering into the Pentecostal Church in her 20s.[6] In this way, she is a shining example of deliverance, an advert for her own faith. Like all religious converts, her belief is fervent. It could be argued that her intelligent orchestration of many facets of different religions (Pentecostal, Catholic, native) in her preaching makes her an Everywoman.

Debate as to whether *End of the Wicked* sparked a surge in belief in child witches is framed by a political, socio-economic and environmental disaster affecting the people living in the Niger Delta region. The oil industry has polluted the country's land and water through gas flaring and spills, with overwhelming effects on people's health and livelihood. Political unrest and militarisation has caused ethnic conflict between Muslims, various Christian groups and believers in ancestor worship. Military groups battle for ownership of oil resources and civilians have suffered in the crossfire. Reportedly, the government and oil companies split the profits for oil 60/40. These profits can scarcely be seen in an area where, for example, fewer than 20% of the Niger Delta communities are connected to the national grid.[7] At such an apocalyptic time, it seems some people in the Niger Delta communities are looking to religion to protect them.

31

6 This is outlined in the founder's profile on the Liberty Foundation Gospel Ministries website.

7 These figures are taken from the website of *Sweet Crude*, a documentary directed by Sandy Cioffi in 2009, which investigates the effect of the oil industry in the Niger Delta on its surrounding communities (www.sweetcrudemovie. com/nigerStatistics.php).

While I recognise that a fictional film is not a document of actual happenings, the narrative of *End of the Wicked* provides insight into the supposed practice and damage witchcraft causes. Family members are portrayed as having double lives. They inhabit two worlds, the world of human family life and the reality of the Land of Torture, where they commit foul deeds that affect people in the 'real world'. Performing her duties as a mother-in-law by day, Lady Destroyer is also a slave to Beelzebub. A child, who on the surface is playing football in the local park and sharing food with his friends, is really transmitting spells via the food to convert his friends to witchcraft. On the night of the transformation, these children are called from their beds by the head child witch who has converted them. In a starburst effect, a girl levitates in her bed and her ghostly brother is transported outside as we hear a laser gun sound effect. A bolt of lightning strikes and the children rise up into the sky. Here, child witches can walk through walls, be transported to the underworld and materialise from nowhere in a flurry of lo-fi special effects that sparkle and smoulder against a domestic backdrop.

The child witches are seen to utilise the everyday comings and goings of family life for evil means. Back in the Land of Torture, the head child witch initiates the new witches. He tells them: 'This is my empire. We operate by picking things from our parents. All properties, condemned things, all things that are carelessly kept. We bring them here and we use them to torment them!' He then invokes the traits of 'stubbornness, lack of interest in school, waywardness and power of destruction' for child witch Mercy, whose new spiritual name is 'Mistake'. She is urged to 'blow up all electronics in her home, break plates, glasses and then cause fever and failure to all other children in her home'. Her brother, given the name of 'Drainage', later comes back to the coven with cotton buds covered with 'discharges from [his] father's eyes and ears'. Another child brings shoes and towels. These are items that could easily be mislaid or moved unconsciously, and in the narrative the children take advantage of their parents being off guard for a moment. These everyday objects are used for horrific purposes by the children to seriously injure and bring calamity to an individual. The cotton buds

these everyday objects are used for horrific purposes

32

are used to summon the father to the Land of Torture and to initiate a spell that causes his eyes to fall out. Back in the real world, he is shown holding his hands to his eyes in pain, blind. Many believers in witchcraft look for any mishap as an indication that a child witch is among them. Any mundane accident can incriminate a child: a dropped towel kicked under the bed becomes a stolen towel, a lost shoe becomes an object used for evil purposes. With such openness to interpretation, any child can be a witch, and any problem can be attributed to witchcraft.

What is particularly interesting in Nollywood evangelist horror films, especially in *End of the Wicked*, is the contrast of the am-dram occult scenes juxtaposed with action set in modern urban Nigerian domestic interiors, such as the kitchen, living room, bedroom or office. While trying to show how witches can be blamed for life's horrors, the films reveal that modernity with its attendant pressures – running a business, accommodating different religions within one culture, owning a car or possessing an excess of material objects, dealing with orphaned children – is more likely to be the cause of the problems that occur than witchcraft. To me there is something sad about mistaking commonplace occurrences for occult oppression, in letting the daily detritus of life become sinister. The fear of witchcraft becomes a form of paranoia that is self-perpetuating and inescapable.

In the end, I still like Ukpabio's film for its transmogrification of Hollywood voodoo tropes: the native doctor, the manifestation of Beelzebub and theatrical renditions of underworld covens are now set against a contemporary African backdrop. Here, motifs once appropriated by commercial Western filmmakers are reconfigured for specific Africa-centred purposes. Yet I also find it impossible to watch the film without considering the way it is used by evangelist believers in witchcraft, and the dark resonance of its representation of the child. ■

33

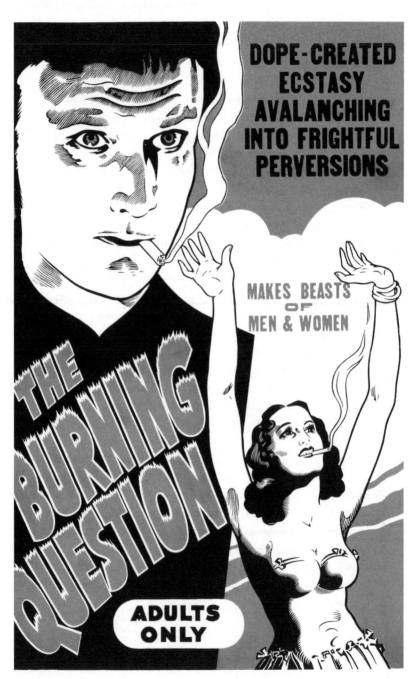

Poster for The Burning Question, *aka* Reefer Madness

SHE SHOULDA SAID 'NO':
The 'sinsational' bad girl/ bad ending drug theme in exploitation cinema

JAMES EVANS

What is socially peripheral is so frequently symbolically central.
—Allon White and Peter Stallybrass[1]

Film history is littered with morality tales of good girls gone bad. Or difficult girls gone bad. Or naïve girls gone bad. Or simply bad girls gone badder. One point of commonality in all of these films – their collective state of being 'on message' – is that if females transgress from the supposed normal and natural roles ascribed to them by culture (patriarchal *and* consensual) then their lives will

Weird orgies
Wild parties
Unleashed passions
Frightful perversions

1 Allon White and Peter Stallybrass, *The Politics and Poetics of Transgression*, quoted in Eric Schaefer, *Bold! Daring! Shocking! True!: A History of Exploitation Films, 1919-1959* (Duke University Press, 1999), p.13.

take a decidedly nasty turn: addiction, pregnancy, abandonment, prostitution, sexual slavery, criminality and often, incarceration. Then there is always the option of narrative dismemberment or death (usually of a graphic or sudden kind), all of the preceding a bane to conformist society and a boon to exploitation filmmakers as shall be seen.

vociferous protestations about the sinful influences of Hollywood films

From the 20s to the 50s and beyond, the message is clear: get out of the pre-ordained gender line and you will be punished. Bring drugs with you into the scenario and you will get lost – and possibly buried – within a labyrinth of torment, confusion, madness and regret – if not death. The classical drug exploitation sub-genre of American bad girls/bad endings films arose during the silent era, grew exponentially during the 1920s-30s – which were periods of great social and cultural upheaval encompassing two defining eras in American life: the Roaring 20s and the Dirty 30s – re-surfaced and staggered on for a few years in the immediate post-Second World War period and was finally made redundant and irrelevant by the more mature and realistic treatment of Otto Preminger's *The Man with the Golden Arm* (1955). In this the drug films paralleled – not unconnectedly – the rise and fall of the once-mighty Hollywood Studio System. They also developed in the wake of modernity's unstoppable march on American culture.

THE CODE AND ITS DISCONTENTS

36

Alarmed by the vociferous protestations from various conservative, religious (notably the Roman Catholic National Legion of Decency) and 'right-thinking' American pressure groups in the 1920s and 30s about the supposed immorality and sinful influences of Hollywood films, the Federal Government began to take a look at film production in the US. The Hollywood moguls, fearful above all of any Federal intervention in their businesses, agreed in 1930 to abide by a self-regulatory Motion Picture Production Code of Practice – the so-called Production Code – overseen by arch-conservative and former Post Master General William Hays and based on a list of cinematic 'Dos and Don'ts', which he had been hired to draw up for the industry in 1927. But Hays was seen to

be mainly a mediator and apologist for Hollywood productions on behalf of the studios. It was not until the tough-minded Catholic Joseph Breen took over as Director of Code Administration in 1934 that the Code was rigorously enforced. Additionally, its certificate of approval, which appeared in the opening credits, was required to prove that the film met the Code's standards of morality, and few producers would take the risk of attempting to release a film without it, especially with the threat of $25,000 fines and well-organised boycotts of their films by concerned citizens.[2]

The Breen-period Code and its strictures had a profound effect upon American cinema right up until the relaxation of standards in the 1950s, the subsequent court challenges in the 1960s and the eventual abandonment of it in 1968 in favour of a ratings system. The Code prohibited subject matter such as depiction of nudity, prostitution, homosexuality, miscegenation, incest, rape, abortion, excessive violence or brutality, profanity, the detailing of criminal acts, the use of drugs and of course, sex. Many of these themes had been a sensational mainstay of pre-1934 films as in, for instance, *Baby Face* (1933), where a young Barbara Stanwyck plays a small-town girl whose own father rents her out for sex to his bar patrons; eventually she takes off for the big city where she rises to the top by sleeping with any man who can further her career. Made by Warner Brothers, this was a racy, no-holds-barred picture for the time, and one that would prove impossible to make after Breen. But the ingenious lengths to which filmmakers walked the tightrope between what the Code required and what many audiences really wanted to see is instructive in itself, and can be discerned in many

37

2 The 1930 voluntary regulations drawn up by Hays – The Motion Picture Production Code – are also frequently described as the Hays Code or the Production Code or simply, the Code. But the interim period during which the Studios continued to make films that paid only lip-service to it until Breen took over (1930-1934) is referred to, rather confusingly, as the pre-Code era. So film writers often talk of an <u>actual</u> pre-Code era (pre-Hays), a *de facto* pre-Code era (pre-Breen) and then the true era of the enforced Code. Recently, there have been a spate of DVD box-sets advertising pre-Code Hollywood films that were made before 1934.

productions of the time, reaching a kind of masterful apogee in *film noir.*

Aside from the Hollywood Studios toiled a group of producers who, for the decades between the 20s and the early 50s, were prepared to work completely outside the system – physically and often legally. They provided audiences with very low-budget films that reflected the social and cultural concerns of the day but with an emphasis on transgression: sex, drugs, abnormalities and violence – essentially dealing with themes that the Code did not permit. These exploitation films arose from – and were exhibited in – relatively unfamiliar sites of cinematic production *and* exhibition, namely the back alleys of cities, the dives, the grindhouses, the flea-pits and the industrial warehouse spaces.[3]

It is at that time that the likes of Kroger Babb, Louis and Dan Sonney, Willis Kent, Dwain Esper, David Friedman and Samuel Cummins carved their movie careers and found their market niches. They were big talkers, shysters, con-men, ex-showmen and dodgy businessmen. They became known as 'The Forty Thieves' 'because they ripped each other off as much as any audience or cinema manager'[4] and they worked in the shadows of the business and the exhibition system. Knowing that the Code really only applied to the big Hollywood Studios, they directly addressed – exploited – the very cultural anxieties that concerned the Legion of Decency and other supporters of the Code. Top among these cultural anxieties were issues of youth in general and females in particular and as such the films are interesting and salutary. They were invariably thinly disguised morality tales: the 'Thieves' used the cheap trick of seeming to be socially concerned and making films 'in the public

3 These exploitation films of the halcyon days of early cinema lasting until about the early 1950s (in contradistinction to later exploitation films made by the likes of Russ Meyer, Doris Wishman and Roger Corman) are a very distinctive group from either the 'B' studio films of the majors (the true B-movies) or the 'Gower Gulch' aka 'Poverty Row' studios like Monogram, Republic and PRO, studios which were situated in the cheaper real estate areas of Los Angeles and not in Hollywood proper.

4 Harry Shapiro, *Shooting Stars* (Serpent's Tail, 2005), p.69.

interest' with themes and scenes of 'brutal reality' that 'Hollywood wouldn't dare to make' as their publicity packs told it. Driving across America, the 'Thieves' took their films on the road, renting run-down cinemas for set times or exhibiting them at midnight on a one-off basis as a forbidden 'adult only' pleasure, paying the cinema managers as little as possible.

With the media and religious groups whipping up hysteria about the breakdown of the family, 'wayward girls' and contemporary moral laxness among the young – especially those who migrated to Hollywood or the big city to seek fame and fortune – the exploitation filmmakers found their narratives: curious amalgams of soppy melodramatic morality tales mixed with an undiluted shot or two of dirty realism. One such potent shot of realism was the depiction of drug use, which in turn reflected larger cultural and racial anxieties.

During the 20s and 30s, America attracted record numbers of migrants while its own internal population was also on the move from rural to urban areas and from Depression-affected states to supposed states of milk and honey like California. This mass movement of people, which disrupted formerly stable communities, created inevitable racial and cultural stereotyping. The Chinese community was one of the first to be linked to vice and drugs, and following hard on its heels was the black community. Lurid and sensational stories circulated in the press about inscrutable 'yellow men' combined with what Harry Shapiro describes as:

39

'the general fascination with the Orient – the mysterious and dangerous, yet exotic and alluring, world of the opium den where young white women were supposed to be lured to a fate worse than death (...) That the Chinese smoked opium was bad enough (...) But worse still, the exotic, slightly mysterious and dangerous atmosphere of the opium den was encouraging white artists, Bohemians and denizens of the white underworld to sink further into their depravities by consorting with heathens. The ultimate outrage was reported by a San Francisco doctor: "the sickening sight of young white girls from 16 to 20 years of age lying half-undressed

on the floor or couches, smoking with their lovers. Men and women, Chinese and white people, mix indiscriminately" (...) Here were all the classic ingredients of the classic shock-horror drug story: young white girls... drugs... foreigners... miscegenation... sex.'[5]

He goes on to describe how Southern plantation owners would add cocaine to the drinks of black slaves to make them work longer and suppress their appetites; later, 'once slaves were freed, they were perceived as an angry subhuman horde who would seek revenge in the most heinous way – the rape of white women'.[6] With the increase of Mexicans entering the US, attention was turned towards another deviant, foreign group and marijuana became the evil menace. Visual and semiotic links were established between opium/Oriental/miscegenation/deviance and marijuana/Mexican or black/miscegenation/deviance/cocaine: 'It was now up to the new engine of mass media entertainment – the cinema – to enshrine these stereotypes on celluloid.'[7] Threats to good, clean American (white) life came from Mexicans, blacks and Chinese in drug narratives that got played out in dingy apartments, hotel rooms and jazz joints – jazz in the 20s and bebop in the 40s being the devil's music as rock and roll was to become in the 50s. According to films of the day, these ethnic groups operated in drug gangs and drug dens and their main occupation was finding new and young customers for their seductive – and addictive – wares. Girls tended to be easy victims, falling prey to the allure and liberating promise of drugs and their associated loose moral behaviour – with the possibility of sexual activity with non-whites being arguably the greatest threat of all. Well before the 'Dos and Don'ts' list was deemed necessary in 1927, and even before the 'Thieves' re-invigorated the genre in the 1930s, cinematic drug conventions were becoming established

5 Shapiro, (2005), p.6, 17.

6 Shapiro, (2005), p.20.

7 Shapiro, (2005), p.21.

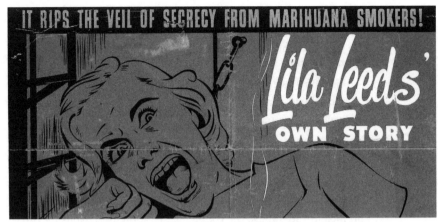

Poster for Lila Leeds' Own Story, *aka* She Shoulda Said 'No'

in films like *The Secret Sin* (1915), in which a sister tries to save her twin from morphine addiction, a habit she initially picked up during visits to opium dens, as well as *Rube in an Opium Joint* (1905), *Deceived Slumming Party* (1908), *The Accursed Drug* (1913), *Slave of Morphine* (1913), *The Little Girl Next Door* (1923), *The Case of a Doped Actress* (1919) and *White Slave Traffic* (1913).

All of this is symptomatic of another cultural fact: modernity. And it can be understood that to an extent, it is modernity that is the target in these moral panics. One aspect of modernity was the exponential growth in technology, industry and entertainment forms, which was reflected in cinema. Another aspect was the movement of populations and swiftly changing demographic patterns. Men and women took a measure of control over their destinies, which, added to the great migration in the 20s and 30s from rural areas to urban ones, resulted in a new social stratum of urban working-class young males and, in lesser numbers, females. The First World War and its aftermath had caused transformation 'to be convulsive rather than gradual' and, as Marek Kohn further observes:

'Women, especially young women ['girls'] were sensed to be the agents and beneficiaries of this transformation. Young women became exceptionally clearly defined as a distinct group in society, and drugs were one way in which anxieties

41

about them could be articulated. Drug use was understood to be a crisis of young womanhood (...) The creation of a drug underground was a specific instance of cultural modernity. It disrupted several highly sensitive social boundaries of sex, class and race, and packed these destabilised ingredients into a confined space. This inevitably provoked a reaction both legal and textual.'[8]

Shapiro notes that it was with the urban working-class youths that a fresh market arose for the drug trade. Unlike previous generations who had often been hooked on morphine, opium and cocaine as they were legally available and widely used as pain-killers, sedatives or 'pick me up' tonics, the younger generation used drugs for fun or to stave off boredom. They became:

'increasingly associated with the slothful and immoral, criminal classes who degraded the nation's cities, narcotics use threatened to retard national growth with pauperism, moral degeneracy and crime (...) Interestingly however, although the younger users were inevitably working class, the message of the films was very much directed at the middle classes and their fears about the safety of their children. Nearly all the drug films of the early period (...) were variations on the theme of degradation and despair visited on the upper and middle classes through drugs. The genre played itself out by the end of the First World War but was revived by the death of Wallace Reid and the release of *Human Wreckage* in 1923.'[9]

Wallace Reid, one of Hollywood's biggest stars, had died young, in a sanatorium where he was battling his well-publicised morphine addiction, and this was followed by a rash of other Hollywood scandals, including the Fatty Arbuckle rape/murder trial and

8 Marek Kohn, *Dope Girls: The Birth of the British Drug Underground* (Lawrence & Wishart, 1992), p.8.

9 Shapiro (2005), p.73.

the dope murder scandal of director William Desmond Taylor.[10] Salacious tales of narcotic use, sexual antics and high living by the stars set the censorial voices of conservatism to work and the aforementioned William Hays was employed to clean up Hollywood's image. With the deep controversies circulating about the release of *Human Wreckage*, a graphic tale of addiction produced by Wallace Reid's wife in reaction to his death, the drug movie moved from the increasingly nervous hands of the Studios into the hands of the 'Thieves'.

By 1928, the 'Thieves' were 'massaging' these tabloid stories. Films like *The Pace that Kills* (1928), written and produced by Willis Kent and featuring montages of hectic urban life, metonymically signifying modernity and alienation, serve as the backdrop against which naïve female characters snort cocaine, become impregnated, sell themselves, turn up in opium dens and commit suicide. But no exploiter capitalised more on the bad girl/bad ending drug film than Dwain Esper – the *crème de la crème* of independent exploitation hucksters and hustlers – with his film, *Narcotic* (1933), one of the last, as Shapiro observes, to focus on the addiction of adults – in future the perceived threat would focus on young people.

As the Code bore down on Studio production, the exploiters went to town – literally and figuratively. In 1936 and 1937 respectively, *Marihuana, the Weed with Roots in Hell* and *Assassin of Youth* were released. The former was an Esper production that successfully travelled the road show circuit and inspired him to buy the rights to a well-meaning (but well wide of the mark) 1936 educational film entitled *Tell Your Children* aka *The Burning Question*, which Esper later re-cut and re-released under the

43

10 Not only Hollywood but Broadway too, as witness the heroin overdose of the beautiful and talented stage star Jeanne Eagels who, shortly after sensationally appearing in only one film, *The Letter* (1929), died of a heroin overdose and is lamented in Samuel Fuller's memoirs, *A Third Face.*

more sensational title *Reefer Madness*, by which it has become more famously known. In the square-up to that film we are told:[11]

'The motion picture you are about to witness may startle you. It would not have been possible, otherwise, to sufficiently emphasize the frightful toll of the new drug menace which is destroying the youth of America in alarmingly increasing numbers. Marihuana is that drug – a violent narcotic – an unspeakable scourge – The Real Public Enemy Number One!'

The narrative arc of these road show exploitation films usually goes like this: good girl leaves small town to find work and chase her dream and/or high school girl wants to act 'older'; she runs into a manipulative male (and/or his female cohort), who lures both girls and boys into their circle; they are persuaded to 'try' a harmless cigarette amid a background of 'jazz music' (metonymically, 'blackness' and the profane); soon she is divested of her clothes, often entering into a strip poker game (which, strangely, men always win!) or accepting a dare to 'skinny dip'. She gets frisky, sometimes gets pregnant and as often as not commits suicide. There will additionally be scenes where youth will run amok after a toke or two of the devil weed or a snort or two of the coke. The wild dancing

11 A square-up is a common feature of exploitation films of the period. The films would begin with a prefatory statement about a social or moral ill followed by a statement about the hope that the film will help to combat it or educate the audience. The intent for these prefatory justifications was to give the films educational or social gravitas and not let them be perceived simply as exploitation movies. As Eric Schaefer points out in his definitive study, *Bold! Daring! Shocking! True! A History of Exploitation Films, 1919-1959*, they served to downplay the very narrow tightrope that the exploiters walked between burlesque films and 'regular' cinematic presentations. They also fulfilled the purpose of warming up the audience for the upcoming film content, which was going to necessarily be brutally honest and shockingly realistic. The exploiters themselves used the term in a slightly different sense, according to David Friedman, interviewed in the documentary *Sex and Buttered Popcorn* (Sam Harrison, 1989). Friedman explains that when the risqué bits of a film had been censored by the local town officials they would show a short reel containing the nudie bits after the edited main feature film to placate audiences who might feel short-changed. This they called the square-up reel.

and extravagant, near-savage behaviour induced by the dope is *de rigueur* in these films. No matter the variations on these plotlines, the girl will almost always be punished – legally, mortally, socially, physically or domestically. These films veritably describe the 'road to ruin'. She becomes a fallen woman – and she won't be standing up again – although she can occasionally come to her senses by wholly accepting advice and guidance from authorities, parents or some older male, as happens in *Wild Weed* (1949). Of course, males get caught up in this maelstrom too, but more often than not, are seen as co-authors of their own downfall, and the

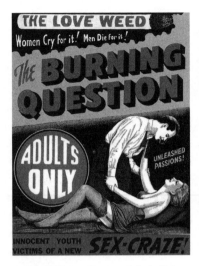

Poster for The Burning Question, *aka* Reefer Madness

other finger is usually pointed at bad parenting, liberal indulgence, doting maternal figures and working mothers – a gal just can't win. A short list of some of these filmic texts and their hyperbolic taglines will serve to illustrate the point; *Marihuana, the Weed with Roots in Hell*: 'Protect your daughters. The picture that exposes hushed-up truths! Weird orgies – wild parties – unleashed passions'; *Reefer Madness*: 'Dope-created ecstasy avalanching into frightful perversions'; and *Mad Youth* (1939): 'Are modern mothers to be blamed for the wild escapades of their sons and daughters?'

45

These tropes of delinquency and its links to negligent or over-indulgent parents continued well past the period under discussion and clearly anticipated the 40s and early 50s social problem films about the so-called 'latch key kids', who come home from school to houses emptied of fathers, but more notably mothers: *I Accuse My Parents* (1944), *Where Are Your Children?* (1943), *Youth Aflame* (1944) and *Youth Runs Wild* (1944). These latter films are interesting texts not because of any psychoactive drug explanations but for the lack of those parental drugs: guidance, attention and discipline; the classic 'nature v. nurture' debate. These films also bridge the interwar and post-war girl and youth problem films

where, as Eric Schaefer notes: 'Whether drug use was the result of delinquency or delinquency was thought to foster drug use, both became intertwined in the 1950s.'[12] And it is its release at this conjunction of the drug exploitation films of the inter-war period, and the continuing interest these films held to audiences in the 40s and early 50s, that marks out the 1949 production *Wild Weed / She Shoulda Said 'No' but She Didn't* as a pivotal piece in film history. It was one of the very last in the cycle: Dwain Esper offered a by-then hopelessly out-of-date production, *The Pusher*, in 1955, but by this time the Code's dictates (though still in operation) were having to loosen up and would soon be challenged outright by a new realistic style of drug film introduced by Preminger's *The Man with the Golden Arm*,[13] which put an end to the kind of drug exploitation film that the 'Thieves' had been offering. *She Shoulda Said 'No'* serves as a memorial to the end of an era.

SHE SHOULDA SAID 'NO' BUT SHE DIDN'T (1949)

As a curious kind of apogee of the classical bad girl/bad ending drug exploitation film of the sort that the 'Thieves' produced, look no further than this film. Embedded within this single Kroger Babb production – written by Richard H. Landau from a story by Arthur Hoerl and directed by Sam Newfield, aka Sherman Scott – can be found most of the tropes and conventions of this cycle of films. Accounts vary as to the order of re-titling and the various rights issues around the film, but the generally accepted account is that the original release title of the film was *Wild Weed*. When it bombed at the box office, it was re-titled *The Story of Lila Leeds and Her Exposé of the Marihuana Racket*, in a shameless attempt to capitalise on the real-life bust of lead actress Lila Leeds for use and possession of marijuana along with Robert Mitchum in the previous year – again it tanked. Finally, it was called *She Shoulda Said 'No' but She Didn't*, which was shortened to a more manageable *She Shoulda Said 'No'*.

12 Schaefer (1999), p.246.

13 Preminger released the film without a certificate from the Motion Picture Association of America, who oversaw the enforcement of the Code.

It was as remarkable a feat of topicality as can be imagined and illustrates just how savvy these carny men were.

The film's lurid poster campaign was typical of the exploitation exhibition strategy, which accentuated lewdness and debauchery, promising much in the way of transgressive behaviours, nudity and sexuality – most of which the audience was emphatically *not* going to see. But in spite of this, the suckers kept coming back for more after seeing the trailer for the following week's salacious film, which teased and promised the same – and for which they received the same. Different posters would be designed for different territories, taking account of each state's differing attitudes to censorship.

She Shoulda Said 'No' (from herein referred to as *SSSN*) opens with a shot of female fingers with carefully painted nails (always a signifier of trivial female vanity, leisure and sensuousness) caressing a large cigarette (say no more!). Then a man is seen lighting a joint and smoking, as the square-up prologue rolls before the credits and against a backdrop of curling smoke clouds:

> 'We wish to publicly acknowledge the splendid cooperation of several of the nation's Narcotic experts and Government departments, who aided in various ways the success of this production.
>
> This is the story of 'tea' – or 'tomatoes' – the kind millions thru (sic) ignorance, have been induced to smoke.
>
> We are proud to bring to the screen this timely new film about Marihuana. It enables all to see, hear and learn the truths.
>
> If its presentation saves but one young girl or boy from becoming a 'dope fiend' – then its story has been well told.'

47

SSSN tells the story of Anne Lester (Lila Leeds), a 'good girl' working in a rather suspect cultural space as a chorus girl earning money to put her younger brother through college. We have learned that an amoral 'tea pusher' named Markey (Alan Baxter) sells kids his 'sticks' and sometimes lures them back to his place to 'let their hair down'. In the opening scene, he sells three sticks of his stuff for

$5 and when the kids light up we see their speedy devolution from normal teens to drug-crazed maniacs. The girls become uninhibited and dance and move around suggestively, signalling a transgression of normally restrained female bodily movement. As noted, in other of these bad girl films, strip poker or skinny dipping become features of this libidinous, stoned behaviour. Also accompanying the ritual of lighting up and progressive intoxication is the weird sound of the theremin, creating a novel and disorientating soundscape that amplifies many drug films, as well as thrillers and science fiction movies. The soundtrack was composed and played by the legendary Dr Samuel Hoffman, a master theremin player who was to the theremin in film history what Wendy (then Walter) Carlos was to moog synthesisers in the 1970s. He had first used this eerie instrument to great effect in both 1945 films *Spellbound* and *The Lost Weekend* – another kind of drug text.

a few puffs, some disorientating theremin and background howls of laughter

Anne gets caught up in drugs when one of the chorus girls, Rita (Mary Ellen Popel), desperate for some dope, agrees to invite her to Markey's place. The smooth talker convinces Anne that she needs to relax. A few puffs, some disorientating theremin and background howls of laughter from the rest of the group and before she knows what's happening Anne is swooning over Markey as a mature and 'smart' man (Oedipal resonances here). They are seen leaving the group, headed for the bedroom.

48

When Anne's kid brother Bob (David Holt) shows up and sees the messy leftover from the night's revels, he wants to quit college and relieve Anne of her financial burden, but she insists he go on. Soon Anne and Rita are fired from the chorus for underperforming, due, we are to understand, to their increasing 'addiction' to the weed. Desperate to make ends meet, Anne accepts a job from Markey selling reefers at his parties. When Bob comes back from college again he becomes aware of his sister's dope (and sexual?) exploits and is so horrified that he hangs himself. He is discovered by Anne, who forthwith assumes a terrible burden of guilt for his death, which reaches a crescendo after she and Rita get busted.

The authorities try to shock Anne out her lifestyle by showing her an addict covered in grotesque needle marks and taking her

to a 'psycho ward' filled with similarly crippled addicts, but she is not moved. She is given three months in jail – the filmic emphasis is placed upon the monotonous and unbearable conditions of internment. As her guilt builds she begins to hear voices in her head calling her 'kid killer'. She has a breakdown and is moved to a hospital where understanding and supportive staff help her through. She is released and hooks up with Markey again, but this time she is hard-bitten and tough: 'The only thing I'm interested in from now on is money,' she informs him. But in reality, she has cut a deal with the drug squad to trap Markey and his cronies in a sting operation.

Although Anne is seen to have suffered and nearly gone insane for her female transgressions, in this particular narrative she comes full circle and ends up with a clean slate. In this, she fares much better than many of her fellow cinematic female drug travellers who, more often than not, come to a very sticky end – either mad, full-blown junkies or simply dead, but certainly irreversibly on the outside of society.

EPILOGUE

Although some of the male actors in *SSSN* such as Alan Baxter, Lyle Talbot and Jack Elam went on to long careers, the 'bad girl' lead, Lila Leeds, had taken on this film only because MGM had ripped up her contract in the wake of her infamous real-life marijuana bust in 1948 with Robert Mitchum. In classic hypocritical gender form, the arrest ruined her career while Mitchum went on to fame and fortune. Jack Stevenson writes: 'By the early eighties, as author Michael Starks reports, Leeds was "living an ascetic existence in Los Angeles[14] and maintains that her life has been transformed by prayer". Her trademark beautiful blond hair was one thing that had definitely been transformed – into an unremarkable frizzled brown.'[15] The latter gratuitous comment seems fitting to remark upon in a piece about the fates of 'bad girls'. Even outside of the

49

14 Lila Leeds died in Los Angeles in September 1999, aged 71.

15 Jack Stevenson, *Addicted: The Myth and Menace of Drugs in Film* (Creation Books, 2000), p.35.

fictional cinematic world of punishments meted out to transgressive females, the real-life Lila Leeds story seems to point to the fact that an improperly conducted 'female' life will likewise result in negative outcomes: banishment from film culture, outsider status, the need to 'repent and disavow' and finally, even the fate of your hair is turned into a morality tale. It's a tale ripped from an exploitation film itself: good girl goes to Hollywood, becomes a star but at the price of becoming a bad girl, smokes 'tea', gets busted, loses work, gets involved with sleazy picture producer and while touring and promoting screenings of the film takes to further sexual and dope dalliances, eventually moves on to heroin, gets arrested for soliciting. Several busts and years later, she straightens up by finding Jesus. Let's shoot it!

By the end of the Second World War and into the early 1950s, these conventions and tropes became codified into new and different mythologies of consumerism, delinquency, the newly evolving rock and roll music, liberalism, hedonism and the culture of 'teenagers' and youth. These young people were far removed from the adult world and became immersed in their own seemingly self-contained sub-cultures, which multiplied and culminated in a vast mid-60s counter-culture. Rebellion and revolution were in the air, initially inspired by a disparate group of poets and writers collectively known as the Beats – wildly mis-represented as juvenile delinquents in post-war teen films such as *The Rebel Set* (1959), *Live Fast, Die Young* (1958) and *The Beatniks* (1959) – who were themselves dethroned by the hippies, yippies and Weathermen of the mid-60s.

In spite of the efforts of Kroger Babb and Dwain Esper to keep the flag flying until as late as 1955, the classic bad girl/bad ending dope film quieted down for a few years. It returned slowly from the cold in the early 50s and then with a vengeance in 1958 with such films as *High School Confidential, Young and Wild, Juvenile Jungle, The Narcotic Story* and *The Cool and the Crazy*. But that, as they say, is another story... ∎

LEGACY OF THE DEAD:

Zombie movies after
George A. Romero

ALEX FITCH AND TOM HUMBERSTONE

LEGACY OF THE DEAD

The end is the beginning in George A. Romero's series of zombie movies, which started with *Night of the Living Dead* in 1968. The first scene is set in a graveyard; in any other film the death of a character would be the end of their time on screen but here it is the beginning of the story.

The film also revitalises a moribund genre. Zombie films had their heyday in the 1930s-40s, starting with *White Zombie* in 1932 and culminating with *I Walked with a Zombie* in 1943. However, with rare exceptions - such as *Revenge of the Zombies* (1943) - the creatures depicted in these movies are not the dead returned to some semblance of life, but people reduced to a zombie-like state through drugs, hypnosis and voodoo. The 1966 Hammer film *The Plague of the Zombies* mixes elements of voodoo and the living dead, but it was Romero's seminal work that created the zombie film as we know it today.

54

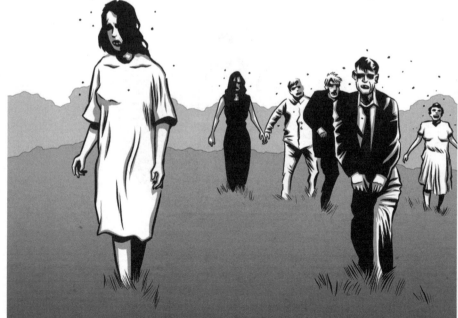

The film's writing
and production in
1967-68 took place
against the backdrop of the Vietnam War and
the Civil Rights movement and the film comments
on both, in particular in its final scenes, when
the black hero is shot by one of the militiamen
rounding up the zombies in the cold light of day. The
unceremonious burning of piled bodies and the end
credits' stills recall the contemporary reportage of
atrocities committed by American troops in Vietnam
and the self-immolation of peace activists in the
preceding years.

With *Dawn of the Dead* in 1978, the zombie apocalypse
is now fully under way: fleeing the outbreak, four
survivors led by another charismatic black hero end
up holed up in a mall. No explanation is given
for the apocalypse in the film; it simply presents
zombies as brain-dead consumers shuffling about the
building, snacking on human flesh between bouts of
window-shopping.

To get funding for *Dawn*, Romero made a deal with Italian film director Dario Argento, who helped finance the project in exchange for international distribution rights. Argento cut seven minutes from the running time and added a new score by prog rock band Goblin, who had previously provided music for his own horror films *Suspiria* (1977) and *Deep Red* (*Profondo rosso*, 1975). Released as *Zombi: L'alba dei morti viventi*, this European version proved hugely successful, leading to other filmmakers wanting to cash in on a quick sequel.

For this reason, a new opening and ending was added to a film that was already

in production. *Zombi 2* (1979) was directed by Lucio Fulci and, like *Dawn of the Dead*, was a massive hit in Europe. It is one of the few

Italian films that pretend to be a part of Romero's saga that has any real cinematic value. Released in the UK under the title *Zombie Flesh Eaters*, it gained notoriety for its infamous zombie-inflicted eye-gouging scene and was banned as a 'video nasty'.

Over the next decade, a variety of other films turned up that purported to be follow-ups to *Zombi: L'alba dei morti viventi* and/or *Zombi 2*. First was Bruno Mattei's *Virus - L'inferno dei morti viventi* (*Virus - Hell of the Living Dead*, 1980), which was also confusingly titled *Zombie 2* in some prints and *Zombie Creeping Flesh* or *Night of the Zombies* in others. The only real connection with *Zombi* is the unauthorised use of some of Goblin's score.

It's probable that Italian audiences found Romero's next film in his original series, *Day of the Dead* (1985), somewhat staid, and another quick cash-in was released a couple of years later: *Zombi 3/Zombie Flesh Eaters 2* (1988) can be seen as a sequel to either of the *Zombi(e) 2* films as both Fulci and Mattei worked on the film. The resulting mess, featuring undead super soldiers, flying heads and a zombie DJ is unsurprisingly disowned by the latter on the most recent DVD commentary. Various other unrelated films have been titled *Zombi 4*, *5* and even *6* and should be avoided at all costs.

Day of the Dead is this writer's favourite entry in Romero's saga. It features the most apocalyptic setting of the series: an underground bunker where a handful of scientists are trying to find a cure for the zombie plague among a bickering mob of soldiers.

The first American bootleg sequel, *The Return of the Living Dead*, appeared the same year as *Day of the Dead*. A black comedy adapted from a script by *Night*'s co-author John Russo (which he then novelised), it creates an alternative world, in which *Night of the Living Dead* exists as a movie based on an actual zombie outbreak.

Over the next three decades, various sequels and remakes filled large and small screens. Better examples include Brian Yuzna's *Return of the Living Dead III* (1993), a surprisingly idiosyncratic and affecting sequel about a girl turning into a zombie, who tries to stave off her (un) death through self-mutilation.

58

The British *28 Days Later...* (2002) copies much of the plot of *Day*, opening with the protagonist exploring an abandoned city and featuring military experiments on the undead while *Shaun of the Dead* (2004) is an affectionate homage to Romero's series.

Due to a cock-up by the distributors, the original *Night of the Living Dead* was never properly copyrighted and so as a public domain film it has been open to remaking, remixing and (re)appropriation. Having already tried to make one sequel to his original co-authored screenplay, John Russo directed 18 minutes of risible new footage in 1998, including a new prologue and epilogue, for a 30th anniversary edition. Adding insult to injury, Russo produced a lacklustre sequel called *Children of the Living Dead* (2001) before writing a comic book titled *Escape of the Living Dead*, which is due for cinematic adaptation in 2011.

Considerably more successful than Russo's remix was Romero's own remake in 1990, which has just spawned an animated prequel, *Night of the Living Dead: Origins 3D* (due in 2011). Both feature genre star Bill Moseley (*Army of Darkness*, 1992) as 'Johnnie'. Moseley has said that he was interested in playing any role in the 1990 remake as the original 'was one of the most powerful movies [he] had ever seen'.* *Night* now seems to be the source of any mash-up or appropriation that filmmakers can devise: over the last 42 years, it has been colourised three times, converted into 3D twice, recut again (2005's *Survivor's Cut/ Benefit for the Living Dead*), animated over in 2009 (*Night of the Living Dead: Reanimated*) and continuously remade, first in 3D in 2006, then as a musical in 2007.

* Interview with Alex Fitch, July 2010

Another, more faithful, remake was also released in 2007 but it has been rarely screened outside festivals as the production company focused its efforts on a prequel that sounds fairly similar, *Dead Genesis* (2010). Like many young filmmakers inspired by the original film, director Reese Eveneshen says he loves 'Romero's down and dirty grittiness, the indie feel, the dark undertones of social commentary' and sees *Dead Genesis* as 'a truer Romero-inspired film, probably the film [he] was trying to make when [he] did *Night 07*'.**

While Zack Snyder's 2004 remake of *Dawn of the Dead* is almost as good as the original, the rest of the decade's official and knock-off franchises offered diminishing returns. 2005 was a bumper year for *Dead* movies, with Romero himself belatedly turning his trilogy into a tetralogy with *Land of the Dead*, an underwhelming conclusion to the series with little to recommend it aside from an over-the-top performance by Dennis Hopper and the continuing humanisation of the zombies started in *Day*. The fact that the film wasn't called 'Twilight of the Dead' was perhaps a bad omen...

2005 also saw the release of two straight-to-video sequels to *Return* shot in Russia and a dire prequel called *Day of the Dead 2: Contagium* (sic). *Day* itself was remade (badly) in 2008, unnecessarily completing the trilogy of remakes.

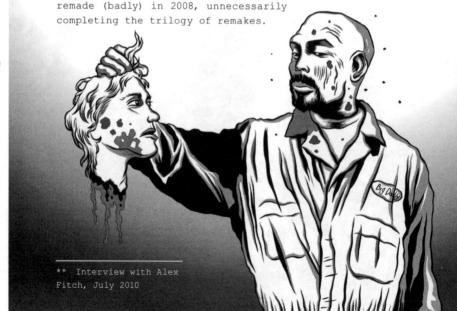

** Interview with Alex
Fitch, July 2010

Unperturbed by the weakening of the brand by himself and others, Romero has since started a new zombie tetralogy. Two instalments have been released so far - *Diary of the Dead* (2007) and *Survival of the Dead* (2009) - with two more to come and a print prequel *The Living Dead: A Novel* due out in 2011. With *Diary*, Romero seemed to be back in touch with the zeitgeist - using video cameras to depict the immediacy of horror (like the same year's *[Rec]*). With *Survival*, he's made a sequel that for the first time includes returning characters from the previous instalment.

Although only a handful of the homages, remakes and sequels have lived up to the promise of Romero's first three zombie films, it's clear that the undead as cultural artefact are as infectious and hard to kill as the fictional creatures themselves. There may be plenty of room in hell for bad sequels that walk the earth, but as a new 3D colour print is about to make its appearance in the cinema and on Blu-ray, it looks like the original *Night of the Living Dead* will be with us long after its imitators have returned to the grave... ■

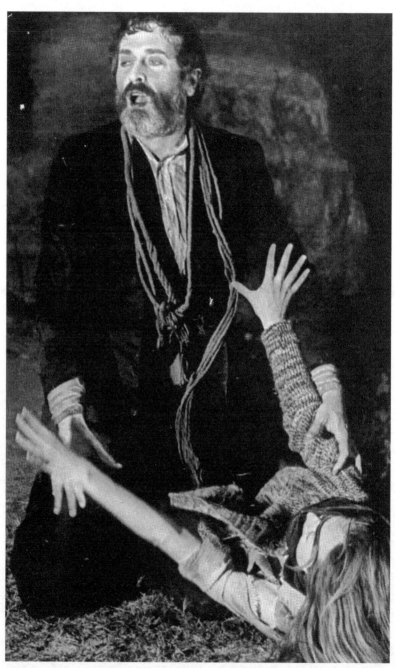

62

Still from The Living Dead at Manchester Morgue | CANAL + IMAGE LTD

THE NEW REGIME:
Spanish horror in the 1970s and the end of the dictatorship

JIM HARPER

By the time he died in 1975, General Francisco Franco had ruled Spain with an iron fist since he emerged victorious from the Spanish Civil War in 1939. The last of Western Europe's dictatorships, Spain finally completed the transition from totalitarian state to democracy in 1978, although a slow but steady process of liberalisation had begun a decade before. Like many dictators Franco had maintained tight controls on the arts and entertainment, prohibiting the production or viewing of so-called

immoral or degenerate art forms, which at the time included horror movies. In the mid-1950s the state's grip had started to loosen a little, allowing for wider distribution of foreign films and the production of more domestic efforts, including a number of mild sex comedies. Wary of the government's somewhat arbitrary and fickle attitude towards cinema, many producers chose to contribute financing, locations and crews to European co-productions, which is most noticeable in the large number of 'Spaghetti Westerns' filmed in Spain. There were still restrictions, however. For example, few of the earliest domestic horror movies – including co-productions – were actually *set* in Spain; instead it was claimed the events were taking place in Portugal or France. Likewise, Spain's greatest horror icon – Paul Naschy's *el hombre lobo*, Waldemar Daninsky, the tortured hero of a dozen movies – had to be given a Polish name, apparently to avoid bringing the nation's image into disrepute. In contrast with its Italian neighbour, Spain did not start producing horror films in any great numbers until the late 1960s. Jesus Franco's *The Awful Dr Orloff* (*Gritos en la noche*, 1962) is widely considered to be the first Spanish horror movie, but it was the first of Paul Naschy's *el Hombre-lobo* films, *The Mark of the Wolfman* (*La marca del Hombre-lobo*, 1968), that really sparked off the trend.

One of the most prolific of the new Spanish horror directors was Amando de Ossorio, creator of the 'Blind Dead' movies. Although not sequels in the strictest sense – each of the films provides a different explanation for the events taking place – they are all based around the same core concept: long-dead Knights Templar return from the grave to seek out and consume the blood of the living. The Blind Dead – in Spanish *los muertos sin ojos* – appeared in four films between 1971 and 1975, all of them written and directed by de Ossorio: *Tombs of the Blind Dead* (*La noche del terror ciego*, 1971), *Return of the Blind Dead* (*El ataque de los muertos sin ojos*, 1973), *The Ghost Galleon* (*El buque maldito*, 1974) and *Night of the Seagulls* (*La noche de las gaviotas*, 1975). Heavily influenced by *Night of the Living Dead* (1968), de Ossorio stages a number of sequences straight from the George A. Romero playbook, frequently trapping his heroes in isolated buildings while the Blind Dead creep slowly through the

streets outside. Where many of the earlier Spanish horror films had been largely bloodless, he also provides generous quantities of gore, this time in glorious Technicolor. Most significantly, de Ossorio also uses the fantasy-horror trappings as a means to examine the political and social environment in Spain of the 1970s.

Although heavily fictionalised in the Blind Dead films, de Ossorio's Knights Templar are potent symbols of Spain's political, military and religious past. They point back to a time when the country was one of the most powerful nations on earth, the ruler of a massive empire, supported by its firm devotion to the Roman Catholic Church. It was these very ideas that General Franco attempted to promote, forging a connection between his new regime and Spain's glorious past. But in de Ossorio's eyes this blind allegiance to tradition and religion is entirely misplaced, for the Knights – and by extension, Franco's regime – were corrupt and brutal. Their wealth and military might were used to oppress the people, literally bleeding them dry, while their Catholicism was twisted into a bloodthirsty form of Satanism.

there are fears that the old era might be far from dead

In a series of flashbacks, de Ossorio shows how the medieval Knights Templar were defeated by their subjects, who finally tired of their sadistic overlords. It's possible this reflects the growing sense of optimism among the Spanish people in the early 1970s; at the start of the decade Franco was 77, and it was obvious that he could not continue forever. The slow liberalisation process in recent years led many to suspect that democracy might follow after Franco's death. However, despite these promising hints, de Ossorio is not entirely optimistic about the future. After all, the Blind Dead films are about the Knights *returning* to take revenge on the living. *Tombs of the Blind Dead* ends with the persecuted heroine leading the undead hordes – previously confined to the area around their tombs – right back to civilisation. In *Return of the Blind Dead*, the complacent townspeople of Bouzano are celebrating the anniversary of their victory over the Knights Templar, only to have their ancient enemies gatecrash the party. Amid the hopes that a new era is coming, there are fears that the old one might be far from dead.

The Blind Dead served as a useful means of attacking Franco

65

Still from The Living Dead at Manchester Morgue *(Canal + Image Ltd)*

and his government, but not all of de Ossorio's comments were quite so indirect. The mayor of Bouzano in *Return of the Blind Dead* is a case in point. The kind of petty dictator that flourishes under authoritarian regimes, he's protected and assisted by a bunch of thugs who act as minders, bodyguards and enforcers. Naturally he's also a coward, quite willing to send a small child to her doom while he makes his own escape, along with the bag of cash and gold he has appropriated during his tenure as mayor of the town. His own superiors aren't much better. After being informed of the crisis at Bouzano, the local governor recites a handful of meaningless political platitudes and returns to the more pressing business of having sex with his maid.

The final film in the series was 1975's *Night of the Seagulls*, and again de Ossorio rewrote the mythology. When they were alive, the Knights Templar demanded the sacrifice of seven virgins from the local village. Every seven years they would appear to collect

their victims, taking one on each of seven consecutive nights; if the villagers refused or failed to provide, the Knights would return and destroy the town. Centuries after their deaths, they continue to extract their bloody tithe. Once the Knights are finished with their victims, the carcasses are dumped on the shore for the crabs to pick at, with the seagulls of the title – each one is the soul of a sacrificed girl – wheeling overhead.

Once again de Ossorio is raging against the oppressors, but he also makes the people his targets too; for the first time in the series, the villagers are complicit in the slaughter. In *Return of the Blind Dead*, the people of the town fought against their oppressors, both in the past and in the present day, but their counterparts in *Night of the Seagulls* prefer to maintain the status quo, even though it means killing seven of their daughters every time the Knights return (unsurprisingly, orphans and village undesirables are the first to go). When they're not selecting one of their number to sacrifice they're chasing the harmless local idiot off a cliff or stoning him for coming too close to the village, and treating newcomers like pariahs. With the villagers mired in antiquated traditions and parochial hostility, it's up to the newcomers – a doctor and his fashionably dressed young wife, potent symbols of the modern, rational and scientific world – to save the day. While the locals are running for the hills, our heroes are demolishing the Knights' Lovecraftian idols, destroying the magic that has kept them animated for centuries.

Night of the Seagulls was the only Blind Dead film to be released after Francisco Franco's death in November 1975, although he was still alive when production was started. It's interesting to note the atmosphere of optimism that the film carries; for one thing, it's the only film in the series that ends with the heroes defeating their enemies. In the others, the Knights either continue their rampage or are stopped by events completely beyond the heroes' control – the arrival of dawn, for example. For de Ossorio, the old guard and their minions have been swept aside in a single night, and permanently too, allowing the series to end on a suitably positive note.

While de Ossorio's desiccated knights were slowly flying across the Spanish plains, Jorge Grau was unleashing his own zombie

67

horde on rural England (with the Peak District standing in for the Lake District) in the excellent *The Living Dead at Manchester Morgue* (*Non si deve profanare il sonno dei morti*, 1974), arguably the finest of the many zombie movies that followed in the wake of *Night of the Living Dead*. This time pollution is the problem: a new machine designed to kill insects without using chemicals has the unfortunate side effect of re-animating the recently dead. Hippie antiques dealer George (Ray Lovelock) and his unwilling travelling companion Edna (Cristina Galbó) find themselves drawn into the situation when her heroin-addicted sister is accused of murdering her husband. Unfortunately, the police aren't inclined to believe Edna's story – that her brother-in-law was slain by a tramp who died three days previously.

The Living Dead at Manchester Morgue is available on DVD from Optimum Releasing.

Unlike the Blind Dead, Grau's zombies don't represent the forces of tradition and oppression. They have more in common with Romero's living dead, faceless monsters who drive the action. Most of the film's political commentary comes from the antagonism between George and Edna and the forces of law and order, represented by the brutal Sergeant McCormick. Played by Arthur Kennedy, McCormick's vindictive and bitter outlook is summed up by his key speech: 'You're all the same, the lot of you, with your long hair and faggot clothes. Drugs, sex, every sort of vice. And you hate the police, don't you?' McCormick's personal approach to police work involves beating suspects, forcing them to sign false confessions and complaining about the 'liberal rot' that's destroying the country. Some of these comments could fit the British setting, but they could also come from Franco's traditionally conservative supporters, many of whom felt that liberalism had gone too far. As Grau paints him, McCormick is a career policeman whose career never materialised, leaving him embittered and resentful, particularly towards the young people he perceives to be taking both his country and his job away from him.

For a film so heavily inspired by *Night of the Living Dead* there really could be only one possible ending. Having spent most of the movie trying to protect her sister, Edna ends up being bitten by her and turned into a zombie. George manages to flee the zombie-

68

infested burning hospital, only to be shot down by Sergeant McCormick, who snarls: 'I wish the dead could come back to life, you bastard, because then I could kill you again.' Appropriately enough, the sergeant's wish is granted. After a self-serving speech about the restoration of true justice, McCormick returns to his hotel room, only to find the undead George waiting for him. The forces of oppression and conservatism might win the battle, but definitely not the war.

General Francisco Franco died on November 20, 1975. Within six months of his death, director Narciso Ibáñez Serrador released *Who Can Kill a Child?* (*¿Quién puede matar a un niño?* 1976), arguably the best Spanish horror

Poster for La residencia

film of the decade. Although he has directed only two theatrical features – the other being *The House that Screamed* (*La residencia*, 1969) – Serrador is one of the key figures in the history of Spanish-language made-for-TV horror, having pioneered the genre in both Europe and South America. Both of his feature films are intelligent, well made, scary and often disturbing, and like his contemporaries Amando de Ossorio and Jorge Grau, Serrador frequently explores political and social themes in his work. On holiday in Spain, two English tourists – biologist Tom and his heavily pregnant wife Evelyn – find themselves on the island of Almanzora, a sleepy little place that has yet to be discovered by the tourist trade. Perhaps it's a little too quiet, with no one around except for a handful of children. The previous night, something drove the children into a murderous frenzy, compelling them to kill every adult in town, and all the time singing and laughing as if it were some new game.

69

Before Tom and Evelyn reach the island, Serrador paints a picture of Spain that could come straight from any Franco-era holiday guide: plenty of tourists from across the world, fiestas and traditional celebrations, excitement, music and a great deal of lively fun. Behind the clichés lurks a disturbing and grotesque reality, however. *Who Can Kill a Child?* opens with a montage of newsreel footage from the world's worst man-made disasters – the Holocaust, Vietnam, the Pakistan-Bangladesh civil war, the crisis in Biafra – highlighting the number of children killed by war, famine and disease. This sequence establishes Serrador's main point: children have been persecuted by adults for centuries, but what happens when they fight back? Making for somewhat uncomfortable viewing before a horror film, this footage adds little to the movie itself.

his children commit atrocities with a smile and a giggle

Although excellent in its own right, *Who Can Kill a Child?* is by far the most pessimistic of the post-*Night of the Living Dead* films made in Spain. Amid all the fireworks and celebrations, Tom talks about the Spanish Civil War, drawing a line between the thriving tourist trade and the chaos of Spain's past. Serrador might be showing his oppressed rising up against their tormentors, but he has little sympathy for their cause. His children are far more horrifying than either the Blind Dead or Grau's zombies, not least because they commit atrocities with a smile and a childish giggle. They corrupt everything they come into contact with. The corpse of an old man is hoisted on ropes and hacked at with axes in a twisted parody of the traditional *piñata*. After one of the children touches her belly, Evelyn discovers that her unborn child is trying to kill her from within, as if it has already joined in the new game. As Tom tries to fight his way back to the boat, an approaching police boat sees him attacking the children and guns him down, assuming him to be a homicidal lunatic. The film ends with the children planning to move to the mainland and find new recruits. In Serrador's eyes there might well be a revolution, but the new masters might be even worse than their predecessors. ■

70

Still from United Red Army | WAKAMATSU PRODUCTION

ORGASMIC REVOLUTIONS:
The nihilistic cinema of Kôji Wakamatsu

PAMELA JAHN

One of the most fiercely independent and adventurous director-producers to come out of post-war Japan, Kôji Wakamatsu has built a remarkable body of work, comprising over a hundred films. Appropriately, he made a confrontational entrance on the world stage when his *Secret Acts behind Walls* (*Kabe no naka no himegoto*) was unofficially submitted as the Japanese entry to the Berlin Film Festival in 1965. It was a *pinku eiga* (pink film), a soft-core porn genre that developed after the Second World War,

FEATURING

Virgins
Radicals
Fanatics

and its mix of sexuality and radical politics projected an image of the country that, unsurprisingly, made the Japanese authorities very uncomfortable. It was labelled a 'national disgrace' by the media and when the production studio Nikkatsu more or less buried the film, Wakamatsu left to form his own independent production company, Wakamatsu Pro (best known for producing Nagisa Ôshima's *In the Realm of the Senses* [*Ai no korîda*, 1976]).

During the 60s and early 70s, the erotic film industry provided him and Masao Adachi, his friend and most important collaborator, with an alternative distribution network that allowed them full artistic freedom. A highly original underground filmmaker himself, Adachi wrote or co-wrote most of Wakamatsu's early, abrasive masterpieces. In the environment offered by *pinku eiga*, Wakamatsu, seconded by Adachi, was free to explore an explosive combination of sex, violence and extreme politics, infused with a very peculiar touch of punkish defiance and nihilistic tenderness.

Wakamatsu's films are fascinated with the human capacity for radical destructiveness and his work is full of images of and allusions to large-scale devastation – war, explosions, terrorist bombs, mass murder, even references to nuclear apocalypse. *Secret Acts behind Walls* starts with lovers in bed, but the eroticism of the scene is perverted as the man injects himself with drugs before the woman caresses his keloid scar, a result of being burnt in Hiroshima. Based on the real-life murder spree of eight nursing students by Richard Speck in 1966, *Violated Angels* (*Okasareta hakui*, 1967) does not merely depict a mentally deranged man's horrific actions and subsequent regression into a childlike state, but establishes a strong analogy between his perverse psychosis and the Vietnam War protest movement, which was going on at the time of production.

Sex is just another tool of destruction and serves as an analogy for social relationships between the dominating and the dominated. One of Wakamatsu's most divisive, as well as rawest films of that period, *Violent Virgin (Shojo geba geba*, 1969), depicts the ferocious ritual carried out by a group of yakuza and their female companions when they travel to the deserted countryside in order to punish their boss's unfaithful mistress and her lover. A savage blend of harsh

eroticism, Christian symbology, surrealist logic and nihilism, the audacious content of the film is matched by the gloomy, haunting black and white cinematography, interspersed with a few poignant scenes shot in colour – such as when the mistress, bound to a cross by the yakuza, bleeds after being shot in the breast by her confused lover. Although Wakamatsu has admitted in interviews that the occasional mix of film stocks was mainly due to the lack of financial means and not primarily an aesthetic choice, he undeniably made a formal virtue out of necessity. In addition, *Violent Virgin* demonstrates his excellent sense for music and sound through an intoxicating aural-visual interplay. It's the combination of these elements that makes Wakamatsu's films such deeply disturbing yet strangely compelling experiences.

the young radicals ultimately turn against each other

The student revolt of the late 60s, followed by the emergence of left-wing militant groups such as the Japanese Red Army, forms the background of further explorations of closely intertwined personal and political acts of terminal destruction. Before Adachi stopped making films in order to actively join the political fight in the early 70s, he worked with Wakamatsu on *Ecstasy of the Angels* (*Tenshi no kôkotsu*, 1972), which centres on a left-wing terrorist faction as they plan an all-out attack on the police station of the Shinjuku district of Tokyo. In yet another visually stunning head-on collision of explicit violence, political revolt and soft-core porn, Wakamatsu (and Adachi) explores the sacrifice and self-destruction that the revolutionary process requires from the young radicals and observes how they ultimately turn against each other instead of combining their forces to fight the odious system. The narrative became shockingly true when the Shinjuku police station bombed in the film was attacked for real only a few days before the premiere. Twelve days later, the nation was rocked by a 10-day police siege, in which the authorities encircled, and later stormed, the Asama-Sansô mountain lodge where a handful of diehard militants had taken refuge.

75

Throughout his work, Wakamatsu has been sympathetic to left-wing revolutionaries while also unflinchingly denouncing the flaws of the militant movement and the dangers of dogma. But like

Still from Ecstasy of the Angels *(Wakamatsu Production, courtesy of Dissidenz International)*

other filmmakers of the time, he and Adachi were drawn further into political activism in the 70s. After attending the Cannes festival in 1971 for the international premiere of *Sex Jack* (*Seizoku*, 1970), Wakamatsu and Adachi decided to stop in Lebanon on the way home. Adachi became a member of the Japanese Red Army (JRA) and the Popular Front for the Liberation of Palestine (PFLP), and he and Wakamatsu made the infamous agitprop piece *PFLP – Red Army: Declaration of World War* (*Sekigun-PFLP: Sekai senso sengen*, 1971) during their stay in Palestine. In politics as in filmmaking, they went that one step further than everybody else.

Over 40 years later, Wakamatsu returned to Berlin with a film that revisits his radical political past, more particularly the subject matter of *Ecstasy of the Angels*. *United Red Army* (*Jitsuroku rengô sekigun: Asama sansô e no michi*, 2007) is a meticulous, gripping and at times gruelling 190-minute history of the terrorist left in Japan, from its emergence in 1960 (with the violent protests against the renewal of the US-Japan Security Pact) to its collapse in 1972 after

the Asama-Sansô incident and the suicide of the imprisoned leader/ideologue Mori Tsuneo. Basing his film on comprehensive research as well as his own memories and connections to some members of the Red Army Faction when it was still active, Wakamatsu once again pushes the boundaries of filmmaking, taking the story from docu-style drama, underlaid with an electrifying psychedelic score by Sonic Youth's Jim O'Rourke, to claustrophobic chamber piece, to breathtaking action thriller in the final act. A profound and painful dissection of ideology rendered with an impressive clarity, *United Red Army* is also a deeply personal project for Wakamatsu, which he had planned since the 70s and for which he even destroyed his own country house – standing for the Asama lodge, it is demolished in the final battle scene as the police overwhelm the militants.

At the end of *United Red Army*, ideology has annihilated everything, leaving no possibility of exit to the revolutionaries, no hope, not even ideals. In his latest film, *Caterpillar* (*Kyatapirâ*, 2010), which functions as a sort of pendant piece to the previous film, the opposite ideology, the nationalistic, imperialistic dogma of the Japanese wartime authorities, has a similar effect on the generation of the revolutionaries' parents. Set in a rural village during the Second Sino-Japanese War in 1940, *Caterpillar* tells the story of a Lieutenant who returns home disfigured and dumb, and with no arms and legs, but highly decorated, with three medals paying tribute to his heroic deeds. For his wife, however, he is less a 'war god', as the media and the authorities call him, than a repulsive burden, as rude and demanding with her as he was before he was maimed. Nevertheless, she has to carry out her duty as the docile peasant, sacrificing herself and her desires to care for the glorified, but less than heroic soldier (as we find out in flashbacks). Using documentary war footage and radio propaganda, the film powerfully contrasts the oppressive official ideology with the utter and hopeless devastation it has caused in the couple's lives.

Fuelled by anger against Japan's authoritarian wartime and post-war establishment, Wakamatsu's films explore the total annihilation of the human spirit and body. Radical in form as well as content, and at once brutal and strangely sensual, his best films are an initiation to the forbidden zones of human life in all its cruel, labyrinthine obscurity.

77

INTERVIEW WITH KÔJI WAKAMATSU

Pamela Jahn interviewed Kôji Wakamatsu at the Berlinale in February 2010.

Pamela Jahn: In 2008, *United Red Army* was shown in the Berlinale Forum section, accompanied by three of your earlier works (*Secrets Acts behind Walls, Go, Go Second Time Virgin* and *Ecstasy of the Angels*). This year, your latest film *Caterpillar* screened in competition in Berlin and is currently touring international festivals. There are also retrospectives

of your work planned in France and the UK in the next few months. Do you feel that your work is finally receiving the attention it deserves in Europe?

Kôji Wakamatsu: It's been 45 years since I've had a film in competition in Berlin. *United Red Army* was shown last year, but because *Caterpillar* depicts the era before that, for me the two films are connected with each other. So I really wanted *Caterpillar* to be in the festival this year, and it is a great honour that it got selected for competition.[1]

Do you see *Caterpillar* somewhat as a prequel to *United Red Army*?

When I was making *United Red Army*, I already knew that I was going to make *Caterpillar* because I also wanted to represent the parent generation of those who later formed the Japanese Red Army. What struck me was the question, 'Why did the kids in *United Red Army*, who are very intelligent and well educated, become that way?' So in order to show 'the big picture', I had to tell both stories, but I couldn't do so in one film, because it would have been too long and nobody would have wanted to distribute or screen the film. That is basically the reason why I put my message in these two films rather than one.

How did *Secret Acts behind Walls* actually make it into the Berlinale in 1965?

A German distributor came to Japan and saw my film in the theatre, and he loved it so much that he bought the German rights to it. So he submitted it to the festival and it got accepted as the Japanese entry in competition.

The film caused a stir after the premiere, which ultimately helped to push you to fame home and abroad and create your

1 *Caterpillar* won the Silver Bear.

own production company, Wakamatsu Pro, in 1966. Absolute creative and commercial freedom seems to be what drives you. Do you think of censorship or audience reaction when making films?

I made all my films exactly as I wanted to make them. I've been my own producer and I've also written and co-written my scripts, so what I do is what I want to do. The starting point for me in all my films is always an antithesis of what is defined as mainstream or as 'accepted' in the current Japanese film industry. So 45 years ago, what I wanted to create with *Secret Acts behind Walls* was an antithesis of the seemingly good, happy life in Japan at that time. The film was considered an embarrassment to the country and I was accused of causing great shame and dishonour to the Japanese. In the national press, the film was called a 'national disgrace' because a *pinku eiga* was representing Japanese cinema. Forty-five years later, it is quite similar with *Caterpillar* because in Japan, mainstream war films still glorify the war, and it is something that makes me very angry because there can never be a justifiable war. Wars are just games being played by governments and others in power, even contemporary ones. There can be no just or good war. In Japan, we have members of parliament who say, 'Yes, we need the atomic bomb', and I'd like to take action against that, because in Nagasaki and Hiroshima more than 370,000 people were killed because of the atomic bomb. So we have to fight to make sure that this is not forgotten. The Japanese tend to forget about their history, so Japan is now becoming more militarised and we have to stop this from happening. I know that back home, many people will be very angry with me again for making this film, but that's how it is.

79

You were still a child during the Second World War. What is your memory of the war and did it play a role when developing the script for *Caterpillar*?

I grew up in a rural area, quite similar to the one you see in the film, and we were cultivating rice there, but like everyone at the time we had to hand over the whole of our harvest to the state. So

we had hardly anything to eat, we had potatoes every day. All of my older brothers were on the front. We didn't have many labourers on the farm, so we children had to work in the rice fields. I was nine years old and would normally have been at school, but when anyone asked us what we wanted to be when we were grown-ups we shouted 'soldiers'. Every day we saw the photograph of our emperor and empress, every time we left or entered the house. When the fallen soldier comes home in *Caterpillar*, and people shout 'hurrah', it was just like that. We also had to shout 'hurrah' when the young soldiers were being drafted into war.

The film *Johnny Got His Gun* by Dalton Trumbo and the book *The Caterpillar* by Edogawa Rampo both deal with a similar image of a veteran who returns home after he has lost his limbs in combat. Where you influenced by these or any other references?

I have seen the film and read the book, but I don't think either had any direct influence on me when making the film. I was mainly inspired by the image of a war veteran, who returns home as a quadriplegic, and his relationship with his wife, but I wasn't consciously referencing Rampo's novel. I just knew that the husband in my film had to be that way. Because it's the most shocking image when a soldier returns home like this, alive but also crippled for life. He has lost his arms and legs, but has all these medals instead, which don't really mean anything. It's like Charlie Chaplin used to say: 'One murder makes a villain. Millions a hero.' And that's what I wanted to show in *Caterpillar*, that this false hero was nothing other than a murderer in actual fact.

And a war criminal, as we see in the sequences where Japanese soldiers violate Chinese women. But your film tells more than just the one story of a false war hero returning home in glory, there's also the story about the husband and wife.

The men in our country used to get very excited about things like these medals and the awards they got for killing people in war, all

80

the things that turned them into national heroes. I think that's such a foolish thing. But most importantly, the Japanese, for once, have to admit that they have committed war crimes too. I think it's probably not the soldiers who suffer most from war, but the women and children who are left behind back home. In 1982, during the Lebanon War, I visited a camp there two days after a massacre, and most of the dead bodies were females and children. To this day, this image is stuck in my mind and I thought then that I wanted to make a film that really does portray the madness of war. The war not only takes place on the battlefield but also in people's homes, where ordinary people suffer. That is the tragedy that I wanted to show. On the other hand, I wanted to show how the relationship between a husband and a wife could change because of war.

The Kôji Wakamatsu box-sets volume 1, 2 & 3 (with English subtitles) are available from Dissidenz. For more information, visit www. dissidenz.com.

The change of the power relation between husband and wife is central to the film. The wife seems to carry out her own revenge in a way.

Actually, I see it not so much as revenge towards her husband but rather as anger, anger against society, or Japan, for returning her husband back in this state, and for having to take care of him like this. She is angry against the society that has turned her husband into a cripple and that now expects her to fulfil her duty as a good wife.

In 1971, Masao Adachi and you, both having ties to the Japanese Red Army, stopped in Palestine on your way home from the Cannes festival, where your film *Sex Jack* had its world premiere, and you returned to the Middle East several times afterwards. How did your political life influence your films and vice versa?

Adachi told me about what was going on in Palestine at the time and so we decided to go after the Cannes film festival. It was there that I was first introduced to Fusako Shigenobu[2], who was working as a translator in Lebanon, and we went together to Syria, Jordan

81

2 Founder and leader of the Japanese Red Army at the time.

and other Middle East countries. For the first time, I saw people who were forced to leave their own country and who had nowhere to go. People who longed to go back home, but couldn't. And that really struck me, because I have always made my films from the perspective of the weakest in society. I think they are the people who deserve my attention. I didn't actually want to become a director and I never actually learned how to make films properly. But I just had the message and I wanted to convey it to the world with the means that I had, and it just turned out to be filmmaking. Another reason why I kept going to Palestine and countries nearby is that when I am in Tokyo, I think I gradually start to deteriorate. It feels like going backwards whereas going to these places reminds me of when I first started making films. But I haven't been for a while because it's quite difficult for me to get a visa for those countries because of my ties with the Red Army.

Looking at your body of work since you started making films in the early 60s, what strikes me is that the cinematic language you use has changed over the decades, but there are two elements that are always there: all your films are both erotic and political.

In the 1960s and 70s, when I first started shooting films, I didn't have a lot of money. So in the beginning, eroticism was a strategic decision to allow me to make the films I wanted, the one condition being that I had to include a number of sex scenes in each one. But I soon realised it could be used as an important tool to convey the political message I had to a wider audience, and what originally had just been an obligation became useful to me. So I don't think that political issues and sexuality go hand in hand, but I think that by depicting something erotic it entices more people to see my films, and once they are watching the film, they might also start thinking about the political issues involved. The difference today is that I've got budgets that are 10 times the size of what I started with in the 60s, and that's also a reason why the range of issues I deal with has become broader. ∎

Detail from poster for Spring, Summer, Autumn, Winter... and Spring | PALISADES/TARTAN

THE CYCLE OF EXISTENCE:
Kim Ki-duk's *Spring, Summer, Autumn, Winter...* and *Spring*

JOHN BERRA

A small Buddhist monastery floats on a raft at the centre of a mountain pond. The monastery is home to an old monk and a child monk, with the elder man trying to pass on the wisdom that he has gained from a lifelong devotion to Buddhism to his young apprentice. The teachings of the old monk are intertwined with the four seasons, and the master is patient in his approach to imparting knowledge, having accepted that wisdom is accumulated over time. His student has some fundamental

FEATURING
Masters
Apprentices
Buddhists
Murderers

failings, which prevent him from being the ideal protégé, although the old monk acknowledges that such mistakes are both inevitable and necessary within the cycle of existence. From this framework, the Korean director Kim Ki-duk weaves *Spring, Summer, Autumn, Winter... and Spring* (*Bom yeoreum gaeul gyeoul geurigo bom*), a spellbinding cinematic tapestry that aesthetically tantalises and satisfies its audience with the natural splendour of its almost otherworldly location and its largely static compositions, but also questions the continued relevance of the world's first missionary religion with regards to the moral complexities of modern society. Although its circular structure is ostensibly derived from Buddhist beliefs, it is entirely in keeping with the world view expressed in the rest of Kim Ki-duk's work.

The release of *Spring* in 2003 represented a significant shift in Kim's career, elevating his standing on the art-house circuit from the promising 'Korean' director of the grim social polemic *Crocodile* (*Ag-o*, 1996) and the politically contentious *Address Unknown* (*Suchwiin bulmyeong*, 2001) to that of fully-fledged 'international' filmmaker. Superficial comparisons were made between Kim and Park Chan-wook, but despite a mutual interest in exploring the physical and psychological effects of violence on the psyche of the individual and the fabric of society, Kim's work has little in common with the self-conscious stylisation of Park's fiercely contemporary thrillers. It should be noted, however, that the two directors achieved considerable status on the international scene through swiftly realised thematic trilogies; Park's 'vengeance' trilogy consists of *Sympathy for Mr Vengeance* (*Boksuneun naui geot*, 2002), *Oldboy* (*Oldeuboi*, 2003) and *Lady Vengeance* (*Chinjeolhan geumjassi*, 2005), while *Spring* marks the conclusion of Kim's 'silence' trilogy, following *The Isle* (*Seom*, 2000) and *Bad Guy* (*Nabbeun namja*, 2001). *Spring* proved to be a surprise commercial success in the United States where it grossed $2.5 million in limited release, with distributor Sony Pictures Classics attracting both Asian audiences and cineastes with a taste for Far East exotica and mysticism. Critics were equally enamoured, even those who had previously expressed reservations about Kim's work due to the director's perceived

misogyny, with Andrew Sarris, reviewing the film for the *New York Observer*, commenting that it 'probably represents the purest and most transcendent distillation of the Buddhist faith ever rendered on the screen'.[1]

Yet it would be wrong to approach *Spring* as a Buddhist text, as its engagement with, and adherence to, the noble truths of the religion is primarily structural. Discussing the film at the Singapore Film Festival in 2004, Kim explained that he does not practise Buddhism and is, in fact, a Christian, and conceded that his knowledge of the Buddhist faith is not particularly extensive. However, Kim is familiar enough with the fundamental principles of Buddhism to ensure the film is carefully and concisely structured around them.

the opening of the monastery gates indicates that another noble truth is about to be exemplified

Buddhism states that there are four noble truths: Dukkha, Samudaya, Nirodha and Magga. Dukkha states that suffering exists, that life includes pain that comes from ageing and illness, but also from such psychological ailments as loneliness, fear, frustration and anger. Samudaya states that there is a cause for this suffering, and this cause stems from a need to control elements of the surrounding world as a means of achieving success or avoiding failure. Nirodha states that there is an end to suffering, meaning that suffering can be overcome, leading to happiness, but only if the need for control is relinquished and one learns to live for one day at a time, not dwelling on the past or speculating on the future. Magga is the need to follow the Eight-Fold Path in order to avoid suffering, developing and practising wisdom on the way to Enlightenment while taking the Middle Way and not engaging in extreme emotions or behaviour; it requires the right view, right intention, right speech, right action, right livelihood and right concentration. The narrative arc – or cycle – of *Spring* revolves around these four noble truths, with the changing of the seasons, and the repeated shot of the opening of the monastery gates, indicating that another noble truth is about to be exemplified.

87

1 Andrew Sarris, 'The Four Seasons of Life: Kim Ki-duk's Buddhism 101', *The New York Observer Online*, www.observer.com, 25 April 2004.

Still from Spring, Summer, Autumn, Winter... and Spring
(Palisades/Tartan)

In 'Spring', the boy (Kim Jong-ho) and his master (Oh Young-soo) go to the forest to gather herbs that can be used for healing illness. Left to his own devices, the boy cruelly ties stones to a fish, a frog and a snake, finding unsettling amusement as his victims struggle to breathe and move. He is watched calmly by the elder monk who waits for the next day to teach the boy a crucial lesson; the boy awakens to find his movement restricted due to the large stone that has been tied to his back by his master. He is told to find and release the animals, with his master warning him that he'll 'carry the stone in [his] heart for the rest of [his] life' if any of them have died due to his mistreatment. When the boy is only able to save the frog, he weeps with regret for the pain that he has caused, but the seasons that follow will show that he has not entirely learnt his lesson.

In 'Summer', the apprentice (Seo Jae-kyung) is in his late teens and has become more curious about the outside world. He becomes excited by the arrival of a young woman (Ha Yeo-jin) who is brought to the temple by her mother (Kim Jung-young) to be cured of an unspecified sickness. The old monk agrees to treat the young woman, proclaiming that, 'When she finds peace in her soul, her body will return to health'. However, the student is aroused by the girl's presence, and they embark on an illicit affair, despite his master's warning that desire awakens the need to possess, and that this in turn can lead to an inclination to kill. The old monk sends the young woman away as soon as she has healed, which prompts his student to pack a few possessions and a Buddha statue before leaving the monastery to follow the object of his desire.

In 'Autumn', the old monk has found companionship in a large white cat, but anticipates the return of his former student when he reads a newspaper report about a young man on the run for the

murder of his wife. Shortly thereafter, the former apprentice (Kim Young-min) returns to the monastery as a fugitive, consumed by anger and guilt, and frustrated and disillusioned by his experiences in the outside world. After preventing his former student from committing suicide, the old monk instructs him to carve Buddhist sutras into the deck of the hermitage as a means of finding the peace within. Two police detectives arrive to arrest the young man for his crime of passion, but allow him to complete his task before taking him into custody, even assisting him when he becomes too tired to continue.

In 'Winter', more years have elapsed, the old monk has passed away and the pond is covered by ice. The former student (Kim Ki-duk) returns, having served his prison sentence in the outside world; his body is fit and strong, and he practises martial arts on the ice while restoring the monastery to its former state, taking the place of his deceased master. A woman who has covered her face with a purple cloth to hide a shame that is not discussed arrives with an infant. After placing the child in the care of the monk, she makes a hurried exit, but falls through the ice and drowns, with the monk discovering her body the following morning. Echoing his early learning experiences, the monk takes a statue of Kwan Yin, the Goddess of Compassion, then attaches a heavy stone to his body and drags it to the top of a mountain, carrying all his suffering and regrets to the highest possible point then meditating while overlooking the pond. As the season of spring returns, the new master lives in the monastery with the abandoned child as his apprentice. Making the same mistakes as his master, the young boy forces stones into the mouths of a fish, a frog and a snake, and torments a tortoise by banging on its shell, suggesting that violence will again occur as the cycle of existence repeats itself.

89

In her 2000 study *Contemporary Korean Cinema: Identity, Culture, Politics*, Hyangjin Lee identifies a group of Buddhist-themed Korean films from the 1980s and 1990s that are 'concerned with the materialism and moral decay that pervaded contemporary Korean society' and serve to 'investigate the psychological and emotional insecurities that plague Koreans living in the hectic

modern world'.[2] She cites Im Kwon-taek's *Mandala* (1981), Bae Yong-kyun's *Why Has Bodhi Dharma Left for the East* (*Dharmaga tongjoguro kan kkadalgun*, 1989) and Jang Sun-woo's *Passage to Buddha* (*Hwaomkyung*, 1994) as examples of this trend, films that were released over a period of 13 years but which are linked by what Lee identifies as 'a widespread interest among contemporary Koreans in re-examining their past'. Being arguably a more abstract work by a filmmaker working outside the culture of national cinema, *Spring* does not belong to this movement; Kim's work is comparatively dreamlike, and while he certainly achieves a sense of the passing of time, through the season shifts and the casting of different actors to play the young monk at the various stages in his life, the hermetically sealed world that the director and his production team have created has no relation to any particular period in the social-economic development of contemporary Korea. The fact that a Western critic such as Sarris responded to its 'distillation of the Buddhist faith' suggests that Kim is striving less for a study of national identity than for a sense of universality (which is emphasised by the nameless characters); the fact that four different actors undertake the role of the young monk, and that the student yields to temptation in both the monastic environment and the secular world, succumbing to lust in the former and the intention to kill in the latter, implies that these experiences are shared by many men of different backgrounds and faiths, all of whom must find their own way to calm their destructive urges.

Although the events that occur in *Spring* allow the film to be read as a Buddhist fable, its thematic concerns have more relevance to the overall oeuvre of Kim Ki-duk than they do to the complexities of the Buddhist faith. In his review for *Sight & Sound*, David Jays notes that the film found Kim 'dealing with the same alienated and marginal characters struggling to attain some kind of peace'[3]

2 Hyangjin Lee, *Contemporary Korean Cinema: Identity, Culture, and Politics* (Manchester University Press, 2001), p. 60-61.

3 David Jays, Review of *Spring, Summer, Autumn, Winter... and Spring*, *Sight & Sound* online, www.bfi.org.uk/sightandsound, June 2004.

although other critics suggested that this particular exploration of man's capacity for cruelty was more cathartic than the director's early offerings. Tim Robey, in his notes for the UK DVD release, suggests that *Spring* can be viewed as a 'purifying exercise' for a director whose association with controversy had become 'a millstone of its own', and believes that it is fitting that the filmmaker himself portrays the

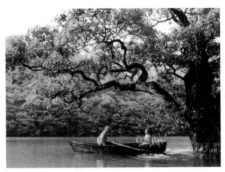

Still from Spring, Summer, Autumn, Winter... and Spring
(Palisades/Tartan)

young monk in the final seasons, dragging the millstone up the hill to atone for his misdeeds.[4] But the final moments, with the boy torturing animals, reinforces Kim's view on the inherent nature of violence, regardless of background, upbringing or institution. Discussing his work with *Senses of Cinema* in 2002, Kim stated:

> 'The reason that in my movies there are people who do not talk is because something deeply wounded them. They had their trust in other human beings destroyed because of promises that were not kept. Because of these disappointments they lost their faith and trust and stopped talking altogether. The violence that they turn to, I prefer to call a kind of body language. I would like to think of it as more of a physical expression rather than just negative violence.'[5]

91

As with the other protagonists of the 'silence' trilogy, the characters in *Spring* rarely express themselves verbally, and such communication either temporarily drains them of their energies or leads to further distress. The sex and violence in *Spring* is not as graphic as in *Bad Guy*, but Kim makes his point by contrasting the

4 Tim Robey, Notes on *Spring, Summer, Autumn Winter... and Spring* (Tartan DVD, September 2004).

5 Kim Ki-duk, quoted by Volker Hummel, Interview with Kim Ki-duk, *Senses of Cinema*, www.sensesofcinema.com, February 2002.

demeanour of the naïve teenage monk who leaves the temple with that of the angry former monk who eventually returns; his pursuit of freedom has led not to happiness but to suicidal self-loathing and, ultimately, incarceration. Suicide attempts are as prominent here as in Kim's earlier films; when the younger monk tries to commit suicide, he sticks small squares of cloth with the inscription 'shut' over his eyes, ears and mouth, and this is repeated by the old monk when he takes his own life in a more patient, ritualistic manner. The suicide of the old monk fits with Buddhist doctrine, as the master knows that he has served his purpose in the mortal realm, but the attempted, impulsive suicide of the younger monk recalls the notorious scene in *The Isle,* in which a character, who is also hiding from the authorities following the murder of his unfaithful girlfriend, tries to kill himself by ingesting fish-hooks. Both suicide attempts are carried out in a methodical manner at an extreme point of desperation and self-loathing, while the characters in both films are saved by the intervention of a concerned companion, thereby offering the possibility of redemption.

As noted, Kim is a devout Christian, and it is also possible to read *Spring* as a respectful critique of Buddhism, one that acknowledges the importance of the faith in relation to the history of Korean society and generally agrees with its fundamental principles, but ultimately finds it to be an inadequate means of navigating the moral quagmires of modern society. As a boy, the young monk weeps when he realises that he has caused the deaths of the fish and the snake, but the lesson does not diminish his propensity for violence; his teacher warns him of the dangers of lust, but the wisdom of the master only drives him from the temple; the student accepts the role of master, but may not be able to guide his own protégé to take the Middle Way. It is perhaps significant that the temple in the film was built by Kim's production company on the century-old, man-made Jusan Pond in Korea's North Kyungsang province, as this floating world is almost unreal, an aesthetic approach that is emphasised by Kim's painterly use of light and colour. When two police detectives arrive towards the end of the 'Autumn' chapter to apprehend the young monk, they are as awed as the audience by the

beauty of the surroundings. After realising that their cell phones cannot pick up any reception and being chastised by the old monk for shooting cans in the water, they lapse into the sedate rhythm of the retreat and acknowledge that their authority as officers of the state is secondary in this environment.

However, Kim does not necessarily equate nature with a peaceful existence and finds moral and physical challenges within the retreat. When the teenage monk and the girl sneak away to have sex, Kim films their copulation in a detached manner, as if he was shooting a wildlife documentary, their bodies almost merging with the landscape as if to suggest that they are also part of the animal kingdom and that an act that is contradictory to the Buddhist faith is also entirely natural, a view that is reinforced by the old monk's nonplussed reaction to his protégé's betrayal of the doctrine. The film features three deaths: the young monk's murder of his wife, the old monk's suicide, and the mother who falls into the ice. The first two deaths are anticipated in accordance with the Buddhist faith in that the old monk predicts that his student's desire will eventually lead to the 'intention of killing' and his suicide is prompted by the knowledge that his role in the cycle of existence is complete because he has imparted all of the teachings he has to offer. The third death, however, is entirely accidental, caused by treacherous terrain in the season of winter that takes life without remorse, however beautiful it may initially appear when the returning monk opens up the monastery gates. Kim's vision of nature is multi-layered, seductive on the surface but ultimately as challenging and treacherous as the modern world, with its own set of hard lessons to be learned and potential pitfalls to be side-stepped.

Kim's vision of nature is multi-layered, seductive on the surface but ultimately treacherous

93

In narrative terms, the end of *Spring* may return the cycle to the beginning, but the thematic conclusion that Kim reaches with regards to the cycle of existence perhaps makes the film the more cautiously optimistic of his 'silence' trilogy; while *The Isle* and *Bad Guy* find their socially alienated couples accepting the day-to-day uncertainty of a life on the move, *Spring* sees the master-apprentice relationship restored, although the emergence of the child's violent urges, indicated by his treatment of animals, suggests that such

destructive behaviour is also part of the cycle. The circular ending of the film has some relevance to the Buddhist notion of the cycle of existence, but with its emphasis on negative behaviour, it has more in common with Kim's other work, commenting as it does on how man can become trapped in a pattern of violence that not only leads to imprisonment and isolation, but is also irrevocably generational. Some may find it troubling, even shocking, that Kim finds the potential for violence in an environment as idyllic as the one featured in *Spring* but the director's approach to the redemptive aftermath of such behaviour is unusually cathartic and, in the apprentice monk's evolution to master, he captures a capacity for compassion where he had previously only found an inability to escape social isolation. ■

96

CUSP:
A memoir

GREG KLYMKIW

A cusp can be as exhilarating as it is disheartening.

When transition occurs, you're initially not even fully aware of it. You amble about, happy as a frolicking lamb. Eventually you notice fewer lambs and there is more meadow to gambol in.

The idyll is short-lived.

As a Neapolitan Mastiff nudges you to the abattoir, dread rises like bile in the back of your throat. Your bleats become

FEATURING | 97

Canadian drive-ins
Porn theatres
Airsickness bags
Midnight movies
End of an era

screams. Your woolly chums follow suit, adding to the cacophony as you await the sledgehammer that will crush your skull.

Unbeknown to your spirit – the one that races towards the light at the end of the afterlife tunnel – your body has been sheared, drained and hacked. It lies on a platter, adorned with sprigs of parsley, accompanied by globs of mint jelly – to be greedily masticated and slurped down the foul gullets of baby-fat-loving upright carnivores.

More often than not, a cusp leads to the end of something. Some even like to think it leads, rather optimistically, to birth or re-birth.

I am not one of those people.

For me, a cusp leads to one thing and one thing only.

It leads to death.

* * *

In the early 1960s, rive-ins were one of the most popular ways to see movies on a big screen – especially for families, young lovers and biker gangs. Bikers could drink beer outdoors and watch mythologised versions of themselves in Roger Corman motorcycle movies. Young lovers could *not* bother watching Frankie and Annette beach party movies and, instead, fuck like rabbits in the back seat of a '49 Dodge Special Deluxe. Families had it best of all. Kids got free admission, there was always a double feature and those on a budget could bring their own Tupperware pitchers of Kool-Aid and homemade popcorn. The kiddies, adorned in pyjamas, would fall asleep by the second feature in the back seat of the car.

When I grew to young manhood, my facial and pubic hair signalled physical maturity, but my spirit remained firmly rooted in childhood. In my late teens, I fondly recall attending an especially Bacchanalian dusk-to-dawn show at the illustrious North Main Drive-In Theatre with my old pal Don. For the price of one admission we would watch four (count 'em!) Hammer horror films.

On the way to Hammer nirvana, Don insisted we load up on fast-food fortification for an evening of Peter Cushing kicking

Christopher Lee's butt (and one entry from the Karnstein Trilogy). We hit several joints along the highway, and my car eventually overflowed with buckets of Kentucky Fried Chicken from Champs, chili burgers from Junior's, fries with gravy from Ma's, thin-crust pizzas from Gondola, fatty BBQ pork ribs from Jerry's and, for roughage, several bags of battered deep-fried Onion Rings from A&W. We also purchased a few packs of Du-Du Coils from K-Mart to burn fumes of toxic smoke in our vehicle to discourage and/or just plain kill any nasty mosquitoes that dared to come a-calling.

watching the 10-minute intermission countdowns with their emulsion scratches and warbling optical tracks

To wash the comestibles down, Don provided a huge Hudson's Bay shopping bag replete with all manner of alcohol – Donini Red, Captain Morgan Rum, Gimli Goose, Pernod, Stolichnaya vodka, absinthe, rye whiskey, champagne, several bottles of beer and, among many other libations, fucking disgusting Ouzo. None of the bottles was completely full, but added together, we were equipped with about 200 ounces of liquor. I assumed Don pilfered this cornucopia of devil's brew from the German Combatants Club (where he worked as a bartender), but it was, in fact, the remnants from a fraternity house party he'd attended the night before.

Eventually ensconced in front of the drive-in screen, we were both delighted that the movies were, without question, extremely riveting. One of the infinite joys of drive-in viewing was watching the 10-minute intermission countdowns with their emulsion scratches and warbling optical tracks – beckoning us to come to the concession stand to purchase a wide variety of foodstuffs (and, of course, Du-Du Coils).

99

Hence we stayed put, never once leaving the car. We had everything we needed.

When dawn broke, the vast prairie skies cast a magnificent glow over the closing credits of *Lust for a Vampire* (1971). We rolled our windows down and tossed the still-burning Du-Du Coils onto the piles of trash on either side of my car. I put the gear into 'drive' and aimed my lime-green 1976 Pontiac Laurentian for the highway back to the city.

In good measure, our movie-booze-junk-food-satiated carcasses entered the West Kildonan Salisbury House restaurant just across the street from the Winnipeg Transit Authority and not far from the site of the Battle of Seven Oaks where in 1816, 60 brave Metis led by Cuthbert Grant decimated an outpost of pemmican-thieving Hudson's Bay Company employees.

Taking a booth at the front of the venerable Winnipeg eatery (now owned by The Guess Who's Burton Cummings), we breakfasted on buttermilk pancakes with Aunt Jemima syrup and thick wads of creamy, yellow and heavily salted St Joseph Dairy butter.

During this long ago, fondly remembered moment of peace, I looked out the window onto the empty Winnipeg streets and could not have ever imagined that:

- the pudgy, smiling, nappy-headed visage on the label of the Aunt Jemima bottle would eventually lose her Hattie McDaniel-like 'Mammy' look;

- St Joseph Dairy, the creamiest little independent manufacturer of udder-squirted product would, some years later, no longer exist;

- the North Main Drive-In would close its gates forever (along with all the other drive-in theatres in my winter city);

- the Hammer Company would stop making movies;

- I'd eventually transfer my passion for film to the business of buying, selling, making and writing about movies.

I was about to enter a Golden Age. Given my year of birth, I sat on the annoying cusp of latter-day baby boomer and early Gen-X – not quite reaping the benefits of those just a few years older and not quite experiencing the Douglas Coupland-coined McJob syndrome of those a few years younger. From 1977 to 1985, I programmed a

repertory cinema and, as a booking agent, I bought motion picture product for a tiny circuit of rural movie theatres. Joy and impending sorrow became my constant bedfellows.

* * *

Repertory cinemas ruled the kingdom of cinema through the 60s, 70s and a pubic hair of the 80s. Anyone who loved movies frequented the reps religiously. You could see everything a cineaste needed to see – from every country making movies worth seeing and every period of film history. You saw 35mm and 16mm film prints, lovingly projected on a big screen and most importantly, in a real movie theatre (as opposed to the rarefied atmosphere of a cinematheque or film society). Depending on the theatre, you could often see four different movies per day.

Growing up in Winnipeg when I did was pretty cool. This sleepy mid-western Canadian city boasted numerous art cinemas, film societies and universities. You could see alternative cinema in museums, art galleries and my favourite – sneaking into post-secondary film classes. Not only did Winnipeggers see 'art' films at independent cinemas, even the chains reserved screens for them. I even considered the numerous grindhouses and porn cinemas in Winnipeg to have a repertory style, as the programming was a definite alternative to the mainstream.

101

The population of Winnipeg during this period barely cracked 500,000, so in retrospect, it seems utterly astounding how cinema-advanced it was. In reality, though, there wasn't much else to do there.

* * *

A hop, skip and a jump from Guy Maddin's family home atop his Aunt Lil's beauty salon (where, after Lil's death, he would shoot most of his first feature *Tales from the Gimli Hospital* in the 80s), I worked, at the age of 18, as head box office cashier for a rep cinema.

The theatre dated back several decades and in the parlance of exhibition and distribution, it was referred to as a 'nabe' (a

neighbourhood movie theatre). It wasn't a picture palace with ornate architecture and jaw-dropping interiors, but interestingly, it was cavernous for a 'nabe' – about 800 seats with a balcony, stage and spacious lobby.

In the early 1970s, an Italian immigrant who always dreamed of owning his own theatre bought it. When the Italian received an offer from Columbia Pictures to book a movie none of the chains were willing to play in Winnipeg because it was considered pornographic, he jumped at the chance. The movie was *Emmanuelle* – one of the few times in cinema history where a major studio fully embraced an X rating. Columbia boldly featured a tag line that proclaimed: 'X was never like this!'

The picture did boffo business at the venerable old 'nabe' – so much so that the Italian eventually transformed his theatre into a palace of smut. Under one roof, gentlemen could see triple-X pictures in 35mm, gaze at strippers between movies, patronise a massage parlour for manly relief and stop by a sex shop to select some dildos, edible panties or frilly undergarments for their wives.

The Italian's sense of showmanship with respect to the movies was his greatest triumph. He wanted to screen only the finest skin flicks. Other full-time porn theatres in Winnipeg imported prints from the province of Ontario, which had a censorship board. Much of that product was badly and annoyingly snipped. The Italian, on the other hand, imported his pictures from *La Belle Province* – Quebec, the land of milk, honey, *poutine*, pudding chomeur, *viande fumée*, *danseuses nues*, French separatist terrorists and no censorship.

Hence, cum shots galore!!!

Surprisingly, Winnipeg (and the entire province of Manitoba) had dissolved the literal censorship of movies. There was a classification board that provided guidelines and ratings that exhibitors had to abide by, but films were never cut. The Manitoba board of film classification was run by a movie-loving Jesuit priest for many years.

Go figure.

That said, pornography laws still existed and the palace of smut was persecuted by the police and the Attorney General. The harassment was so constant that the Italian decided to shut down all the sex-related stuff and convert the cinema into something more legitimate.

His first foray into going straight was to turn the porn house into a rep cinema. Things went well. Agents from rep cinemas in larger cities outside of Manitoba booked the entire slate of product and box office was through the roof.

There was to be, however, a spanner in the works.

The Italian had a house manager in his employ who was arrested for planting live bombs all over the city, making telephone calls wherein he threatened to set them off (which thankfully he never did), and in his apartment, police discovered enough bomb-making supplies to take out several city blocks.

Needless to say, this was not the greatest publicity in the world and another make-over was imminent. Local programmers were hired and they redesigned the venue into a very classy first-run art house.

And this, as head box office cashier, was where I came in. It was one of those jobs that never felt like a job. It was easy, fun and, of course, I got to see all the movies.

103

However, the Italian was constantly depressed because the box office returns left a bit to be desired. In all fairness to the programmers, the movies were good and the numbers weren't that bad. But the previous scandal had taken its toll and the same (slightly older) audiences who would flock to the other independent and chain cinemas showing art product seemed less than thrilled about coming to a place previously managed by a mad bomber.

Add to the mix huge legal bills left over from the porn prosecutions, the staggering costs of not just one, but two major renovations and the general expenses of running a movie theatre day to day and there was indeed some cause for concern.

One night, the Italian came by to check the box office. Alas, the takings were rather dismal that evening. The Italian sat down heavily, leaned forward, buried his face in his hands and shook his head. He stared into space and uttered his common lament: 'Oh my God! Where are you?' Then, his face transformed into something almost malevolent and he began to curse the programmers.

He was silent for a moment then looked at me. 'Say kid, if it was up to you, what kinda movies would you play here?'

I replied I liked the current crop of movies just fine, but I also told him why I thought audiences were staying away. The mad bomber scandal in combination with the porn prosecution scandal was probably enough to create a serious dent in the number of 'class' customers who would patronise the joint.

This depressed him even more. 'So who da fuck's gonna come here? You tellin' me I gotta play suck-fuck shit for scombaggies?'

I tried to raise his spirits. 'You don't have to play porn anymore if you don't want to.'

'So you tell it me. Who da fuck's gonna come here?'

I shrugged my shoulders and said matter-of-factly, 'People like me'.

For the first time in a long time, I saw his eyes twinkle.

* * *

In the 1970s and 80s, the motion picture distribution and exhibition landscape was very different from what it is now. In terms of technology, it was night to our current day. There were no fax machines, no email and no cell phones. National and international communication was via telegram or clunky, inconvenient Teletype machines. Regular snail mail and landlines were ultimately the order of the day. For record keeping, everything was written down by hand in huge booking binders, ledgers and file cards. When it came to entering anything that involved a date that could conceivably change, one used the phrase 'pencil in', and a pencil was used to

literally enter the information. Common items oft used in such cases were erasers and manual pencil sharpeners. If something was going to be 'inked in', it was like signing a deal with the devil himself – you might as well be signing with your blood.

Canada's vast size (six or seven times that of Europe – not in terms of population, but physically) meant that the logistics of distributing films were complex indeed. To accommodate this, every major studio had branch offices across the country. First and foremost, all the studios had their head office in Toronto, with branch offices in Quebec, the Maritimes, British Columbia, Alberta and Manitoba. Winnipeg, the capital city of Manitoba, was responsible for distributing motion picture product in Canada's second-largest distribution territory, which included Manitoba, Saskatchewan and north-western Ontario. The studio offices in Winnipeg included Columbia Pictures, 20th Century Fox, Paramount Pictures (which also handled Disney product in Canada), MGM-UA, Universal Pictures and Warner Brothers.

Other exhibition/distribution companies were also represented in Winnipeg. The major exhibition (movie theatre) chains, Famous Players and Odeon, had fully staffed branch offices across the country. In addition, various commercial and social organisations thrived, such as the Motion Picture Pioneers and the Variety Club.

I not only felt like I was really in the movie business, but there was an incredibly vibrant sense of community – one I've never experienced in quite the same way since.

105

<p style="text-align:center">* * *</p>

I started reading the motion picture trade paper *Variety* at the age of 10. I bought the weekly edition and read it cover to cover. When I started to programme the Italian's repertory cinema, I had the lingo and a lot of the rules of the business down pat.

And I was true to my word to the Italian. After he hired me to programme the cinema, I began feverishly selecting movies with an accent on 'people just like me', and being obsessed with the *business*

of movies as well as the *art* put me in a unique position at such a tender age.

One influential movie I had seen was *El Topo* (1970), and one of the people I noted on the credits and became especially enamoured with due to my Variety readings and subsequent research was the New York cult film impresario/guru Ben Barenholtz. He pioneered the whole idea of midnight movies, head films and cult films and made hits out of pictures like *El Topo, Holy Mountain* (1973), *Pink Flamingos* (1972) and many others, paving the way for movies like *The Rocky Horror Picture Show* (1975) to hit their stride theatrically in a unique way.

They're not even sure it's a baby!

I also stayed true to my word with respect to *The Rocky Horror Picture Show* – I did not play films I didn't like (or had no interest in seeing) and that was a picture I detested. In Winnipeg, it eventually went to another theatre and they were doing boffo business. The Italian thought I was nuts, but I assured him there was another plan up my sleeve. Having seen a Ben Barenholtz discovery by the then-unknown David Lynch, I decided to secure the exclusive exhibition rights to *Eraserhead* (1976). A tiny indie distributor in Toronto handled it and I booked the film to play every Saturday at midnight.

Box office was initially soft, but I held true to my belief in the picture and clung to the words of encouragement Barenholtz had given to Lynch – that the numbers would double each week. I also began modifying the ad campaign and used a bit of dialogue from the movie as the tagline in all my promotional materials: 'They're not even sure it is a baby!' I ordered thousands of airsickness bags and provided them to customers. I secured a promotional tie-in with Winnipeg's highest-rated hard rock station and got myself booked as a special guest with all of the top DJs to talk about not only *Eraserhead*, but *all* the pictures playing at the cinema.

In one of my more questionable, though successful, stunts, I encouraged people to vomit in the cinema by daring them *not* to vomit during one of my radio talks. Though we were distributing airsickness bags, customers chose to vomit on the floor of the

auditorium, lobby and washroom – everywhere except in the airsickness bags. No matter. I had a loyal 12-year-old boy from the neighbourhood, Paulo, who did odd jobs around the theatre and, though it sickened him to do so, did a bang-up job cleaning each mess as quickly as possible.

I also looked the other way on stupid, repressive by-laws, allowing all manner of smoking (legal and not-so legal) and alcohol consumption in the theatre. Every night was party night and miraculously, in four years, the joint was never nailed for any infractions.

Eraserhead was a hit and played every weekend at midnight for two years.

<p style="text-align:center">* * *</p>

Booking movies for small-town movie theatres had its ups and downs. Doing the rep house, I was able to book cool shit I loved and specialise in cult films, rock pictures and anything that was extremely edgy. But small-town movie theatres were basic first-run houses, so I was always on the lookout for anything recent that would make money.

Drive-ins, on the other hand, were pure fun to book – especially the dusk-to-dawn shows on long holiday weekends. This involved trying to secure a mix of first and second run that could be 'flattened out'. Movie theatres in small towns, particularly drive-ins, loved paying flat rental fees. The majority of films cost a percentage of box office as low as 35% and as high as 60%. If you secured a movie 'flat' you paid $35 to $50. If grosses were high, you'd not only score on concession sales (where movie theatres make the majority of their money), but on the admission prices too.

<p style="text-align:center">* * *</p>

The plus side to booking first-run product was getting to see major Hollywood pictures well in advance of their release dates. Once in a while, you'd see a semi-complete cut of a film. For a movie psycho like me, this was always eye-opening. I also loved seeing a picture in advance where you knew in your gut how well it would

do. One movie I sold the farm on was *Beverly Hills Cop* (1984). I offered top advance money and extremely high percentages. And yes, sometimes you'd pay film rental in advance – and God help you if the picture was a dud. The Eddie Murphy action comedy was huge, and in spite of the high price of rental, it still brought in scads of dough for my exhibitors. I had my flops too, though. Does anyone even remotely remember a picture called *Rustlers' Rhapsody* (1985)? It was a Western spoof starring Tom Berenger that some of us thought could be a new *Blazing Saddles*. Alas, it turned out to be 'Sore Saddles'.

The other advance exhibitor screening I loved attending was the one in which you could, in a small way, shape a major studio picture. One such example was Adrian Lyne's *Fatal Attraction* (1987). This movie had all exhibitors and I on the edges of our seats. Glenn Close gets crazier and crazier and the suspense builds to a fever pitch until – wham! – a downer ending. It was probably the right ending, but all you could see was negative word-of-mouth coming from mainstream audiences who got a major cold-cock at the end. All the exhibitors in Winnipeg felt this way, and as it happened, exhibitors all over North America said the same thing. The release was delayed. New footage was shot. And the rest, as they say, is history. The new ending was ludicrous, but kicked ass, and box office was huge.

* * *

The Old Distributor refused to retire.

When I met him, he had been in the movie business for 60 years. His career began in the silent era as a shipper in a warehouse full of nitrate film prints – he was not even 20. He was responsible for making sure every single movie got exactly to where it needed to go – and on time. His territory included hundreds of movie theatres dotting the plains from the Saskatchewan-Alberta border in the west to the town of Wawa on the rugged Canadian Shield in the east, and he learned about every nook and cranny of it.

This intimate knowledge held him in good stead when he began

working as a film distributor. Back in the early days, movie distributors on the prairies worked as travelling salesmen – each one a Willy Loman – going from town to town by train, hustling their slate of motion pictures. The Winnipeg distributors, while competitors, were also friends, and given the breadth of sales runs, they'd work in tandem to keep each other company while in collusion to ensure an equitable split of product.

When the Old Distributor (as a young man) made his first run, his colleagues initially scooped up the first few accounts – not to screw our hero, but to teach him a thing or two about the journey that had only just begun. And what a journey it could be. For example, at night, an oil lamp hung on the station platform. When a whistle was heard, travellers would swing the lamp back and forth, signalling the train to stop. In those days, if a train didn't have to stop, it wouldn't. This particular sales run was in the winter, and as Canadian prairie temperatures dipped to 40 or 50 degrees below zero, travellers didn't go onto the platform until they had to.

One night, the train didn't stop. It sped by, leaving a swirl of blinding snow in its wake. The Old Distributor, being at his most youthful and ambitious, grabbed the lantern, jumped off the platform onto the tracks and ran like a madman towards the train, his small suitcase in one hand and the swinging lantern in the other, trying to get it to stop. His colleagues screamed out, but their cries were lost to the powerful prairie wind. They knew that the train only saw them at the last minute and was, because of the ice on the tracks, gradually stopping before it would back up to return to the platform. Clearly the Old Distributor, due to his inexperience at the time, didn't realise this. As the train backed up, the lantern smashed against the caboose and the deep, crisp, sub-zero prairie night swallowed everything whole.

109

A search ensued, but there wasn't enough manpower or light to do things properly. The veteran distributors were billeted by some locals and decided to wait until the Royal Canadian Mounted Police detachment from the next town arrived in the morning.

The train left the platform and moved on down the line.

The following day, the mounted police arrived, but several inches of snow had fallen through the night. It was decided that a further search might have to wait for the spring thaw. Devastated, the distributors waited for another train.

In the next town, and the next, and the next, and so on, the Old Distributor had managed to sign every small-town cinema to exclusive packages on all his product for the next quarter, leaving little play-date space for his colleagues. From his years as a film shipper, he was well aware that the train would stop and back up. When it got close enough, he tossed the lamp, jumped to the side, and boarded the train when it stopped. He hid in a washroom until the train eventually chugged forward. He was not known to smile often, but that night, he most certainly did.

The Old Distributor first told this story to me privately. Over the years, I heard him, at the behest of other industry people, repeat the tale – often at Motion Picture Pioneers and Variety Club luncheons – and once into a microphone for about one hundred distributors, exhibitors, bookers and, of course, hookers, at a Motion Picture Association Convention where he was being feted for his many years of service to the movie business.

110

During those years as a repertory booker and film buyer for small-town cinemas, the Old Distributor taught me the art of negotiation to secure product and then to haggle over the price. On occasion, he'd let me rummage through the storage room of his office, which was crammed with several decades of cool publicity materials, and take an item or two.

To have experienced a slice of old world movie exhibition and distribution, but most importantly, to have had the friendship and mentorship of a true giant in the industry, whose wealth of knowledge has served me to this very day is now, in retrospect, something that was beyond my wildest dreams and yet, was not. It was a dream I shall never forget.

Things changed – slowly, incrementally and in a way, rather creepily. Studio releases got wider and yet, the rental terms were often beyond the capacities of small-town theatres. Exhibition technology advanced in terms of picture and sound and yet, the costs associated with these advancements were also beyond the capacities of small-town theatres. In larger centres within reasonable driving range of many small-town theatres, the exhibition chains started to build state-of-the-art multiplexes – big box emporiums beckoning small-town audiences to see movies there.

The movies themselves were changing – becoming rollercoaster rides and video games on a big screen – appealing to a youth market that was more than happy to go to where the lights were bigger and brighter. Adult audiences had another option. The home video boom of the 1980s encouraged them to stay home. Home video unleashed the entire slate of product the repertory cinemas were showing. The audiences who frequented the reps in the 60s and 70s were getting older, richer and lazier. They either went to the big boxes to watch *Rambo* or stayed home to watch VHS tapes on their television screens.

Even drive-ins were losing their appeal. Families could watch movies in the comfort of their own homes or in megaplexes. Even horny teenagers found more comfortable places to have sex than the back seats of cars.

111

I eventually got the telephone call I believed I'd get sooner rather than later.

'How ya' doin', kid?' said the Old Distributor.

He always called me 'kid'.

We got through a few pleasantries and then silence – just the sound of his slight wheeze on the other end of the phone.

'Kid, they're closing down my office,' he finally said. 'Why don't you come by this afternoon? I'm going home for lunch, but I have a little something I want to give you.'

When I arrived, piled near the door were several boxes of historic publicity materials from the studio that the Old Distributor hoarded in his closet.

'My boy was going to throw them out, but I got the girl to haul 'em out here,' he said. His 'boy' was a 50-year-old man who'd been his assistant for 20 years. The 'girl' had been his secretary for 30 years.

'I knew you'd probably want all this junk, kid.'

* * *

Within a matter of months, every major studio closed their offices in Winnipeg. The exhibition chains laid off their upper management staff and closed their regional offices. Multiplexes were going up rapidly and even the venerable downtown picture palaces were closed in favour of the big boxes – located mostly in the suburbs. Independent theatres closed by the hundreds across the territory.

I briefly toyed with the idea of getting a real life and applied to several law schools. I was accepted by all of them, but as luck would have it, I was offered a marketing and distribution position with a little non-profit filmmaking co-operative. This eventually led to producing independent movies.

Everyone from my former life in movies seemed to drop off the face of the planet.

112

About one year after the Old Distributor shut his office down, I sadly and reluctantly found myself, on a warm summer day, walking along the sidewalk on Wellington Crescent towards the Shaarey Zedek synagogue. It was one of those great Winnipeg days. The sky was a bright, rich blue, the sun beat down with a magnificent dry heat and the majestic oak trees lining the street were lush and green.

Outside the synagogue, I saw a few familiar faces from the distribution business and we all greeted each other solemnly. The Old Distributor had been a devout and long-time member of the Shaarey Zedek congregation. I mentioned I'd be happy to pay my respects to his wife after the ceremony. The Old Distributor's 'boy'

shook his head in distress. After the service and interment, it had been arranged to place her directly in a long-term care facility. She had been afflicted with Alzheimer's for a number of years and when he retired, the Old Distributor dismissed the private nursing staff and personally took care of her until his dying day.

In the outer lobby of the synagogue I retrieved a *yarmulke* from the basket left out for those who were not of the faith. I donned it and went in.

When the ceremony ended, two men were leading the Old Distributor's wife out to the limo. She was quite distressed and worried aloud that she'd be home in time to make lunch for her husband.

Driving to the interment, I glanced into the rear-view mirror and noticed I was still wearing the *yarmulke*.

I never did return it. I've kept it these many long years and cherish it as a reminder of a great old man of the movies and a time that is, sadly, gone forever.

It is a time that will go with me to my grave. ■

CLOSING SHOTS:
The directors' cuts

ILLUSTRATED BY SEAN AZZOPARDI

'It strikes so hard because it's deeply private and because it's impossible.'

Earth

THE BROTHERS QUAY

Dovzhenko's *Earth* (*Zemlya*, 1930) ends with the death of the hero. There is a great cortege through the landscape and the people sing what is obviously a metaphysical hymn to brotherhood and camaraderie for him and the new era. (Dovzhenko had to do that, but he does it so beautifully.) Tarkovsky's composer Ovchinnikov wrote the score, and he uses a fabulous, rich overlay of chorus. The final shot is a big close-up of a woman looking up with a spellbound expression on her face, and you think she's looking up to the sky. The shot cuts back a bit wider and you realise that she's in the arms of her husband – the man who has died. They look at each other and neither of them moves for a long time. Finally, it begins to dawn on her that it's real, that they're together forever, and she starts to smile.

It's a real fairy tale ending, but it strikes so hard because it's deeply private and because it's impossible. It comes after that terrifying moment when Dovzhenko cross-cuts between a priest who thinks that the world has gone mad, a woman who is giving birth, and the grieving wife who's just lost her husband. It's birth, death, madness in this great chorus, and Dovzhenko almost mathematically charts this progression, so when you see that final shot, everything comes back, the whole journey that has been made, and it's very moving – frightening in a way.

The Ovchinnikov score is crucial to the entire film. It mixes this great elegiac chorus with a hallucinating movement that scorches the brain because of the pain that has been traversed. You can see why Stalinist times had trouble with it: the pantheistic vision is so powerful – more powerful than the approved message of the film. ∎

117

The Brothers Quay conjure up dark dream worlds in their acclaimed stop-motion animation short films and live-action feature films, *Institute Benjamenta* (1995) and *The PianoTuner of EarthQuakes* (2005).

'A dark, gaping abyss of hopelessness.'

Invasion of the Body Snatchers

SCOTT MCGEHEE AND DAVID SIEGEL

By the end of *Invasion of the Body Snatchers* (1978) we've come to realise that imitating the zombie walk of the alien pod people is the only way to survive.

The movie's penultimate scene is one of hopeful but thwarted chaos: Donald Sutherland, trying to destroy a pod incubation greenhouse, is ratted out by a shrieking replica of his love Brooke Adams, naked and still moist from her slimy alien rebirth. (Her rasping pod shriek, we learned from DVD extras: human crossed with pig, in Dolby Surround.)

Now Sutherland is zombie-walking alone through the deserted plaza in front of San Francisco's City Hall. (Incidentally, the same City Hall where, just weeks before the film's 1978 release, a Twinkie-brained Dan White murdered Supervisor Harvey Milk and Mayor Moscone.) It's winter, and the rows of leafless, aggressively pollarded sycamores lining the plaza are a haunting arboreal echo of the regimental submission we've seen in pod-world.

Along comes Veronica Cartwright. She's outwitted the pod horde longer than anyone. Cartwright has an amazing presence: vulnerable and human; innocent, with oversized, sad eyes. She's pretty, but not the pretty girl. (That would be the afore-naked Brooke Adams.) We've watched her lose her husband, the adorably young and scrawny Jeff Goldblum, and have been rooting for her.

Now she's overjoyed to see her only friend Sutherland. She drops the ruse of the zombie walk, calls out, her face a portrait of desperate, naïve human hope. Sutherland stops, turns to face her. And tragically, inevitably, he raises his trench-coated arm, then shrieks the bone-chilling pig-shriek of the pod people.

119

The last shot is his shot. A simple, three-quarter angle, pushing in, then jumping to a close-up on his face. But it's Donald Sutherland's face: extravagantly mannered eyebrows framing those crazed bulging eyeballs. As he shrieks, we keep pushing, right into his once human mouth, now a dark, gaping abyss of hopelessness. When the frame freezes, we just keep going, right towards it. Right into the unimaginable darkness. ■

Scott McGehee and David Siegel made their filmmaking debut in 1994 with the masterful cerebral thriller *Suture*, a landmark of American independent cinema.

'The end is a void. Absence. Is She dead or has She abandoned him?'

L'avventura

PETER WHITEHEAD

Fellini! It seemed clear. But then the doubts. Was it *La Dolce Vita* (1960) or *8½* (1963)? The VHS tapes lost in the attic. And so much also lost in the attic of my mind. But then a flash, not a flash-back but a flash-forward. Might this forgetting perhaps show the continuity of Fellini's films? He, like all great directors, suffering the unconscious controlling 'monster' that dictates the gyres of every narrative; denoted by the similarity of end shots, always arriving at the same end point, that ties up all the loose Ends?

Or *L'avventura*? (1960) The end is a void. Absence. Is She dead or has She abandoned him? Is this why Antonioni made films? Fear of the End Shot? In life? Is it film as well as woman that embodies betrayal? Antonioni's fear that the End in life and film is inevitably the same. Suddenly, She is no longer there.

The end shot of every Bergman film that I saw and re-saw and saw again, seeking to deny the End Shot, decimated and lonely. Closure. An End would mean there is no God. Only a void. *Persona*, the older woman, the actress, having come full stop with words. Beyond the End Line she had spoken: Silence.

Perhaps my self-portrait, Pierrot le fou, blue-faced Belmondo becoming a puff of smoke on the cliff top. No, Fellini! The party-goers, after the strip-tease, the husband's return to see his wife naked on the floor, caressing herself... Then the long meandering End Shot, drunken guests stroll onto the beach where, staring at them, with its hideous eye, the huge ugly monster, such a monster as swims in the personal oceanic unconscious of us all. Was it *La Dolce Vita*? I am not sure.

I prefer the uncertainty of Antonioni. In which there can be no end: no end shot, no closure. It is only Reason that ends with an End Dot. ■

121

Peter Whitehead is an experimental British filmmaker who documented, as well as participated in, 60s counter-culture in London and the USA with films such as *Tonite Let's All Make Love in London* (1967) and *The Fall* (1969). His latest film is *Terrorism Considered as One of the Fine Arts* (2009).

'Why do animals let us feel things we cannot put in words?'

Stroszek

DEBRA GRANIK

The ending shot of Werner Herzog's *Stroszek* (1977) is a chicken on a turntable, dancing behind the glass of a miniature tableau in a roadside arcade. The chicken dances to the careening harmonica and whooping vocals of Sonny Terry, scratching the surface and turning in circles. The chicken is out of context, isolated, projecting feelings of confusion and loneliness. The music imposes a sense of frenzy and desperation. This chicken encapsulates the emotions of everything that has come before.

Why do animals let us feel things we cannot put in words? Do we project onto this chicken our feelings about the protagonist and his struggle to survive in the US? The chicken is locked inside an arcade in which Genuine Indian Souvenirs are sold, adjacent to a parking lot in which a lone Native American man in full regalia is standing, watching as cars drive by. This lone figure is set within the larger arcade of the tawdry re-sale of his culture, encased in a cheaply constructed asphalt and cement site of fast-buck commerce.

As I replayed the dancing lonely chicken and heard the police officer say, 'can't stop the dancing chicken' into his walkie-talkie, I wondered if it was not wildly heavy-handed. But sometimes, especially when it comes to letting out emotions about this big old conflicted, fast, cheap, outta control nation, I crave the heavy-handed and the catharsis it may elicit. Herzog does not shy away from confrontation, holding up mirrors, or catharsis. I have a special reverence for filmmakers who do what I dare not.

Herzog claims that he had to have this shot. Animal images cannot be defended with words. This reminds me of Claire Denis, who chose the final image of *Beau travail* (1999) simply 'because it felt right in a way that words cannot explain'. As I make films I circle around this mystery: why certain images feel precise, and make us feel. I try to strengthen my filmmaker *cojones* and take heart from my European colleagues who use images because they feel right, not because they make a 'balanced, suitable, satisfying' ending. ∎

123

Debra Granik's latest film is *Winter's Bone*, a haunting tale about a young girl living in the Ozark Hills forced to face violent relatives to save her family from ruin, which won acclaim at the Berlinale and Sundance Film Festival in 2010.

'It's like a Swiss watch: perfectly constructed and diabolical.'

Se7en

VINCENZO NATALI

There are many things that are extraordinary about the ending of *Se7en* (1995). First and foremost, the entire film leads to that final moment. It's like a Swiss watch, it's perfectly constructed to bring us to that inevitable conclusion and it's so diabolical, disturbing and uncompromising.

When the film was first released it was truly shocking because there was nothing to compare it to. I would choose that as my favourite ending because I think the whole film rests on that final sequence: it defines the movie and the movie succeeds because of it. I know that at various points in the production, different endings were being considered – in fact, they might have even shot variations on it, I'm not sure – but it's a wonderful twist of happenstance and serendipity that they were allowed to keep that ending because it's so supremely dark. For all those reasons, I love it and I try to emulate it.

In all movies the ending is the most important part, and yet invariably it is always the hardest thing to come up with. Most movies, frankly, fall short – most start a little better than they finish. What's challenging is that after over a hundred years of cinema and hundreds of years of the novel, we know what to expect; and as a storyteller you want your ending to be unexpected, but you also want it to be coherent and to make sense, so it's hard to balance those two things.

I've seen many endings that surprised me but didn't really add up. Conversely, I've seen many endings that didn't surprise me in the least. Neither type is satisfying and it's rare to find a final shot that really transcends expectations. ∎

125

Vincenzo Natali is the director of a number of cerebral sci-fi gems, including the metaphysical chiller *Cube* (1997), the futuristic corporate espionage tale *Cypher* (2002) and the genetic mutation thriller *Splice* (2009).

'The complexity of the film is summed up by the final image.'

The Story of Qiu Ju

ASIF KAPADIA

In rural China, pregnant chilli farmer Qiu Ju, played by Gong Li, fights for justice after her husband is kicked in the groin by the village headman, Wang Shantang, for questioning Wang's lack of children.

Zhang Yimou's *The Story of Qiu Ju* (*Qiu Ju da guan si*, 1992) is made in a naturalistic documentary style that is quite different from his highly stylised *Hero* (2002) or *Curse of the Golden Flower* (2006). It focuses on the determination of a pregnant woman taking on the feudal system in rural China, and for me, Qiu Ju is one of the strongest female characters in film. The story hinges on the simplest thing: Qiu Ju wants an apology for a wrong that has taken place; she doesn't want money, she doesn't want to go to court, she refuses to make any compromise. But the apology never comes, so Qiu Ju keeps fighting and takes it to the local, regional, and, finally, governmental authorities.

This culminates in a brilliant ending: Wang, with whom Qiu Ju has feuded for the entire film, is invited to a party to celebrate the birth of her baby boy. Qiu Ju and her husband reveal that Wang saved her and the baby's lives by taking her to the hospital when her waters broke. But Wang never arrives at the party. Instead, a local policeman appears and tells Qiu Ju that the X-rays showed her husband had suffered a broken rib following Wang's kick, and as a result, Wang has been arrested. Qiu Ju runs off to try and stop the police.

127

I love the fact that Qiu Ju's pregnancy is there to see but not mentioned for the length of the film, and the whole story ties up with the birth of the child at the end. The complexity of the film is summed up by the final image: a freeze-frame of Qiu Ju with an expression of anguish on her face. ∎

Asif Kapadia is the director of two magnificent folk tales set against hostile and beautiful nature, one in the Indian desert, *The Warrior* (2001), the other, *Far North* (2007), in the Arctic.

'If I had a cinema, there would be a "No Opinions" sign.'

You, the Living

DAVID OREILLY

My current favourite film ending is in Roy Andersson's *You, the Living* (*Du levande*, 2007). Planes fly over the city while ragtime music plays in the background. Like most of the film, it's poetically absurd without explaining anything. This scene gives us space to ponder what on earth we've just been through.

It's been said that every film ends in the mind of the viewer. The moment a film finishes you are exiting one world and entering another. I would argue that the highly standardised fade to black, end title and rolling credits evolved to ease this delicate transition. You're still hearing the echoes of each character and feeling their emotions, and, in some cases, readjusting your world view and priorities.

The only part of the cinema experience I hate is when you're getting up to leave and everyone suddenly wants to shower you with their expert opinions about the film you've just seen. The same way a memory or dream is destroyed when we try to explain it, the entire experience and interaction with a film is destroyed when we summarise and colour it with opinion.

The moment when a film ends is so sensitive. You only have a brief window of time to hold this experience completely, to absorb it before it is overwritten by the trivialities and worries of the real world – taxes to pay, deadlines to meet and an apartment slowly filling with garbage. If I had a cinema, there would be a 'No Opinions' sign next to the 'No Smoking' one, and it would consist of the words 'The End' over a little character projectile-vomiting faeces into the air as everyone runs for cover. ∎

129

David OReilly is an innovative animator who won the Golden Bear for Best Short Film for the unexpectedly poignant cat-and-mouse love story *Please Say Something* at the 2009 Berlinale.

130

'All is fine until that last, so well-known shot.'

Super Sea

STEPHANIE BARBER

If I ever have to watch *Super Sea* (1977) again I will leave before the final shot. True, this 'have to' may be a little dire. It is rare I *have to* do anything except, perhaps, to avoid seeming rude I will *have to* engage in discussions about ingredients in a *tarte* or pasta salad, or *have to* listen to someone as they give me directions from one part of a city to another. This is a mild forcing and I wish there were a more appropriate phrase for this societal occurrence – something like 'put-upon' without the sartorial implications. But, though this milder *have to* is rare, it points to a million possible and actual *have tos* that inevitably damn a day with worry.

In *Super Sea*, the main character (really the tree, right?) is riddled with *have tos* like a Western ablution's wind sock. My friend Calvin says that sort of business – the bad business of moving through your life that way – is just the thing to bring you into a mattress factory late on a Sunday evening. Nobody I know who knows Calvin knows what that means, but it has a poignancy I think the tree would respond to.

All is fine until that last, so well-known shot. You who spent your childhoods watching and re-watching *Super Sea* know the horror of that final moment, the way the camera's slow zoom suggests its complicity in the proceedings. The way the soundtrack ceases its endless barrage of music and leaves us viewers alone with our *having to* consider. The way the screen begins to expand and wrap its edges around the viewer and the filmic intussusception moves from psyche to soma. The way your own face and gestural ticks become grafted onto each character and killed off one by one. This *have to* is not pasta salad. It is not the listing of salt and pepper, onions and black beans we are being asked to consent to. Should I find myself, as I so often do, slouched down in the red velvet darkness nearing this final shot I will have to excuse myself. I will ask directions to the mattress factory. I will go to the mattress factory. ∎

131

Stephanie Barber is a multi-media artist who creates meticulously crafted, odd and imaginative films and videos as well as performance pieces that incorporate music, literature, video and anything she is thinking about.

'The door closes on John Wayne's wounded conscience.'

The Searchers

MICHAEL ALMEREYDA

Most great films have great endings, that kind of goes without saying. *The Searchers* (1956) probably has one of the greatest endings of all time. The door closes on John Wayne and his wounded conscience and his alienation and his bravery, and that's a great ending.

I think I was a teenager when I first saw it. My family moved from Kansas to California and that was when I got interested in movies because there were more TV stations there and they would play old movies on TV. People like Howard Hawks and Alfred Hitchcock were still alive and speaking. They appeared at the local LA arts museum and a lot of that rubbed off on me. I must have seen *The Searchers* at one of those showings.

It's a very American film, but it's also a film that acknowledges and reels from these huge questions of genocide and race. It's in some ways an ugly film – the ground is really smoking in that film, it's not a pretty picture. It's not a simplistic picture either and it's not the John Wayne that people tend to caricature and dismiss either as an actor or as a presence. ■

133

Michael Almereyda is the director of the dreamy vampire tale *Nadja* (1994), a contemporary reworking of *Hamlet* (2000) and the lyrical travelogue *Paradise* (2009).

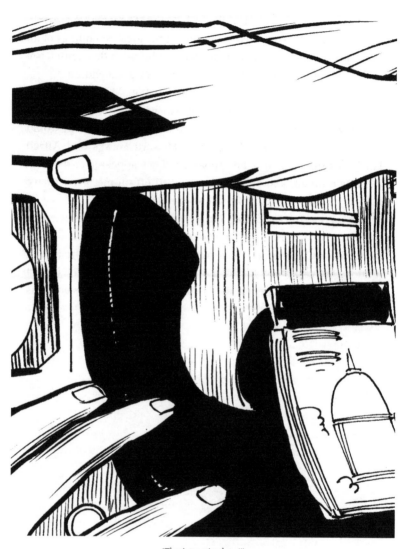

'That's it, we're done!'

United 93

MARC PRICE

The final shot of Paul Greengrass's *United 93* (2006) undeniably stands out, not just because of the obviously weighty subject matter, but because it serves as punctuation for an intense sequence, ending a superbly crafted film.

I'm not a morbid 9/11 fanatic, but I learned through newspaper articles and the odd documentary that, among other things, there isn't any evidence to support the idea that German passenger Christian Adams refused to participate in the revolt and that there is some debate as to whether the passengers made it into the cockpit to wrestle control from the terrorists. But these creative departures are the differences between United 93: The Flight and *United 93*: The Film.

Greengrass's film blisters with an emotional truth, beautifully realised notably through its engaging hand-held style and casting of non-professional actors (who in many cases were re-creating their experience on the morning of 9/11) alongside seasoned performers.

At its core the film is about communication. The Federal Aviation Administration, air traffic controllers and the military all struggle to comprehend what is happening where and how. It all ends in chaos and confusion when FAA National Operations Manager Ben Sliney (playing himself, in one of the film's most powerful moments) decides to shut down the entire US airspace. He leaves the movie, declaring: 'That's it, we're done!'

The tail section of United 93 becomes a hub of information where the passengers work out their likely fate, which ultimately leads to their decision to act.

135

That last shot of hands grappling for control of the plane, followed by the vertiginous image of the sky rolling over to reveal green fields rushing towards the camera before a heart-arresting cut to black an instant before impact, is possibly a creative liberty. But it is one of the most perfect closing shots. ∎

Marc Price is the director of the inventive DIY horror movie *Colin* (2008), which adopts the point of view of a novice zombie as he wanders melancholically around a devastated London.

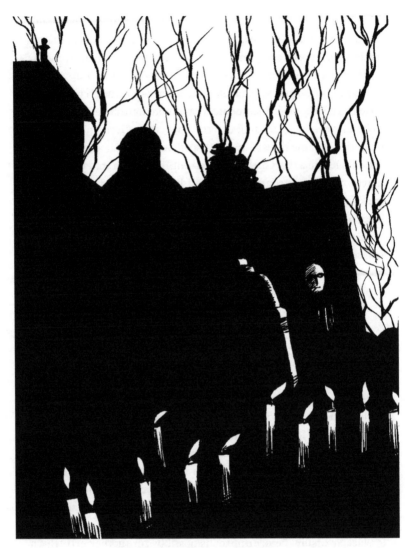

'The dirt bites. The fingernails crack. The lamp glows.'

The Hourglass Sanatorium

GREG MCLEOD

The final shot of Wojciech Has's *The Hourglass Sanatorium* (*Sanatorium pod klepsydra*, 1973) is beguiling in the sense that it is ambiguous, it asks questions.

The notion of time is challenged throughout the film and the final shot offers a possible answer to Joseph's journey. His need to have time with his father, his sadness at his mother's lack of interest in him.

And so... Joseph...

...fingernails dirty and encrusted with regret and remorse. Time here is undisciplined, jumps up and bites, twists and turns, plays tricks and deceives. The dirt and the dark that reveal an imagined, dreamed reality. A reality that located Joseph in his father's memories. Time here plays tricks when it's freed from reality. His father spread about him, youthful then ancient and decrepit, and now finally dead.

The dirt bites. The fingernails crack. The lamp glows.

Joseph's stolen sight.

A conductor with no carriage, no passengers.

Black fingernails drag Joseph high over the discarded gravestone. Lingering foliage brushes and scrapes as he climbs. Then out and up into a forest of orange candles sharp silhouettes of barren trees ancient unreadable graves and the looming sanatorium.

The sanatorium... His destination? Like father like son?

Unseen to Joseph, his mother always so distant is now close. Unmoving, barely distinguishable from the surrounding stones.

His mother rapt with grief for her husband, does not see her son.

Joseph blind and broken, haunting, tentatively treads through the candles and broken black branches, and so to the sanatorium and so to the darkness of the grave.

Joseph finally abandoned by his past, by his mother and father. Abandoned by his time. His identity shattered. The sanatorium his only possible destination.

Like father like son. ∎

137

Greg McLeod is one half of animation team The Brothers McLeod. Their latest film, the Gothic fairy tale *The Moon Bird*, was selected by the Edinburgh International Film Festival in 2010.

'Outside thought, outside time.'

2001: A Space Odyssey

ASIEL NORTON

I have seen *2001: A Space Odyssey* (1968) countless times. It is a film I remember pondering about and debating with my family since childhood. Like *8½* (1963), *Persona* (1966), *Citizen Kane* (1941), *Andrei Rublev* (*Andrey Rublyov*, 1966), *The Passion of Joan of Arc* (*La passion de Jeanne d'Arc*, 1928), it is a film that I'll never miss if I see it is playing on the big screen.

The Star Child may be the most ambitious and spiritual final moment in film history. Cinema is an art of images. The best images are metaphors that strike us deep in our soul and our psyche. Art is the means by which we create and communicate mythology, and mythology, among other things, reminds us of the transcendent mystery that is all life, and connects us to that mystery. In *2001* we have the perfect modern myth, and in the Star Child we have the perfect mythological symbol of man's rebirth into the scientific age. It is a symbol that is at once classically timeless, yet incredibly modern. Like all great mythological symbols, it is an image that at once shows us the mystery of our being, and connects us to that mystery, yet its elements of space, the planets, the globe and the wise foetus could be of no other time. Also of our time is the fact that this all-knowing state was not reached through prayer or some godly father figure, but through intellect and the tools of the modern era. The highest function of art is to connect the viewer to a consciousness that transcends their own limited experience, to put them in a state of stasis. Outside thought, outside time. To me, the last 30 minutes of *2001*, culminating with the Star Child drifting through space in a resplendent sphere of light, is the embodiment of this in movies, and therefore perhaps the pinnacle of cinematic art. ■

139

Asiel Norton is the director of *Redland*, a rugged poetic tale of forbidden love, family relationships and hunger in the mountain wilderness of Depression-era America, which won the award for best debut feature at the Raindance Film Festival in 2009.

Still from Henri-Georges Clouzot's Inferno I **PARK CIRCUS**

ENDLESS VISIONS:
Henri-Georges Clouzot's
Inferno

VIRGINIE SÉLAVY

The history of cinema is littered with unfinished grand projects by megalomaniac directors, including Orson Welles, Stanley Kubrick and Erich von Stroheim. That Henri-Georges Clouzot should be added to this list may seem, at first, surprising. One of France's greatest directors, he established his reputation with tight, economical, superbly crafted crime thrillers made throughout the 40s and 50s. But in 1964, he embarked on the filming of *Inferno* (*L'enfer*), a formally

inventive story of obsession and jealousy featuring one of the leading stars of French cinema, the beautiful Romy Schneider, and the craggy-faced Serge Reggiani as her increasingly paranoid husband. It was a huge production on a scale unprecedented in French cinema, with the financial means provided by the American studio Columbia. But after only two and a half weeks of a difficult shoot, Reggiani fell ill, Clouzot had a heart attack, and the project was halted. The story of this disastrous production is told in Serge Bromberg's documentary *Henri-Georges Clouzot's Inferno* (2009), made after a chance encounter with the director's widow, Inès Clouzot, led Bromberg to unearth the 185 cans of unexposed film that had lain dormant in an archive for the past 45 years. The documentary describes the making of 'a film that wanted to revolutionise cinema', and it reveals Clouzot as a bold, risk-taking innovator rather than the old-school craftsman derided by the *nouvelle vague*. Now, the only way to see the extraordinary images of this unfinished masterpiece is in Bromberg's film.

Clouzot's phenomenal ability to create tension on screen was such that it made Hitchcock tremble for his title of Master of Suspense, and the first part of Clouzot's career shows a supreme command of the classic filmmaking style predominant at the time – thorough storyboarding, carefully composed shots, elaborate editing. This is best seen in his showbiz-set murder mystery *Quai des Orfèvres* (1947), the international hit *The Wages of Fear* (*Le salaire de la peur*, 1953), the superb *noir Les diaboliques* (1955) and the exceptional *The Raven* (*Le corbeau*, 1943), a spectacularly dark study of toxic suspicion and moral decay set in a small town plagued by anonymous poison pen letters.

Although Clouzot had found success with those films, he started exploring different directions in the 1950s, starting with the documentary *The Picasso Mystery* (*Le mystère Picasso*, 1956), in which he filmed the artist at work. The following year, he experimented with fiction in *Les espions*, an absurdist spy thriller in which the agents no longer know who they are working for in a world where all is illusion and lies. This was followed by *The Truth* (*La vérité*) in 1960, which sees Brigitte Bardot's Dominique accused

of the murder of her lover. During the trial, her life is dissected and interpreted in divergent ways by the prosecution and the defence, constantly changing our perception of her character.[1] Clouzot's desire for a new kind of filmmaking, the recurrent theme of shifting truths, and his interest in other art forms would converge in *Inferno* a few years later.

By the time Clouzot came to make the film, it is clear that he had paid attention to the radical innovations that revolutionised cinema in the 1960s. Director Costa-Gavras, who worked as assistant director on *Inferno*, says in Bromberg's documentary that Fellini's *8½* (1963) had opened up Clouzot's eyes to new possibilities: it was 'the birth of a cinema that was something else entirely. *L'enfer* for Clouzot was the desire to make another kind of filmmaking'. His vision of the different type of cinema he was searching for was strongly influenced by other art forms. According to Bernard Stora, intern on *Inferno*, Clouzot was very interested in pictorial and musical pursuits and felt that cinema was lagging behind. The project of *Inferno* was to 'elevate' cinema.[2] For this, he drew in particular from electronic music and the serial work of contemporary composer Pierre Boulez as well as Op Art and kinetic art, more specifically the work of Victor Vasarely and Jean-Pierre Yvaral.

Inspired by the ground-breaking artistic developments of his time, Clouzot started doing tests for *Inferno* on a scale unheard of in French cinema. He had his team working on unusual special effects, building a rotating wheel to light the actors, devising a complicated

143

1 *The Truth* dramatises generation conflict but although the film is sympathetic to the youth, it did not stop Clouzot being singled out by the *nouvelle vague*'s young guns as an example of the antiquated filmmaking they wanted to get rid of. This view of Clouzot has unfortunately shaped the critics' perception of his work and may be the reason why he has been unjustly neglected. But while the majority of the *nouvelle vague* filmmakers became increasingly conservative as they got older, Clouzot showed a remarkable willingness to take risks and to experiment in the later part of his career. Ironically, Claude Chabrol's version of Clouzot's *Inferno*, released as *Hell (L'enfer)* in 1994, is a blatant example of this: stripped of all of Clouzot's formal experiments, it is a conventional psychological drama.

2 Serge Bromberg, *They Saw the Inferno (Ils ont vu L'enfer)*, extra feature on the DVD of *Henri-Georges Clouzot's Inferno* (Park Circus, 2009).

colour inversion process and filming an exhibition of kinetic art at the Museum of Decorative Arts. There were make-up experiments involving blue lipstick and olive oil. Electronic music composer Gilbert Amy, an associate of Pierre Boulez, was hired to work on sound. As described in the documentary, the Boulogne studio where the tests took place was buzzing with feverish, if somewhat unfocused, activity for several months.

After seeing the initial tests, a handful of Columbia executives gave Clouzot an unlimited budget. This was a unique situation, as Stora points out: 'What makes [*Inferno*] (...) something rare in cinema, is that the means, the money, weren't there to have 100,000 horsemen or build huge sets. (...) It was to give a creative artist, Clouzot in this case, the possibility of freely experimenting, of freely searching, to tame ideas gradually, to see if they came or not.'[3] But combined with Clouzot's colossal ambitions, his obsessive perfectionism and the lack of a completion date for the project, it was a recipe for a grandiose disaster.

There was an additional difficulty. After months of searching, Clouzot had chosen as his setting a hotel by a lake under the Garabit Viaduct in the Massif Central, a huge railway bridge constructed by Gustave Eiffel (itself a madly ambitious, difficult project in its day). The lake had been artificially created and was due to be drained to generate power by the electricity company 20 days after shooting began. Clouzot knew this, but wanted no other setting. In order to make sure the exterior shots were completed before the lake was emptied, it was decided to shoot with three crews – again, something French cinema had never known. Clouzot had the best technicians in the industry, the best equipment, and even an old steam train, which the train company put back on the railway line just for him...

Perfectionism, visionary dreams, unlimited means... All was set for an impossible production, an unfinishable film.

144

3 The translation given in the documentary was altered slightly to reflect Stora's choice of words more accurately.

'PRISONER OF AN IDEA GONE MAD'

Bromberg's documentary tells the story of two parallel obsessions: the failed shoot, narrated through testimonies of Clouzot's filmmaking crew, and *Inferno*'s tale of insane jealousy, reconstructed using footage and test images (the missing parts of the story are filled in by scenes of two actors performing the script in a bare setting). It charts the obsessive creation of a work that itself is possibly the ultimate filmic expression of obsession.

if it is true that

Jealousy and obsession are thematic threads that run through the whole of Clouzot's work. *Quai des Orfèvres* features a flirtatious chanteuse and her intensely possessive husband. *The Raven* is spurred to write poison pen letters partly by jealousy. *Les diaboliques* is a story of vertiginously twisted marital betrayal while in *The Truth*, Bardot's character is driven to murder after her lover abandons her for another woman.

Clouzot was

each of his

heroes in turn

With *Inferno*, it is as if this theme became more personal and Clouzot's own obsessive personality converged with that of his character, Marcel.

'Hell is being prisoner of an idea gone mad that lives in you, without you being able to control it. And if jealousy is a prison, perversion is another. So *Woman in Chains* could have been called *Hell* [*L'enfer*](...) I went through many difficult moments of this kind, and like Flaubert in *Madame Bovary*, I am not ashamed to admit that I am, or rather, I have been successively each of my heroes.'[4]

145

These words were pronounced by Clouzot in 1968 on the occasion of the release of *Woman in Chains* (*La prisonnière*), a film that directly followed *Inferno* and took up many of its themes and visual experiments. And if it is true that Clouzot was each of his heroes in turn, nowhere is this more clearly discernible than in his two final fiction films. While Marcel is almost like a filmmaker in the way he

4 Henri-Georges Clouzot in an article by J. Baroncelli, *Le Monde*, 22 November 1968, quoted in Philippe Pilard, *H-G Clouzot* (Editions Seghers, 1969), p.108. My translation.

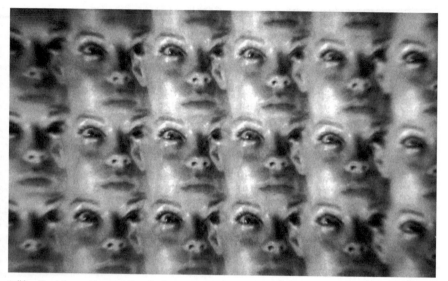

Still from Henri-Georges Clouzot's Inferno *(Park Circus)*

creates visions, *Woman in Chains'* art collector Stan gives orders to a crew of fractious artists as they prepare for an exhibition as if he was directing on a film set. Strong, domineering and cold, he brutalises people, especially women, in the name of art. He is presented as a failed artist as well as an emotionally repressed man, and both things are connected through his 'hobby': making nude photos of women in bondage. If this is really a self-portrait, it is merciless, and for that it is an all-the-more poignant depiction of the chains that bound Clouzot himself.

By naming his characters Marcel and Odette in *Inferno*, in reference to Proust, Clouzot instantly indicates the nature of their relationship: a somewhat deluded man infatuated with a sensual, maddeningly unattainable, unknowable object of desire. Marcel's jealousy is caused by Odette's relationship with Martineau, the town's mechanic and local stud (Jean-Claude Bercq), but also with her sassy, sexy hairdresser friend Marylou (Dany Carrel). Who is Odette? A loving, faithful wife or a promiscuous temptress? How can we know for sure? The impossibility of answering that question with any certainty drives Marcel to distraction.

The images of *Inferno* that appear in Bromberg's documentary are evidence of a feverish creative effort to find new visual ways of representing obsession. Jealousy distorts Marcel's perception of reality and the film shifts from the black and white of ordinary life to the colour of his lurid fantasies. Faces are stretched and deformed or cut up into close-ups of eyes, mouths and noses. These are sometimes multiplied to create an endless pattern of body parts, their abstract quality contrasting with slight movement or breathing. These strange landscapes of flesh are paralleled by abstract patterns borrowed from Op Art, for instance flashing red, blue and black concentric squares, a red-tinted grid which the camera zooms in and out of, white balls moving mechanically inside a mirrored square box, reflected and multiplied. There are also multitudes of faces revolving and the startling image of an eye made of a circle of eyes, turning infinitely. These perpetual movements and endless patterns drag the viewer into the repetitiveness and circularity of obsession.

The zooming in and out of geometrical forms also conveys the notion of being 'prisoner of an idea gone mad' in another way: in the diseased jealous mind, everything becomes sexual. First assistant operator William Lubtchansky recounts that, as cinematographer Andreas Winding was lighting an abstract image of triangles, Clouzot said: 'No, Andreas, the left thigh should stay in the shadow.' Lubtchansky concludes: 'So he really saw something else, something very sexual on something that apparently was not. (...) I'd become the specialist of optical coitus. He had me zoom in and out, faster and faster (...) like in coitus, to reach the final orgasm.'

What can be seen of *Inferno* in Bromberg's documentary is indeed an extraordinarily sensual, almost tactile film that probes the very texture of desire and jealousy. There is a lot more nudity than in any of Clouzot's previous films; of course, this is partly due to the more liberated times in which *Inferno* was made, but it is also as if Clouzot was cinematically discovering the human body, giving the film the intensity of a first sexual experience. Romy Schneider is explosively beautiful, emerging from the lake slowly swaying her hips on jet-skis like a triumphant goddess of sex. In other scenes, the olive oil and

147

glitter used as make-up on her face make the golden smoothness of her skin almost palpable. Soft flesh is contrasted with hard metal: in one of the most magical sequences in the film, Schneider, lying on a bed, moves a metal spring up and down her body by gently shifting her hips. It is both charmingly playful and incredibly erotic. But the juxtaposition of flesh and metal can also convey the aggressiveness of desire: in another sexually charged scene, she is tied half-naked on railway tracks as a train speeds towards her, a cloud of white steam jetting from its chimney – echoed in the white cigarette smoke she blows out of her mouth in other scenes.

Flesh is also set against transparent material that both reveals and conceals the female body. Schneider appears wrapped up in a plastic sheet tied around her neck, as if she was a sweet or a doll (and the shot ends with two hands coming up from behind and strangling her; when the man behind her walks off, it looks like it's Clouzot himself). Dany Carrel is filmed almost naked underneath a plastic coat, moving her hips suggestively, the camera lovingly capturing the curve of her breast and the undulation of her belly under the plastic. In other scenes, Marcel reaches out to a sleeping Odette, but his hands are stopped by an invisible wall, as if she was under a glass dome. There are also sequences in which a sheet of water drips in front of a shot of Odette and Marcel, or Odette and Martineau, the image washed away, their bodies dissolved in the water. This startling juxtaposition of the desired body with plastic, glass or water creates a terrible sense of longing, a painfully heightened perception of both the body's utter unattainability and unreality as well as its flesh and physicality.

Through these images, *Inferno* constructs a territory of uncertainty: 'Instability was what we wanted to provoke: the non-visual security of people who look at something and the denial of visual logic,' says visual artist Joël Stein. The reality of everything, the 'truth' of everyone is questioned. The make-up emphasises the unreliability of how we perceive the characters – blue-grey make-up gives Schneider an almost malevolent look that contrasts with the softness of her face in the black and white of daily life. The blue lipstick underlines her sensual mouth while making it

Still from Henri-Georges Clouzot's Inferno *(Park Circus)*

look like a forbidden, poisonous fruit. There are also shots of split faces monstrously made up from those of two characters: Odette and Marylou, Marcel and Martineau, but also, more disturbingly, Odette and Martineau and Odette and Marcel. All the combinations are possible, this seems to say: lovers are interchangeable. Worse than that, it suggests that none of the characters' identity is secure.

Crucial to this atmosphere of instability is the use of light. Before working on *Inferno*, Clouzot had seen *Images du monde visionnaire*, made by Henri Michaux and *Inferno* special effects man Eric Duvivier in 1963. The film was about Michaux's drug experiences and the hallucination sequences had so impressed Clouzot that he decided to apply the same filmmaking technique to human faces. This is what gave him the idea of the rotating wheel; it could be made to turn slower or faster and with different coloured lights, and the corresponding modification of the actor's face conveys the supreme strangeness and unknowability of the other. The light rotating on Schneider animates her face with an alien life, a life that is not hers, changing both her expression and our impression of it as it turns. The effect is startling and it introduces a certain

149

fluidity and slipperiness in the perception of the characters, of Odette in particular: Marcel can never quite grasp her, figuratively and literally.

While the elaborately fashioned visuals are truly exceptional, we learn in Bromberg's documentary that sound was meant to be as crucial an element in the film, if not more so: according to Gilbert Amy, Clouzot wanted sound to be 'the mainspring of the film', and the starting point of the images – Marcel's nightmares are triggered by the train whistle, for instance. Only one sound reel of tests was found, and it suggests that Marcel's monologues were constructed almost like experimental musical pieces, with the reiteration of words and phrases and the voice distorted as if redoubled, but out of synch by a tiny fraction of a second. In one instance, the voice repeats endlessly: 'I'm not a madman. I'm not a monster or a madman.' Another section of the monologue exposes the frighteningly twisted logic of the obsessive mind: 'Well, maybe that arouses you? We play bitchy mama. Hanky-panky, titty-titty, bang-bang, clickory-clock. You bitch! Hell, he's married. All the more reason to be two-timed. Let him feel her up, stick in things lying around. There's no risk, it leaves no trace, no fingerprints. Just a kid sometimes, as a souvenir. Wait, bitch. I have my key. You're gonna get locked up. Double lock. Gotcha, old girl.'

The maniacal torment evident in these lines is made all the more affecting knowing that it is Clouzot's voice reading them for the sound tests. And just as Marcel ceaselessly replays his fantasies in his head, Clouzot, plagued by insomnia and anxiety, would rewrite the dialogue at night during the shooting at Garabit, and compulsively re-shot scenes that had already been filmed again and again, even as the crew and actors around him became increasingly frustrated with the lack of progress, even as the date the lake would be drained neared irremediably.

Clouzot, plagued by insomnia and anxiety, would rewrite the dialogue at night

THE CLOUZOT MYSTERY

Clouzot's behaviour on the set seemed so incomprehensible that some of the crew members wondered whether the director really wanted to finish the film. Is it possible to imagine that he somewhat

perversely headed for incompleteness? Is it that he so wanted the film to be 'his ultimate achievement', as Bromberg says, that he could not finish it? By making the scale of the production so enormous but choosing a location with a very finite expiry date, did he more or less consciously ensure that the film simply could not be completed?

Or was Clouzot pushing himself to the limit with such a set-up, just like he did with everybody else, to see what would come out of it? His infamous treatment of actors, which involved slapping Suzy Delair and Bernard Blier on the shoot of *Quai des Orfèvres*, for instance, or surreptitiously feeding sleeping pills to Bardot on *The Truth*, seemed to have been motivated by the desire to get the very best performances out of them: 'He pushes people to the extreme so that people would either break down or... And if they do, he's happy and he would say, "Let's shoot,"' says script supervisor Nguyen Thi Lan in the documentary. On the shoot of *Inferno*, he made Serge Reggiani run behind the camera for miles and miles until he was utterly exhausted while Dany Carrel had to repeat a scene in which she was slapped on the bum until she was purple. Is it possible that he applied the same principle to himself, and with *Inferno* tried to push himself to breaking point to see if he could produce his best work?

Some of the documentary's participants remark on Clouzot's strange indecisiveness on *Inferno*, which contrasted so strongly with his supreme competence and efficiency in the early part of his career. This may be because with *Inferno* Clouzot's view of the film director seems to have shifted from craftsman to artist. The trigger for this may have been *The Picasso Mystery*. In this unique documentary, Clouzot probed the enigma of artistic creation by placing a camera behind a transparent canvas on which Picasso painted: the screen is equated with the canvas and what we see unfold is the drama of creation, brush stroke after brush stroke. The colour paintings are interspersed with black and white shots of the studio, a combination Clouzot would use again in *Inferno*. While the earlier paintings are fairly simple, the later paintings show an extraordinary process of transformation: *The Dreaming Woman* starts stretched out, but ends

up in a crouching position in the finished work. *On the Beach No 1* goes through many metamorphoses as Picasso repeatedly paints over what he's already done, magically transmuting the figures in a joyous creative explosion. This is a thrilling conclusion to the film, and one that prompts the question: when is the work of art finished? This was clearly a central concern for Clouzot, as the principle of the film demonstrates: it was agreed that all the paintings created by Picasso would be subsequently destroyed, so that they exist only in Clouzot's film.

In a similar way, *Inferno* now only exists in Bromberg's documentary. The documentary is itself the record of an extraordinary moment of creation, and this gives another meaning to the sexual imagery of the film. Watching the images recorded in Bromberg's documentary feels like being plunged into a bubbling volcano of creative energy on the verge of eruption. It is possible that *The Picasso Mystery* disturbed Clouzot's previously held view of what a film and a filmmaker were to such an extent that he no longer knew where the process of creation ended. 'He had consciously taken the risk of searching but with 100 people around him. Which was a courageous enterprise but an extremely risky one. He deliberately put himself in danger,' says Stora.

The experiments of *Inferno* were not entirely lost: they later found their way into *Woman in Chains*. The film's central female character, Josée, starts an unusual relationship with Stan after her sculptor husband sleeps with a journalist on the opening night of a kinetic art exhibition. When Stan shows Josée his S&M photos, she is both disgusted and attracted by them, and she is gradually drawn into his world of sexual perversion. The exhibition shows the kinetic art that inspired *Inferno*, and there are similar images – moving mirror strips hanging from the ceiling, a curtain of glass circles, white balls rolling inside a mirrored box. Josée discovers Gilbert flirting while she is wandering through a maze in the exhibition, the art installation creating kaleidoscopic images of her and Gilbert with the girl multiplied and cut up against black brick walls, recalling Marcel's distorted view of reality when in a jealous fit. One of the S&M photo shoots involves Dany Carrel gyrating,

Serge Bromberg's Henri-Georges Clouzot's Inferno is available on DVD from Park Circus.

152

half-naked in a plastic coat, while Stan snaps her, faster and faster – a photographic coitus. The astonishing final sequence (which has been described as 'psychedelic') shows the nightmares of the comatose Josée, a montage of flashes of colour, composite faces, red and blue concentric squares, rotating light on multiplied close-ups of eyes and images of Josée tied up in chains. Obsession is here male and female, and both Josée and Stan are 'prisoner(s) of an idea gone mad'.

Woman in Chains is a remarkably inventive and daring film, and yet, it is not as satisfying or as madly creative as what remains of *Inferno*. The dialogue seems strangely stilted, the references to art are too self-conscious. It feels crushingly personal and not quite fully controlled, the balance between the more experimental, purely artistic elements and the narrative not entirely successful.

In contrast, *Inferno* has the quality of the unfinished: it has no filler scenes, no narrative line to follow, no dramatically important but dull sequences; it is a film made only of climaxes. What Bromberg documents and renders visible is a unique moment of pure creation, one of those wonderful, exhilarating moments of cinematic insanity, of quixotic persistence in the face of untameable realities, a boat over the mountain moment, as Stora understood: '[Clouzot] taught me (...) [that] you have to see your madness to the end (...) you have to take responsibility to the end. At some point, everyone wonders, "Where is he going? Into a wall." That's the moment when you have to keep going.' ∎

154

'Anyone who has not been Born Again is Left Behind.' | MARK STAFFORD

JESUS REBOOTED, JESUS FREEBOOTED:
David W. Thompson's apocalyptic evangelical cinema

MARK BOULD

For the longest time, I could only recall two movies ever giving me nightmares. That shot in *Carry on Screaming!* (1966) when Oddbod shuffles over the glass-tiled ceiling of the underground conveniences of Dan Dann the lavatory man (hey, I was four). And *Apaches*, the notorious Public Information film about the dangers of playing on farms. Specifically, the POV of the kid drowning in a slurry pit. I was nine. And this shot does not actually exist.

FEATURING

The Second Coming
The Tribulation
The False Rapture
Tank Girl Jesus

But last summer I discovered that for 30 years I have repressed the memory of a film that absolutely terrified me. You see, I managed to get my hands on a copy of Donald W. Thompson's Christian apocalyptic *A Thief in the Night* (1972).

And it all came flooding back.

The church hall. The haranguing evangelist. The emotional manipulation.

The break from this horrorshow for a film that I thought might offer some respite.

I was wrong…

The Bible says that Jesus will return 'as a thief in the night'. This does not mean that he will be in top hat, tails and domino mask, but that his reappearance will happen when least expected. Nevertheless, for a century and a half, 'dispensationalist' Protestants have, with a remarkable blend of dogmatism and imagination, produced interpretations of biblical prophecy that 'prove' The End Is Nigh. Fictionalised versions go back at least as far as R.H. Benson's 1907 novel *The Lord of the World*, in which a beleaguered pope organises secret resistance to an American antichrist, but this predominantly Protestant genre is much more likely to identify the antichrist with Europe and the Vatican.

In the 1970s, Hal Lindsey's *The Late Great Planet Earth*, a pop-explication of biblical prophecy, sold 28 million copies, prompting similar volumes and fictional treatments to proliferate, such as Stanley A. Ellisen's 'non-fiction' *Biography of a Great Planet* and Carol Balizet's novel *The Seven Last Years*. Hollywood knows a bandwagon when it sees one. While *The Omen* was busy grossing $60 million, a couple of low-budget, Christian filmmakers were quietly toiling away in Iowa to scare the crap out of me.

Thompson's apocalyptic quartet – *A Thief in the Night* is followed by *A Distant Thunder* (1978), *Image of the Beast* (1980) and *The Prodigal Planet* (1983) – starts with the Rapture, when True

Believers are whisked up into heaven. Anyone who has not been Born Again is Left Behind. The films chart the ensuing seven years of Tribulation as the antichrist rises to global power, and end as the battle of Armageddon kicks off. They were produced by Russell S. Doughten Jr, who started out making *The Blob* (1958) for the secular division of a Christian production company. After a fitful, marginal Hollywood career, he returned to his native Iowa, where since 1972 his companies have produced 20 or so issue-orientated, intentionally didactic, evangelical feature films. His website boasts: 'Over 6 million have come to Christ through our motion pictures.'[1] My anecdotal evidence is every bit as dodgy as his statistics, but something of the under-the-radar reach of these films is surely indicated by the fact that I was subjected to one of them in the late 1970s.

an earnest young evangelist propounds biblical prophecy to the folk-rock stylings of The Fishmarket Combo

By stick-in-the-mud Methodists.

On Dartmoor.

A Thief in the Night begins with a dark screen and a ticking clock. Patty wakes up in an empty bed. The radio announces that 25 minutes earlier millions of people suddenly disappeared from all around the world. She staggers into the bathroom, in search of her husband Jim, but finds only his razor. The Rapture has happened.

The film goes back to before Patty and Jim started dating. As college-age kids, their summer of fun involves Des Moines' zaniest fun spots: a lake, a carnival, a youth centre where an earnest young evangelist propounds biblical prophecy to the folk-rock stylings of The Fishmarket Combo. While her friend Diane encourages Patty to hang out with boys, another, Jenny, is born again. Time passes, couples form. Not particularly stylish Iowans sport 70s fashions and hairstyles and British-looking teeth. They sit around talking about Jesus and stuff.

One day, Jim is bitten by a cobra. There is no anti-venom. His only

157

1 www.rdfilms.com.

hope is a blood transfusion from a snake farmer who has survived similar attacks. While Jenny prays, cross-cutting suggests that divine intervention gets the snake farmer's plane there in time. Months later, being reminded of this 'miracle' is enough to persuade Jim to be born again.

The very next morning, Patty wakes up in an empty bed...

The evil new world government (the United Nations Imperium of Total Emergency) replaces money with a credit system that requires people to be tattooed on the forehead or the hand with a pattern of zeroes and ones – 666, the Mark of the Beast, but in binary, so no one will know that UNITE represents the forces of Satan. Refuseniks are 'subject to arrest and prolonged inconvenience'.

UNITE are after Patty because of her (belated) faith in Jesus. She flees town, making it to the dam, where Diane and her husband will pick her up and rescue her. But wait! They both bear the Mark of the Beast!

Patty backs away, falls from the dam...

And wakes up in an empty bed...

The clock is ticking.

A Distant Thunder follows Patty's experience of the Tribulation, and ends with her strapped to a UNITE guillotine for refusing the tattoo. *Image of the Beast* opens with a fabulously extended revision of her death. Before the executioner can do his job, the skies blacken and an earthquake sends everyone running. She is left strapped to the guillotine, face up, struggling to untie her bonds as the tremors gradually loosen the catch holding the blade in place.

The narrative focus shifts to David, who is plotting to disrupt UNITE's computer system. He is played by William Wellmann Jr, who has more acting credits than the entire cast of the four movies put together, and even contributes 'additional story material' to *The Prodigal Planet*, the longest and dullest of the series, an even poorer man's *Damnation Alley* (1977).

159

'Jesus is foul-mouthed and loves making lines from the Bible her own.' | MARK STAFFORD

Although the later films more closely approach professional norms, the first two remain the most intriguing. In them, Thompson's grasp of cinematic possibilities is strongest. This is most evident in the claustrophobic narrative structure that entraps Patty, and in *A Thief in the Night*'s long-lensed shot in which she runs – seemingly for ever – towards the camera to Fishmarket Combo's refrain, 'You've been left behind'. And they are also the films in which there is the greatest gulf – often hilarious – between Thompson's cinematic smarts and what the budget will permit. There is the music ripping off the theme from *Where Eagles Dare* (1968), used without attention to aptness or effect; the weird associative editing (on being born again, Jenny says she feels like she can fly; cut to the carnival's helicopter, flying; cut to a fly on a kitchen window that Patty swats); the horror set-ups without pay-offs (in *A Distant Thunder*, Patty finds Grandma's house unlocked, walks up dark, Dutch-angled stairs, pushes open Grandma's bedroom door and screams in terror – only for the reverse shot to reveal *a phone that is off the hook since Grandma was Raptured mid-call*).

And there is the sequence in *A Thief in the Night* that begins with a preacher's anecdote about a woman who woke up thinking the Rapture had happened because her husband had gone downstairs to get a drink. The camera zooms in over the congregation onto the face of the young Sandy. She returns home, but no one is there. She calls and calls. No reply. A rapid montage of growing panic... and then her sister and mother suddenly appear. They are fine. But it looks a lot like a prank gone wrong. And it terrorises Sandy into being born again.

While such moments (now) seem funny rather than scary, one sequence in *The Prodigal Planet* remains truly – if unintentionally – horrific. All attempts to get the imprisoned David to betray fellow-hacker Cathy have failed. UNITE personnel threaten to harm her four-year-old son, Billy, if David won't speak up. He hears someone being taken to be executed, the *whirr-thunk* of the guillotine blade. Through his window bars, he sees Billy's red balloon drifting into the sky.

160

But wait! Billy is OK!

He's not been executed. He gave his balloon to that nice lady, Leslie, who told him all about Jesus, and it is she who was guillotined. David – apparently forgetting that Leslie is his sweetheart – is relieved. He doesn't have to betray Cathy. Thanks to Leslie, Billy was born again, so now it's perfectly alright for UNITE to decapitate him.

Since the 1970s, such fiction has become commonplace. Among others, Pat Robertson, who once campaigned to become the Republican presidential candidate, reputedly intending to launch a nuclear war so as to prompt the Second Coming, wrote *The End of the Age*; and Hal Lindsey, who spent 2008 warning voters that Barack Obama might be the antichrist, gave us *Blood Moon*. Films include *Years of the Beast* (1981), *Vanished* (1998), *The Moment After* (1999), *The Omega Code* (1999), *Gone* (2002) and *Six: The Mark Unleashed* (2004), some of them with sequels. The greatest commercial success has been Tim LaHaye and Jerry B. Jenkins's 16-book *Left Behind* series (1995-2007), selling over 60 million copies. Franchised spin-offs include nearly 50 other novels, mostly for teenagers, 10 graphic novels, three video games and three movies. Typical of these works' smug spite is the defence offered when the video game *Left Behind: Eternal Forces* was criticised for promoting violence against non-Christians: it was claimed that the game taught pacifism because if the player chooses to shoot rather than convert a non-believer, he must pause to pray in order to regain lost 'spirit points'. Still, it's nice to see Christians treating prayer as a penalty. And there *is* an option to play on the antichrist's side.

161

Clearly a lot of money can be made from apocalyptic Christianity, so I want to pitch my own End Times movie. The Rapture does not take everyone who expects to be swept up, just the downtrodden of the Earth who deserve to be somewhere better. No misogynists or homophobes or white supremacists. No advocates of the silver ring thing or the *Twilight* franchise. None of those who think there is a liberal media, and sometimes even suspect Fox News is part of it. The Christian right, its ranks undepleted, begins to talk about the

False Rapture (seriously, google Project Enoch) and precipitates the world into war.

The second act, set some time later, has a kind of *Red Dawn* scenario. A handful of decent people fighting the fundamentalist Army of God. Jesus returns and joins the resistance. Oh, and Jesus is a girl. Of mixed race and ambiguous sexuality. A dark-skinned cross between Tank Girl and Ellen Page, who sounds like Holly Hunter playing white trash. Christian Bale is her intense dad and says intense dad-like things: 'No daughter of mine is going out to battle the forces of evil dressed like that! And be home by midnight.'

Jesus is foul-mouthed and loves making lines from the Bible her own. There's this scene in which the Army of God destroy the resistance headquarters, leaving the barely alive Bale mangled in the rubble. And she faces them down: 'I am the way, the truth and the life, motherfuckers' – *ch-chunk* of pump-action shotgun being pumped – 'and no one gets to my dad except through me'.

The third act is still a bit hazy, but Jesus teams up with the antichrist to overthrow both God and the devil.

Though I can leave it open for a sequel. And if we pitch it to Michael Bay, I can play up the horror elements. My nightmares are no more pathetic than his horror remakes. ■

Detail from Heavy Rain *poster* I QUANTIC DREAM/SONY COMPUTER ENTERTAINMENT

END GAME:
Interactive films

TOBY WEIDMANN

Only a couple of decades ago, comparing films and video games would have been an exercise in futility simply because the connection between the two was negligible at best. The relationship was not good: the films based on video games were predominantly embarrassing (the dismal *Lara Croft: Tomb Raider* [2001] is the most successful video game-to-film adaptation, and widely considered the best of the bunch!) while licensed video game tie-ins often had little in common with their film counterparts – a game

such as *X-Wing* (1993), for instance, was more about offering a visceral *Star Wars* combat experience than tapping into the space opera's emotional and narrative heritage.

But the description of recent video games as 'interactive films' and the emphasis on the cinematic qualities of others show that games have become more ambitious, the most sophisticated examples using means and striving towards ends that are not entirely dissimilar to those of their artistic parent. The advent of the PlayStation and the home PC (and the integration of first DVD, and now Blu-ray, technology into both) has allowed the correlative relationship between the two media to draw much closer. More and more films are taking their inspiration from video game franchises: while movie productions of *Gears of War* (2006) and *Halo* (2001) may have stalled, films of *Heavy Rain* (2010) and *Mass Effect* (2007), among others, are in the pipeline. High-profile films are being strategically launched alongside new iterations of their gaming inspiration (*Prince of Persia*, for example). With mainstream film struggling for originality, video games not only offer movie-makers a fresh take on invariably tired ideas by broadening the creative ideas pool beyond the film industry, but also deliver a guaranteed audience already familiar with the dynamics of the story.

Conversely, video games are being released alongside short films and DVD-based support materials, such as the animated prequel to *Dead Space* (2008) and the live action webisodes for *Alan Wake* (2010) and *Assassin's Creed II* (2009). The latter two used a mix of live action actors and CGI to recreate their respective game environments (i.e., the fictional small-town America of Bright Falls for *Alan Wake* and Renaissance Italy for *Assassin's Creed II*), introducing characters, setting up plot threads and broadening the depth of the gamer's overall experience.

Video games are taking more notice of the elements that make film such an accomplished art form and are integrating the best of these into their visual, narrative and emotional make-up. Almost all of the big games launched over the past few years (bar sports games) have some root in established film genres; *Resident Evil* (1996) draws on horror, *Call of Duty* (2003) on war movies, *Heavy*

Rain on psychological thrillers and *film noir*, *Grand Theft Auto* (1997) on gangster films, *Halo* on sci-fi and the list goes on. Anyone who has played any of the games above will recognise thematic facets and character archetypes in their structure based on film (and sometimes literature) genre classics: the story and characters in *Red Dead Redemption* (2010), for instance, are rather brilliant composites of those found in the Westerns of John Ford, Sergio Leone, Clint Eastwood and Sam Peckinpah, without being overly derivative. And in another example of the ever closer links between film and video games, *RDR* was accompanied by a 30-minute short film directed by John Hillcoat (edited from footage from the game itself), whose Australian take on the Western *The Proposition* (2005) was an acknowledged influence on the writer of the game, Dan Houser.

More than anything, it is the narrative element of film that video games are increasingly emulating. *RDR* is more interesting and emotionally engaging than standard shoot 'em ups because the fighting is framed by a sophisticated story of personal redemption that unfolds against the backdrop of larger themes, such as civilisation versus nature and the beginning of industrialisation. In the supernatural game *Alan Wake*, the protagonist is a writer of horror fiction who is forced to battle against the possessed inhabitants of Bright Falls where he has retreated, while the mysterious pages of a book that he does not remember writing announce events to come: essentially, the gamer is placed in the position of the man who has written the game he is playing.

BioShock (2007) is another interesting example. It is set in the beautifully rendered underwater city of Rapture, whose creator Andrew Ryan is the game's main antagonist. Ryan taunts the gamer with philosophical and sociological rants about humanity and the soul, as well as the corruption of the surface world, all as his wonderful, 1930s art deco-themed city falls into rack and ruin around him and the inhabitants are driven insane by mutated gene-splicing. A mix of science fiction and horror conventions, with explorations into art, theology and philosophy, all wrapped up in a 'dumb' first-person shooter game.

It's games like these that show how far the medium has progressed when it comes to narrative complexity and its corollary, a satisfying conclusion. Early video games had very little storyline and usually no ending: in *Donkey Kong* (1981), for instance, the story involved a man (bearing a striking resemblance to Mario) saving a damsel in distress from a giant ape with a penchant for chucking barrels. The story was simplistic at best: dodge the barrels, reach the top, save the girl, job done. When all the levels were completed, the process started all over again at a greater difficulty setting, until eventually the gamer reached the infamous 'kill screen', when the game screen simply froze (as captured so brilliantly in the documentary *The King of Kong: A Fistful of Quarters*, 2007).

Slowly, developers started to include an end sequence to games once they had been completed, giving the story some finality and, in the process, the gamer a sense of achievement. In the 1980s, this concept was developed further with the introduction of text-based adventure games, usually spawned from established franchises, such as 1982's *The Hobbit* and the rather splendid *The Hitchhiker's Guide to the Galaxy* (1984). These games were again simplistic in approach – the gamer typed in simple instructions, such as 'look', to move the story forward – but for the first time games had the beginning, middle and end (or three acts) that are common in Hollywood films. The introduction of a narrative structure gave gamers something to strive towards beyond setting a new high score. This was particularly important as games started to move away from coin-operated arcades and into our homes through the ever-widening growth of the home entertainment games systems.

As more powerful systems of delivery were introduced, able to produce better interaction and more impressive graphics and sound capabilities, storylines were taken to the next level. Indicative of this was the point-and-click adventure game, where players use their mouse to interact with objects in the game world, and by doing so solve puzzles. Compelling storylines and stronger character development became the focus of such games – interestingly, a games developer born out of the film industry, LucasArts, was at the forefront of this genre, developing such exceptional adventure

168

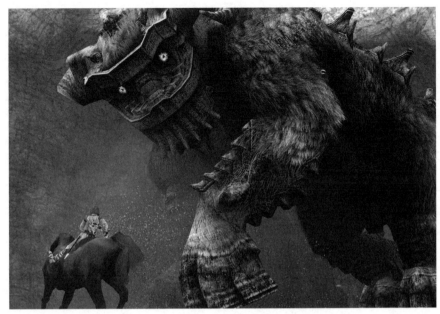

Still from Shadow of the Colossus *(Sony Computer Entertainment)*

games as *Maniac Mansion* (1987) and the extremely popular *Monkey Island* series (1990). It would be unfair to overlook the success of the puzzle adventure game *Myst* (1993) during this time, not only because it used a unique first-person viewpoint – which placed the gamer in the middle of the action, rather than manipulating a character's actions on screen – but also because it became one of the best-selling games of its era.

169

Further improvements in hardware, including better graphics, faster processing speed, more power and greater memory capacity, have led to the near-extinction of the point-and-click genre in more recent days. However, their influence and success in the late 1980s and early 1990s can still be felt in the first- and third-person video games of the modern era, particularly in the likes of the *GTA, Metal Gear Solid* (1998), *Half-Life* (1998) and *Mass Effect* series. All integrate character interaction and growth with strong storylines.

While the ground-breaking developments in storytelling that *Metal Gear Solid* and *Half-Life* contributed to video gaming are

discussed in more detail below, *GTA* is a perfect example of how gameplay has changed through technology. The original *GTA* games, with their top down viewpoint (the action is witnessed from above), crudely drawn characters and essentially repetitive challenges, were very basic. The games' developers always provided plenty to do within each locale, but it all felt very contained and contrived. The modern iterations, from *GTA III* onwards, are set within an open 3D game world that allows the gamer to explore at their leisure, choosing to complete the main adventure or partake in a huge number of side quests, or even just go for a wander. You would be surprised by how many gamers just leap in a car (or more likely steal one!) and go for a drive around the *GTA* environments of Vice City, San Andreas state and Liberty City, listening to the wide variety of music on numerous radio stations and admiring the view.

While it is not a universal truth, most modern games that fall within the overarching 'adventure' genre rely on narrative structure to absorb the player. At the same time, the driving principles behind most games are 'action' and 'solving challenges'. Depending on the style of game, the weight of action and puzzle-solving can vary, but there's usually an element of both in all adventure games – even bombastic, shoot-anything-that-moves games, such as *Gears of War*, have some basic puzzle elements to get players scratching their heads, if only for a few minutes between chainsawing alien monsters in half.

A good example of a game where the puzzle element outweighs the action but retains a strong story structure is the recent Xbox 360 Arcade release *Limbo* (2010). In this game, the player controls a young boy who wakes up in a nightmarish, flickering black and white world (not dissimilar to early silent films) and must solve increasingly perplexing puzzles to complete the game. While the game does not deliver a storyline as such (there's no dialogue whatsoever), there is indeed a story being told. The creepy environment in which it is set, the characters and creatures that are featured and the puzzles the boy must overcome to be reunited with his sister tell their own story and invite the gamer to fill in the blanks. As this mix of puzzle-solving, visual identity and ambiguous storytelling shows, games

have had to work out various ways of integrating narrative with the more traditional elements of gaming.

The most common method of doing this is through pre-rendered 'cinematics' or in-game 'cut scenes', which are extensions of the original 'end sequences' mentioned previously. These sequences interrupt the interactive segments of the game, where the player is in control, to deliver non-interactive 'scenes' that further the story. Often they are used at the end of a level to link the story and develop plot strands, and, being pre-rendered (essentially created like an animated short), the visual quality is usually very high. The *Final Fantasy* (from episode VII onwards, 1997) and *Metal Gear Solid* series are perhaps the finest exponents of the cinematic/cut scene, particularly the latter where the cut scenes often run at over an hour and play out like mini movies.

Metal Gear Solid is one of those Marmite titles

MGS is one of those Marmite titles – it has a huge following of fans who love putting their controller down and sitting through countless scenes of heavy dialogue and impressively rendered cut scenes, while there are many others who bitterly complain that they have bought a game and so want to play it, not sit through hours of exposition. Each to their own, but there's no denying that expertly done cut scenes can be used to develop the story in a more ambitious way. In the case of *MGS 4: Guns of the Patriots* (2008), the exceptional 90-minute or so final cut scene is almost like a reward to the loyal fans who have stuck with creator Hideo Kojima through the entire 'stealth 'em up' series.

171

Other games interweave narrative into the interactive environment. Part of the innovative charm of *Half-Life* is that the gamer remains in control of their character throughout the scenes where other characters are delivering exposition. The scene plays out, a door is unlocked, for instance, and the game then progresses. The appeal of this approach is that there's no break in the interactive flow of the game, maintaining suspension of disbelief and keeping the player 'in the game'.

The *Mass Effect* sci-fi series chose to go another route with its exposition, but its engrossing storylines and epic finales are no worse for it. In these games, conversations between characters are

Still from Bioshock *(Take 2 Interactive)*

used as a way of finding out a little more about them, their history and why they are so passionate about their mission (which naturally is saving the universe from an unknown menace!). The gamer's character, Commander Shepard, is given a series of choices of what to say as a text selection pops up on screen. The gamer can choose to be friendly, professionally non-committal or even aggressive in their responses – although the latter doesn't work too well if you want to pursue a relationship with another crew member. While text appearing on screen can highlight that it's only a game, the skill of the conversations that follow (reinforced by some nifty voice acting from the likes of Martin Sheen, Carrie Anne Moss and Michael Dorn) really involves the player in the story.

All in all, however, most games' stories remain as linear as those of mainstream films – with characters having to reach point C after moving from point A through B, the gaming equivalent of films' first, middle and final acts. While many games follow a strict path where the player has to complete a set task within a level before

moving on to the next chapter, 'sandbox' games such as *GTA* are more open, allowing players to pick and choose what path they wish to take and giving them the freedom to decide what missions they want to do and when. However, even in sandbox games, with their vast playing areas and multiple side quests, the main storyline remains structured.

An effective storyline can help disguise linearity and leave the player feeling that they maintain control of the game's progression. The choice offered by gameplay provides a very different experience from someone watching a film. While the latter is passively following the story, the gamer is interacting. This is the biggest point of difference between film and video games; interaction allows games to offer something that films cannot: total immersion created by being *part* of the narrative.

In order to achieve this immersion, the first-person protagonist (*à la Myst*) has become a standard affectation in video games. Placing the player directly in the shoes of the game's lead character is another narrative device that can be used to directly involve the gamer in the story. In some cases, however, it can also distance the relationship between player and lead character, particularly if that character is supposed to be someone other than you (some adventure games offer a choice of view between first and third person). In games such as *Fable* (2004) and *Fallout 3* (2008), the gamer's character is you – you can choose its sex, what it looks like and, during the game, even how it reacts and changes – whereas other games force you to play a character, such as the titular *Alan Wake*. Sadly for female gamers, there's a paucity of good and playable female characters, with most games' main characters male, and usually muscle-bound gun-lovers at that.

173

It's interesting to note that the first-person point of view is practically an anathema in film and has very rarely been attempted – in *Lady in the Lake* (1947), for instance – because it appears to spoil the audience's ability to become absorbed into the film. On the other hand, perhaps the biggest flaw of films based on video games is that the removal of the active first-person approach feels like the loss of a vital element. In the film based on *Doom* (2005), the

most popular sequence with the game's fans is the one that switches from a third-person to a first-person shooter viewpoint, just like in the game.

The level of immersion is growing with almost every new video game release, and this is also helped by the huge improvements in the quality of the graphics. Games are still far from photorealistic – in the same way that CG films have yet to truly match actual performances, even if they are motion-captured – but they are certainly getting close. There are numerous examples of exceptional graphics recreating astounding and shocking environments – from realistic war games such as the *Call of Duty: Modern Warfare* series through to more fun adventure games, like the *Indiana Jones*-esque *Uncharted* duo – and they can be beneficial in recreating evocative settings – the melancholic world of *Shadow of the Colossus* (2005) would not have been half as emotionally involving without such impressive graphics. But photorealistic graphics are not necessary to totally immerse players in the game world: anyone who has played the *Legend of Zelda* (1986-onwards) series on the Nintendo will not try to convince you how good it is on the back of its graphics, but they will highlight the strength of the narrative and gameplay.

The development of narrative as well as graphic qualities of video games, and the correspondingly higher degree of immersion in the world they create, has led to the possibility of a much stronger emotional connection than previously. Capturing emotion and drama is often where video games let themselves down. It's this deficiency that has led to critics of the format, film reviewers in particular, derogatively referencing video games (almost all films based on video games come under this kind of criticism). This has not been helped by the fact that games such as *The Godfather* (2006) or *Scarface: The World Is Yours* (2006) are evocative of their source material but fail to deliver the emotional gravitas of the films they are based on, preferring to focus on action instead.

However, games such as *Shadow of the Colossus,* and to a lesser extent its predecessor, *Ico* (2001), both rely as much on making an emotional connection between player and protagonist as they do on delivering exciting thrills. For instance, in *Colossus,* it's virtually

174

impossible not to feel the slightest flicker of dismay and regret at the self-serving destruction of the beautifully animated colossi (which is the main task of the game). There are numerous other examples – from the shock of the deaths of several main characters in the *Modern Warfare* games and the neat twists in the story of *BioShock* through to *RDR*'s inevitable but still somehow surprising ending.

This emotional connection, combined with the first-person viewpoint, allows the most thoughtful games to raise interesting moral questions. Many games offer alternative good and evil endings, usually a result of the choices the gamer makes in their play-through – for instance, in *Mass Effect*, the outcome of each conversation gives Commander Shephard either Paragon or Renegade points, and the more you have of either provides Shephard with additional skills and unique conversation responses next time. Another example is the end of *Shadow of the Colossus*, where the player realises that they have been following the instructions of a far from benign entity and successful completion of the task has tragic consequences. In *BioShock*, the choices made throughout the game lead you to either save human lives or unleash madness and destruction on the world.

Heavy Rain is a PS3 game published by Sony Computer Entertainment.

While these multiple endings give games additional life – as gamers play through twice or three times to see the different endings – few games have offered as much choice in how narrative develops as Quantic Dream and Sony's *Heavy Rain*. Quantic Dream's second release *Fahrenheit* (2005) was promoted as the first 'interactive film', but it has gone much further with its latest title, *Heavy Rain*, which boasts an elaborate narrative structure in which the player's interaction directly dictates how the story will unfold. And there are reputedly 22 unique endings to the game...

175

When it was unveiled at the Leipzig Games Convention in 2008, it was pitched as a game that was taking brave new steps in the games industry, both in content – by offering an adult thriller with a complex plot – and in gameplay – where the player shapes the story by making choices that decide its path. While this is not entirely true – as has been mentioned, there are other adult games that deliver multiple endings – its structure is unique in the medium and more akin to the 'choose your own adventure' books that were so popular in the 80s and 90s.

The game wears its film pretensions on its sleeve; it is a modern *noir* thriller that takes its inspiration from the likes of *The Silence of the Lambs* (1991), *Se7en* (1995), *Zodiac* (2007) and *Saw* (2004). The gamer plays four characters who are all trying to decipher the identity of a serial child killer, and while they are all archetypal caricatures (grief-stricken protagonist, driven journalist, drug-addled copper and grizzled PI) the inclusion of such innocuous tasks as taking a shower or making dinner means that the player takes a more vested interest in their welfare.

The player takes control of each character in a series of vignettes and is presented with various options, both in how to act and in what to say. These trigger how the story develops – make a wrong decision and this can lead to the death of a character and their subsequent removal from the story. While the identity of the killer always remains the same, there are multiple story threads and endings that can ensue. This type of story development is something that cinema has not been able to satisfactorily use to date and it will be interesting to see how the planned film adaptation of the game approaches it.

Like *Fahrenheit*, *Heavy Rain* has been described as interactive cinema – and arguably it makes for a better viewing experience than a gaming one. With its immersive depth, gripping storyline and evocative score (the music is one of the game's best features), it could be a sign of things to come.

Despite sharing many similarities with film – even at the most basic level, such as the production of concept drawings, art direction and even how a game's trailer is edited – video games still have some way to go before they can be considered an art form in the same way that film is. But given the advancements that have already been made over the last few years, as well as video games' ability to delight and satisfy in such a distinctive way, there's no doubt that this end could be within reach sooner rather than later. ∎

Still from Spin | MAX HATTLER

SYNC:
Circular adventures in animation

MAX HATTLER

I was never all that much into film, which for a long time I only knew as narrative, live-action drama. Nor was I interested in animation, which I had only experienced as 'cartoons' – drawn funny films. I came to film in a roundabout way, through an interest in visual arts, design aesthetics, and the time-based media of sound and music. Perceiving these disciplines as disparate, it took me a while to realise that I had to combine them through the medium of animation film. Discovering the works

FEATURING

Loops

Cycles

Patterns

Heaven and hell

179

Still from Collision *(Max Hattler / Royal College of Art)*

of avant-garde animators such as Hans Richter, Walter Ruttmann and Viking Eggeling was an eye-opener. These were people who, in the 1920s, approached the new medium of film as an extension of abstract painting and music – rather than as an extension of theatre and the novel, which is how it came to be perceived through the dominance of the live-action film championed by Hollywood.

The 1920s have therefore played an important role in the development of my work. The early abstract animators showed me that film does not have to be narrative or figurative, and that it does not have to follow a linear progression through a beginning, a middle and an end; that it can instead be structured more like music, through visual and time patterns, rhythms and loops. In my films and live audio-visual performances, I try to explore the relationships between sound, music and the moving image. I am very interested in abstraction and abstractedness. Not so much pure abstraction but rather an aesthetic that comes out of ideas of repetition, shapes, texture, patterning and symmetry. This can open up an alternative space in which meaning is suggested, rather than fixed; in which inbuilt ambivalence and ambiguity help construct more open-ended narratives, which engage the viewer in a different way.

My Royal College of Art graduation film *Collision* (2005) explores graphic art as metaphor. By discarding traditional storytelling, it presents a marriage of image and sound to produce a kaleidoscopic take on our turbulent political situation. The aim of the film is to be subtle and bold at the same time, and to mesmerise the viewer with symbols that are detached from their established context and applied in the service of an alternative reality. The basics of *Collision* are constituted by the colours and shapes of flags. The green of Islam is contrasted with the American (and British) red and blue. However, red is also the colour of Arab nationalism while white features in the flags of all parties involved. All this is

mixed again with the graphic patterns that are central to the heritage and identity of these cultures, American quilts on the one side and Islamic patterns on the other. Rather than focusing on differences, the film points out similarities across these cultures, symbolised by their cultural iconography. While the film follows a clear narrative structure, it is at the same time open to interpretation. The film ends with a sequence in which all the colours collide and create intricate morphing kaleidoscopic patterns to the sound of gunshots and fireworks. The reading is open-ended: cultural carnage or carnival of cultures.

Another noteworthy aspect of patterning and symmetries is that they are directly and universally perceived as beautiful. In *Collision*, this creates an interesting tension. The viewer is instantly pulled into the work through its aesthetics, while the narrative only unfolds progressively. As the narrative impact hits the hardest, the audience is already hypnotised, unable to escape. For me, this is also a comment on the aestheticisation of violence and the mediatisation of war, its packaging into palatable portions, attractively served as evening entertainment.

My short film *Spin* (2010) develops some of these ideas, focusing on what Siegfried Kracauer in 1927 termed 'mass ornament' – the patterning of individuals into 'indissoluble (…) units whose movements are mathematical demonstrations'.[1] Set around the time when Kracauer made this statement, *Spin* takes inspiration from Busby Berkeley's escapist Hollywood musical vision as much as from communist parades and Leni Riefenstahl's fascist fantasia. In *Spin*, toy soldiers – from the past and present – are coerced into visual patterns to play out a conflict-as-spectacle. Sides are irrelevant; it's just one big party for everyone. The boundaries between violence and entertainment are blurred, as troops become troupes become troops become troupes. While this is not strictly abstract work, it makes its point through an act of visual and conceptual abstraction. And while the references are historical, the questions the work poses

Spin takes inspiration from Busby Berkeley as much as from communist parades

181

1 Siegfried Kracauer, 'The Mass Ornament', in Barbara Correll and Jack Zipes, *New German Critique*, No. 5 (Spring 1975), p.67-76.

are as burning as always. The ending here is much less ambiguous than in *Collision*. For the film to bring its message home, the end needed to be final: death for everyone, albeit in mass ornamental fashion. Having said that, *Spin* can also be seen as a loop, a never-ending cycle of destruction.

Not all of my work is as political, or as narrative. In 2008, I directed the experimental short film *Aanaatt* to the music of Japanese electronica artist Jemapur, with additional animation by Noriko Okaku. This retro-futuristic stop-motion film is situated somewhere between abstraction and realism, between constructivist design and the manual-analogue creation of space through continuously shifting displacements, reflections and reconfigurations. One influence, mainly in terms of technique and movement, was Slavko Vorkapić 's *Abstract Experiment in Kodachrome* (c.1940), a stop-motion film in which multi-coloured wooden building blocks create a series of simple patterns and graphic shapes. Constructivism and the work of Bauhaus master László Moholy-Nagy served as visual references for the overall layout of the film. Another more tentative Bauhaus link exists through the actual objects used in *Aanaatt*. The majority of these objects come from the *omnium-gatherum* of Hans (Nick) Roericht, Design Professor Emeritus at the Berlin University of the Arts, and a graduate of the former Ulm School of Design, direct progeny of the Bauhaus. *Aanaatt* was described by Darry Clifton as a '"machine-aestheticized" vision [that] harks back to a more innocent age, when modernist ideals and a belief in the curative potential of technology influenced the work of filmmakers like Dziga Vertov and Hans Richter'.[2] While this is true, the film is also a response to the recent wave of motion graphics works that so heavily rely on the curative potential of digital technology, forgetting about the beauty and believability of analogue media. *Aanaatt* was aptly featured in onedotzero's 2009 Craftwork programme, the digital film festival's first-ever screening dedicated to 'post-digital' works. *Aanaatt* was largely created in sequence and without

2 Darryl Clifton, 'Animation's Brave New Worlds', in *Varoom*, No. 12 (Spring 2010), p.20-25.

storyboard, developing over a period of three weeks of constant shooting. External factors such as weather, time of day, availability of resources and accidents were allowed to become part of and shape the film. While there is a certain dramatic development, the film fundamentally describes a continuum, a circular state rather than a narrative.

Still from 1923, *aka* Heaven
(Max Hattler / The Animation Workshop)

My most recent works go one step further: they are continuous animation loops. *1923*, aka *Heaven*, and *1925*, aka *Hell* (2010), are firmly rooted in the digital. Their inspiration though, again, comes from the pre-digital 1920s. Both loops are based on the intricately patterned paintings of French outsider artist Augustin Lesage, more precisely on two of his paintings made in 1923 and 1925, both called *A Symbolic Composition of the Spiritual World*. Satisfying my appetite for patterning and abstraction, as well as the abstraction of ideas, Lesage's work proved to be a rewarding starting point for an exploration of ideas around beauty, spirituality, eternity, and the cyclic nature of time. Created as an installation, the two loops are played continuously on two opposing walls in a blacked-out room, offering two simultaneous, differing visions of the spiritual world. As they inhabit the same physical space, their sounds and emanating light merge and overlap to create an immersive environment.

183

I directed the two loops during just five days in February 2010 at the Animation Workshop in Viborg, Denmark, where they were produced by a crew of excellent student animators and computer graphics artists. The Animation Workshop had set 'The Outsider' as a theme to work to. I decided to look at outsider art for inspiration and I came across Augustin Lesage. I was immediately hooked by his obsession with symmetry and repetition, combined with his spiritualist understanding of art. Lesage, a coal miner who picked up painting after an inner voice told him to do so, claimed never to have painted except under the explicit guidance of spirits, among

Sync, installation view (Max Hattler / Pavlov E·Lab)

them Leonardo da Vinci and Apollonius of Tyana. Being partial to patterns and mirroring myself, I liked the idea of transposing his vision of the spiritual world into a contemporary moving image context – updated through the lens of pop-cultural and art-historic references – using sound, image and movement to try and heighten the sense of the spiritual, while adhering to Lesage's parameters of symmetry. The idea of a loop made perfect sense both in terms of a *tableau vivant* as well as an endless cycle – eternity – implicit in Lesage's spiritual vision.

With all my work, I tend to feel my way from a generally nebulous starting point to the finished piece. Since making animated films is a slow process, I prefer not to storyboard but to keep things open-ended and let them develop organically. Storyboarding locks down much of the film's development before production has even begun – you become a slave to your own creation. So for this project my aim was to do the same while working with around 10 students split into two groups. I gave each group one of the Lesage paintings and a set

184

of instructions, and asked them not to discuss with the other group. I really wanted to develop two very different takes on Lesage with them. Lesage's 1923 painting has a hint of perspective, so it seemed natural to follow that lead and develop it into a forever ascending loop. We worked out a way of mapping moving 2D animations onto the 3D geometry created by the students. This enabled us to translate Lesage's vision into a futuristic, meditative, uplifting loop reminiscent at once of Fritz Lang's 1927 *Metropolis* and the psychedelic films of computer animation pioneer John Whitney, but also of *Tron* (1982) and DMT hallucinations– hence the alternative title *Heaven*. For *1925*, we started out by cutting up sections of Lesage's painting and layering them as a series of consecutive walls. It seemed logical to develop his patterns into moving parts and mechanisms, and doors through which the viewer must pass. *1925* ended up in a much darker place, a forever repeating spiritual world somewhere between C.G. Jung and H.R. Giger, ancient Egyptian tombs and the *Tomb Raider* (1996) video game – hence the alternative title *Hell*.

With my latest work, an abstract floor-projection animation installation, I tried to push the idea of circularity yet further. *Sync* (2010) is the result of a collaboration with Pavlov E-Lab, Dutch theoretical physicist Eric Bergshoeff and American chronobiologist Martha Merrow. As well as being a single-shot film and a continuous loop, *Sync* is also circular in shape, taking the form of a large mesmerising mandala. It is modelled on the zoetrope ('wheel of life' in Greek), an optical device that produces the illusion of movement from a rapid circular succession of static images. The narrative and animation of the whole film are in fact produced by just one gigantic virtual disc, a single image spinning at 7400 degrees per second, which the camera continuously zooms out of. In an attempt at visualising all possible time scales from subatomic Planck time to the lifespan of the universe itself, the film is based on the idea that there is an underlying unchanging synchronisation at the centre of everything; a sync that was decided at the very beginning of time. Everything follows from it, everything is ruled by it: all time, all physics, all life. And all animation. ■

185

IN HEAVEN EVERYTHING IS FINE

'The grainy, staticky noise of Eraserhead.' | LISA CLAIRE MAGEE

DARKNESS AUDIBLE:
Sub-bass, tape decay and Lynchian noise

FRANCES MORGAN

Noise is the forest of everything. The existence of noise implies a mutable world through an unruly intrusion of an other, an other that attracts difference, heterogeneity and productive confusion; moreover it implies a genesis of mutability itself.
—Douglas Kahn[1]

DREAMING IN THE BLACK LODGE

In the interests of research, I undertake a *Twin Peaks* marathon, from the iconic first eight episodes to the end of season two. Afterwards, I dream I am lost in a dark, airy house, populated with indistinct presences. Like Dale Cooper making his multiple ways in and out of each curtained alcove, I become increasingly confused, roaming through

FEATURING
Death
Dread
Drone
Distortion
Doom metal

1 Douglas Kahn, *Noise Water Meat: A History of Sound in the Arts* (MIT, 1999), p.22.

long rooms that change in shape and size. I can hear a voice, distorted, slowed down and incomprehensible: as the register sinks lower, the house's darkness becomes more oppressive. Fear hums like a vast machine that operates almost below audible range but whose vibrations are felt in the feet and chest; death and decay take aural shape in rumble, static and hiss.

This is not the actual sound of David Lynch's Black Lodge, of course. *Twin Peaks*' sound design reflects the restrictions imposed by television, which has a smaller dynamic range than film, and the series' abiding sonic impressions, for most, are the constant presence of Angelo Badalamenti's score, followed by the creative use of the voice, such as the backwards/forwards dialogue used by characters in Cooper's dreams or visions. My own dream, while inspired by *Twin Peaks*' final episode, is more like a composite of Lynchian sound realisations: the dense, machine presence of *Eraserhead* (1976), the abject, humming mid-range evil of the underrated *Twin Peaks: Fire Walk with Me* (1992),[2] the oppressive domestic drone of *Lost Highway* (1997) and the ominous rumble of much of *Inland Empire* (2006). It is also drawn from music: from the amplifier worship of Sunn O))), the disintegrating tapes of William Basinski, the enraged, overdriven voices of Whitehouse, or the dystopian bass quake of Kode9 and the Spaceape's album *Memories of the Future*.

The registers of sound where the listener both hears and feels the limits of their sonic perception are places explored by most kinds of extreme music. The attraction of low-end, distorted or heavily layered sound for musicians is obvious and manifold: it can be violent and disorientating; melancholy and ecstatic; used to illustrate or induce psychological disturbance or summon occult presences. But while noise-based music can often be filmic, and influenced by film – long form, atmospheric, ambiguous but with a sense of narrative – in film, noise is used less often than we might think in any way other than illustrative: a sound may be enhanced or exaggerated, but it

2 Another reason to reappraise this film is that Lynch himself took control of the sound mix, giving *Fire Walk with Me* much of its perverse atmosphere and resulting in key musical scenes like Laura and Donna's visit to the Roadhouse.

usually corresponds directly with a visual analogue, *the thing that made the sound*. This is true even of the most 'atmospheric' horror or supernatural films: a drip of water, for example, can be amplified for uncanny effect, but it still is what it is; it is still water. Noise's mutability, to use Kahn's description, does not correspond well to cinema's definite visions, outside of the most abstract art film.

Yet David Lynch, while creating iconic, successful films, with particularly influential musical soundtracks, is one director who has often approached noise in this more abstract way, using noise both on its own and interwoven with, or augmenting, more 'traditional' music to create atmospheres of disquiet and liminality. Death, memory, decay and the existence of other, darker worlds within and around this one are themes central to his vision: this undertow is realised most effectively in carefully constructed passages of low-end, haunting noise. His films, and their sonic landscapes (not necessarily, but sometimes also, their soundtracks), should, I would argue, be part of any account of underground music of the last three decades.

David Lynch's very first feature was a noise film

David Lynch's very first feature was a noise film, to the point where it feels sometimes – for example, in the surreal, slow-moving opening sequence – like a music video, so clearly does the sound, on which Lynch worked closely with noted sound designer Alan Splet, appear to generate or propel the visuals. This seems a superficial way to describe the synthesis of *Eraserhead*'s low-lit, black and white cinematography with its thrumming, chugging, hissing and clanking electro-acoustic soundtrack, but, to contemporary eyes and ears, the rhythmic interdependence of sound and image suggests music video form as much as it nods, in its visual aesthetic, to classic silent film. *Eraserhead* uses noise in a similarly 'classic', early- to mid-20th-century way too, though: its clear references are the concrete music of composers such as Pierre Schaeffer or Pierre Henry; its placing of industrial sound and rhythm as musical score an echo of John Cage's assertion of the musical validity of all sounds. Its parallels with industrial bands such as Cabaret Voltaire and Einstürzende Neubauten are more coincidental than intentional (although the film's status as a cult 'midnight' movie in the late 1970s and early

189

1980s makes it likely that a good many underground musicians were among the audience). Low-end sound – drones and more disrupted, white-noise textures – represents not only the relentless process of the industrial setting, but voids and recesses, cosmic and sexual, of the human body and mind. *Eraserhead*'s analogue warmth, and our nostalgia for the organic and inventive means by which film sound was made before computer technology, has perhaps detracted from the story's nightmarish body horror over the years, but its noisescape is still its most memorable element.

After the release of *The Elephant Man* (1980) and *Dune* (1984), both of which feature Splet's sound work, Lynch would state: 'People call me a director, but I really think of myself as a sound-man.'[3] Over 25 years later, with the director's own intense sound realisation of *Inland Empire* as evidence, the much-quoted assertion holds up remarkably well. It also prompts film sound theorist and composer Michel Chion, in his key book on Lynch, to write insightfully of the aural quality of Lynch's films, in which 'it is from the inside of the narrative and even of the image that Lynch's cinema is transformed by the central role allotted to the ear'.[4] In writing of the 'acoustic impressions' of Lynch's films, Chion refers in this instance to the registers of characters' voices. However, the sonic assault of *Eraserhead* aside, it is Lynch's recognisable and idiosyncratic musical soundtracks, his work with composer Angelo Badalamenti and the use of haunting pop music, that capture many viewers' and critics' imaginations more immediately than the subtler layers of timbre, tone and texture that permeate the sound design of his films. This is not surprising: not only is 'Lynchian' music distinctive to the point of being adjectival, but his music and sound design are inextricably linked. We don't hear the tune of, say, Badalamenti's opening theme to *Mulholland Dr.* (2001), and then observe in isolation its use of low instruments and sympathetic recording techniques to induce the film's simmering, lush and portentous darkness; atmosphere and

3 David Lynch, quoted in Michel Chion, *David Lynch* (BFI, 2006), p.159.

4 Chion (2006), p.159.

mood are created by the combination of these elements, not their separation.

This essay is not an attempt to survey all the music and sound of Lynch's films,[5] nor will it endeavour to exhaustively connect it to the history of noise throughout the 20th century. Rather, it is meant as a suggestion to re-listen to the soundtrack beneath the soundtrack; an attempt to explore a sonic point at which I feel certain ideas, feelings and atmospheres of fear, death, memory and decay are located: to tentatively plot together certain currents in extreme music, in the changing technologies that make, record and disseminate sounds, and in the work of one of our more prominent extreme filmmakers.

It is inspired most directly by Lynch's most recent film, the sprawling and rumbling *Inland Empire*, but its genesis is really a memory of an earlier film and of myself as viewer of it.

PRE-MILLENNIAL TENSION

In 2007, American band Dirty Projectors released an album called *Rise Above*, a loose cover version, from start to finish, of Black Flag's 1981 album *Damaged*, otherwise referred to as a 'reimagining' after frontman David Longstreth claimed he had not listened to *Damaged* in 15 years; the project was an attempt to interpret his memory of the album based on his listening to it on cassette as a teenager. 'I wanted to retroactively smudge my own existential/teenage angst with Black Flag's, so I couldn't remember which was which,' he explained.[6]

191

On finding that *Lost Highway* is not the easiest film to locate on DVD – it is currently deleted in the UK – I toyed briefly with the idea of doing the same thing: writing about the film's sound with only my memories of 1997 for guidance. In the time it took to track down a used copy, this made for an interesting exercise: while my memories strove for some accuracy, they filled in the blanks left by

5 Philip Halsall's essay, 'The Films of David Lynch: 50 Percent Sound' (British Film Resource, www.britishfilm.org.uk/lynch, 2002) is a good musicological summary of Lynch-music from *Blue Velvet* to *Mulholland Dr.*

6 Interview with Sean Moeller, www.daytrotter.com, May 2007.

the lack of actual product with peripheral impressions, drawing a partial map of my listening around the period of *Lost Highway*'s release. I did not have to search my mind for *Lost Highway*'s sound, the sound was what I remembered the most: not only was it 'the one with Trent Reznor' and 'the one with Rammstein', it was also, crucially, the one with the video and the drone. It was the one with all the low end. It was the time with all the low end: my memory of sitting in the cinema, excited and scared in equal measure by the psycho-sexual angst and lowering, ominous sonics of *Lost Highway* was filed next to one of emerging from an East London club in the early hours of a morning, ears pummelled by frantic drum and bass, and seeing a meat lorry unload its wares for the next day's market, chilled carcasses steaming in the dawn air. Clangs, drones, beats, flesh, sub-bass, darkness all permeate my memories of that time.

In 1997, my attention was shifting away from songs and towards how music was built texturally. My pre-millennial teenage music tastes – US indie, post-rock, mildly left-field electronica, trip-hop – would expand over the next few years to include louder, deeper and darker sounds: industrial music, doom and black metal, austere electronic composition, minimal techno, harsh noise. Concurrently, I developed the fondness that most young film and music obsessives have for David Lynch, after a double bill at the Everyman Cinema allowed me to experience the grainy, staticky noise of *Eraserhead* and haunted jukebox songs of *Blue Velvet* for the first time on the big screen.

Not too long after watching *Lost Highway*, I visited a short-lived club night called Harder Louder Faster, which played industrial music, gabba, jungle, breakcore, techno and grind. Leaning against a wall that seemed to literally pulse with the low frequencies was, hackneyed as it sounds now, revelatory, opening up my understanding of what sound could do on a physical, visceral level, and expanding the impressions I was forming of my still-new home city and the sound I could make there, mirroring the never-ending hum of its pulses and energies. *Lost Highway* was, in a way, the inverse of the noise club, but a direct and perfect inversion; the shadow side to noise, the noise that is always there, even during

silence: what Lynch, talking about *Eraserhead*, calls 'presences – what you call "room tone"'. It's the sound that you hear when there's silence, in between words or sentences'.[7]

Lost Highway's first chapter tells the story of a couple, Fred (Bill Pullman) and Renee (Patricia Arquette), who wake to find a series of videotapes on the doorstep of their ultra-modern LA home. The first tape shows the exterior of the house; the second, the interior and Fred and Renee themselves, sleeping. They are not a happy couple; they are distant with one another, Fred possessive and frustrated. There is something sinking and decaying at the heart of their relationship, and this is mirrored in both music and sound. Badalamenti's orchestral score swells and groans like a foundering ship; during a strange, disconnected sex scene, low strings and muffled timpani pulse like slowed heartbeats. The effect of the orchestral music is not only engendered by its composition, which puts the timbre of the instruments at the forefront: the recording sessions with the City of Prague Philharmonic Orchestra saw Lynch experimenting with homemade effects and oddly placed microphones locked to plastic tubes of varying sizes and dropped into wine bottles and jars.[8] Noise sequences devised by Nine Inch Nails' Trent Reznor accompany the couple's viewing of the videotapes; and throughout, there is a low hum of bass (generated by one channel of the film's sound mix going through a sub-woofer) that presses on the ears and the conscience, the claustrophobic, rotten heartbeat of a domesticity turned to nightmare.

If I had, like David Longstreth with *Damaged*, reimagined *Lost Highway* without seeing it again, it would consist mainly of this first part of the film. The second, in which Fred, imprisoned for murdering his wife – an act that he does not recall, but sees on the final delivered videotape – somehow transforms into an entirely new character, Pete (Balthazar Getty), left less of an impression. Sound-wise, it eschews the suggestive textures of the earlier part of the film for a more song-based soundtrack; for the modish songs

193

7 Chris Rodley ed., *Lynch on Lynch* (Faber and Faber, 2005), p.73.

8 Rodley (2005), p.240-1.

by Marilyn Manson, Rammstein *et al* that make this film one of Lynch's least timeless. Time has not been too kind to these very specifically '1990s' elements of *Lost Highway*, which echo the films that Lynch (as David Foster Wallace puts forward in his essay, 'David Lynch Keeps His Head'⁹) might have unwittingly inspired – the Tarantinos and the Oliver Stones and the various other ironic, stylised, sexy killing spree movies of the time – and it's fair to say that its soundtrack has something to do with this.

Watching *Lost Highway* now, it is not just the duality between the two 'halves' of the story that stands out. Another duality occurs: it is as if the film had its official soundtrack, and then a shadow soundtrack, one that exists in the space where music and sound effects meet, which Lynch describes as 'the most beautiful area'.¹⁰ For example, the 'Videodrones' (as they are collated on the soundtrack album¹¹) make use of the sound of the video itself – interference, white noise, the slow whirr of the tape spools – but not as sound effects in any normal sense: aesthetically they are equal to the low bassoon or bowed bass strings that also lurk within the drone, or the low-end digital tones created by synth or sample. The glitches and crackles in the tape are musical; the creaking of the video playback echoed in the rumbling of the house. What also distinguishes this sound from sound effect is its place within the overall sonic narrative. Structurally, what strikes you about the sound and music in perhaps all of Lynch's films is their constant presence: sound and music do not just appear at intervals for effect (that is, it is not a 'sound effect', or an explicit musical directive to 'feel this now'), and can be listened to more like an album or a

the creaking of the video playback echoed in the rumbling of the house

194

9 David Foster Wallace, 'David Lynch Keeps His Head', *Premiere Magazine*, www.lynchnet.com/lh/lhpremiere.html, September 1996.

10 Rodley (2005), p.242.

11 On *Lost Highway*'s official soundtrack album, Trent Reznor as producer saw fit to edit these impressive ambient sequences into less than a minute's worth of sound, interspersed with fragments of dialogue from a sex scene, presumably to make the album a more commercial, song-based release. Ironically, I suspect many listeners in 2010 would happily sacrifice the Smashing Pumpkins track he includes in full in favour of a few more 'Videodrones'.

long piece with motifs and recurring themes than excerpts from a film soundtrack.

The 'borderline' that Lynch speaks of, this distinction between music and sound effect, is one made very much from a filmmaker's point of view. From the perspective of music criticism, the difference had already become blurred. Lynch goes on to say in the same 1996 interview that he sees this as a direction in which things are 'going'. He was both right and wrong: noise music had existed long before *Lost Highway* and before Trent Reznor's drone pieces – an explicit reminder of this is the appearance of another name on the sound credits of *Lost Highway*, that of Throbbing Gristle and Coil's Peter Christopherson, by then a veteran creator of industrial and dark ambient music.[12] However, Lynch is right that the final years of the 20th century were a confident, and fruitful, time for extreme music and electronic music. It is not surprising that such a sonically aware director picked up on this, making use of, not only popular extreme bands (as did almost every horror director during nu-metal's peak years), but also of the sample-heavy, cinematic beats of Barry Adamson. *Lost Highway*'s post-industrial noisescapes, perhaps unconsciously, echo those created by underground noise artists such as Merzbow, Masonna and Pan Sonic, all of whose work achieved greater prominence and appeared on larger, more commercial labels in the latter part of the 1990s.[13] *Lost Highway*'s atmospheres of unease are balanced with the soundtrack album's harsh confidence,

12 If Throbbing Gristle made what many consider the paradigmatic industrial music – which as a genre emerged contemporaneously with *Eraserhead* – Coil's music mined more esoteric territory, applying the industrial preoccupations with strength, power and control to occult ritual, emphasising the role of transgressive sexuality in achieving altered states. A much filtered – and heterosexual – version of this aesthetic can be heard in the music of Nine Inch Nails and other hugely successful industrial and metal acts.

13 Noise musician Jessica Rylan remarks in *Pink Noises: Women on Electronic Music and Sound* (Tara Rodgers, Duke University Press, 2010, p.151-2) that the signing of extreme Japanese artists Merzbow and Masonna to metal label Relapse in 1996, followed by a US tour, was particularly influential; in the UK, Masonna took part in the 1998 Meltdown festival, performing at London's Royal Festival Hall.

a certainty that we are still in control of sound. The videotape that is so important to the story signifies horror in its subject matter, but tape itself has not yet come to symbolise ghostliness and decay. In its mixture of control over, and abandonment to, sound's possibilities, *Lost Highway* is perhaps the ultimate pre-millennial noise film.

ATTACK/DECAY/SUSTAIN/RELEASE

In the summer of 2001, composer William Basinski was revisiting tape loops that he had originally constructed in 1982.

> 'I (...) went to the kitchen to make some coffee and came back and after a few minutes I started realising that the tape loop itself, as it was going around on the deck, was starting to (...) disintegrate. Recording tape is a plastic medium. It has glue and iron oxide, rust basically, that holds the magnetic recording. So the glue loses its integrity and the iron oxide starts turning to dust again (...) Over the period of an hour this loop disintegrated right there in the studio so I just let it go for the full length of the CD and then faded it out.'[14]

Basinski released a series of albums entitled *Disintegration Loops* the following year. The cover of each was illustrated with a still from video footage, filmed from the roof of his New York studio, of the site of the September 11 attacks, which happened shortly after Basinski began the project. The explicit connection of obsolete and literally decaying technology with death and mourning was immediate for listeners: *Disintegration Loops* is Basinski's most successful work to date.

Decay has a musical or sonic meaning: the time it takes for a note or sound to die away, having reached its peak volume. *Disintegration Loops* reminds you that sound can also literally decay, and can signify decay through physical processes. These reminders of transience and a sense of nostalgia are common to much noise and

14 Interview by Kiran Sande, *Fact*, www.factmag.com/2009/05/28/interview-william-basinski, May 2009.

extreme music of the last decade, almost in riposte to the confidence of the preceding period.

The year of *Disintegration Loops* saw a return to the basic fascination of sound vibrating air, fetishising low end and high volume via the music of Sunn O))) and the revitalised doom metal scene. Throughout the middle of the decade, metal's image changed subtly. Terms like 'avant-doom' and 'post-metal' appeared in music criticism, and long, mostly instrumental tracks adhered to doom's monolithic riffs, but with a new awareness of texture, timbre and sound as an element in its own right, both in newer bands such as Nadja, Asva and Isis, and rejuvenated older ones such as Neurosis and Earth. A new melodicism was also present in metal that, to my ears, kept coming back to a familiar source: the sweeping, deceptively simple compositions of Angelo Badalamenti.[15] Electronic music hinted at powerlessness, not futurity: Norwegian electronic musician Helge Sten, aka Deathprod, credited the brooding compositions he created with his armoury of antiquated, modified equipment to an 'audio virus': a description that implied mutability and helplessness rather than control. New networks and organic processes (voice, tape, circuit-bent and home-made instruments: laptops almost disappeared from stages, to be replaced by cassette decks and FX pedals) resulted in a number of scenes that seemed to multiply despite – or perhaps through – the atomisation of the music industry in the internet age. Separate from the vibrancy of the actual music-making, the obsolete and almost obsolete technology produced an elegiac effect not dissimilar to that generated by Basinski's more 'composed' *Loops:* an attempt to assert the 'human', as well as an exploration of sonic memory; a quest to locate ghosts in these increasingly dusty machines. Noise's process has become its content, in a way its subject matter.

197

15 This is not the essay that surveys the influence of *Twin Peaks* on US underground music of the 2000s, but the minor intervals of 'Laura's theme' crop up as a melodic imprint, an unspoken influence, so often that perhaps there should be one.

In 2006, a needle drops onto a record and David Lynch's *Inland Empire* begins. The first sonic event after the brooding, monochromatic opening credits is this crackle of vinyl, a fuzz of analogue interference through which words can be heard indistinctly, like recordings of EVP (electronic voice phenomenon, the accidental simulation of voices in radio static, sometimes interpreted as 'spirit' voices). This is followed by a sequence in which a young woman watches a videotape – and it is clearly a video, not a DVD. Two obsolete technologies are thus shown within the film's first few minutes, despite its setting in the present day, and the much-noted fact that *Inland Empire* is shot entirely on digital video; Lynch is reported to have said, at the time of its release, that he will not work with film again: 'Film is like a dinosaur in a tar pit. People might be sick to hear that because they love film, just like they loved magnetic tape.'[16] *Inland Empire*'s sound design is therefore also a digital production, yet it feels pointedly 'analogue', its textures deliberately as organic as Alan Splet's on *Eraserhead* – in which of course Henry (Jack Nance) uses a crackly record player in a key early scene. It has a sense of being 'about' analogue sound processes (in the way the visual narrative is 'about' the making of a film), using them illustratively.

Inland Empire's horror and unease are frequently located aurally rather than visually. Intentionally referential to Lynch's previous work – not least the other 'LA' films *Lost Highway* and *Mulholland Drive*, with which it forms a loose trilogy – *Inland Empire* seemed to me less involving, more fragmented and overlong than its predecessors, until I listened to it. (Ironically, given its format, my first viewing was on a quiet laptop: Lynch might have embraced the digital with gusto, but his films often fall down without a decent set of speakers.) An aural reading of *Inland Empire* suggests it to be as 'post-noise' as *Eraserhead* or *Lost Highway* are 'noise', reflective of the uncertainty of much of this decade's extreme music. It

198

16 David Lynch, *New York Times* interview, 2007, quoted in Zoran Samardzija, 'DavidLynch.com: Auteurship in the Age of the Internet and Digital Cinema', *Scope*, www.scope.nottingham.ac.uk/article.php?issue=16&id=1171, 2010.

199

'Fear, out of sight, but within earshot.' | LISA CLAIRE MAGEE

also mitigates the need to find 'meaning' in what is a deliberately mysterious, elusive narrative: hearing accommodates, in fact welcomes, ambiguity more than seeing.

The film's narrative trajectory roughly follows a downward path. Actor Nikki Grace (Laura Dern) is cast in a film that she learns is a remake of a Polish production regarded as cursed after the murder of its lead actors. She then seems to enter a series of collapsing realities in which she merges identities with her character in the film; we are uncertain as to whom the increasingly dark events that unfold are happening. A parallel narrative takes place in a 19th-century Polish city; a chorus of young would-be actresses or prostitutes appear in choreographed sequences throughout the story; there are short excerpts from an imagined TV series featuring a family of rabbits in human clothing who utter gnomic phrases over grainy synthesiser chords. What is clear is that things get worse, and that the film's menace increases exponentially, and that this is signalled by sound as well as action. The vinyl crackle at the beginning is echoed in odd touches of sound – unrelated to events in the film – that flicker through scenes. An ominous, queasy rumbling effect that feels like thunder just out of earshot surfaces throughout the film. It is similar to the sub-bass in *Lost Highway*, but less specific, and even further abstracted from direct visual analogues. It appears almost randomly at first, but then more frequently, until we realise it signifies fear: perhaps out of sight, but within earshot.

200

The depth of *Inland Empire*'s sonic range is the most noticeable aspect of its sound design: throughout, it is an unquestionably bassy film. Bass has a physicality that is not shared by other registers: it is this that makes it comforting, immersive, pleasurable, as it mirrors natural rhythms and processes. It can also be alienating and dehumanising – low-end sounds can make you aware of your physical fragility, make you feel sickened, disorientated and crushed. Bass can also be profoundly sad, suggestive of vast, lonely space. Lynch's low end in *Inland Empire* seems to mine all its uses: in the sultriness of the scene in which the young women discuss a shared lover, set to Lynch's song 'Ghost of Love' (a *Twin Peaks*-ish bluesy composition that uses that most contemporary of devices,

Autotune, on the director's voice); the simmering menace of a scene between Nikki/Sue and her husband; and the melancholic plateaux of Lynch's own instrumental tracks.

Lynch's 'Woods Variation' and 'Call from the Past' sound naïve at first, sub-Badalamenti: synthesised strings create mournful intervals, there is maximum sustain on everything, and the shimmering melody hovers upon an undertow of sub-bass that's almost out of hearing range. But the overall effect is one of huge regret, not dissimilar to British musician – and former extreme noise artist[17] – James Leyland Kirby's 2009 *Sadly, the Future Is No Longer what It Was*, three instrumental albums that used samples, fragile synths, piano and tape-like textures to create atmospheres of loneliness and decay. Abstract as Kirby's work is, it does not fight emotion, with nakedly personal titles, and Lynch's music is likewise emotionally vulnerable, for all its glacial electronic tones. The fear and pain in *Inland Empire* are as 'real' as the film's appearance is stylised, and it is the film's sound that reinforces these emotions, taking us into a place where we are afraid for our own selves.

Likewise, an extract of Krzysztof Penderecki's 'Als Jakob Erwachte' (also used in Stanley Kubrick's *The Shining* [1980]) reinforces the fear in the scene it soundtracks, in which Nikki, following her on-screen death as the character Sue, confronts the 'Phantom', a threatening man whom she has encountered once before, and sees a distorted, terrifying version of her face superimposed onto his. Penderecki's use of extended string techniques gives the orchestral piece the quality of electronic music: the deep swells of brass support a high note more like sine wave than violin. The sense of atmospheric interference comes partly from Penderecki's innovative use of the orchestra as sound source, partly from Lynch's sound mix, and partly from our own expectations, which by this point in the film are of uncertainty: we no longer know who is alive or dead, or where the sound 'comes from'.

201

17 As V/VM, a pranksterish noise alter ego given to brutalising and mashing up pop records, Kirby appeared on the cover of *The Wire* under the sub-heading 'Harder! Louder! Faster!' in 1998.

David Lynch has always used sound, and particularly low-end sound, to indicate danger and fear: at this latest point, it has moved inward, from the industrial landscape of *Eraserhead*, to the muted bedroom nightmare of *Lost Highway*, into *Inland Empire*'s existential dread. As in the extreme music that has run parallel with his films, it has become clear that there is not just one noise, that noise is multiple and vulnerable and not as powerful as perhaps was once thought. It does not provide answers; it is full of questions. Those of us who seek out the low end, the outer reaches of sound, in music and in film, also seek out not-knowing, and resonate with Michel Chion's beautiful image of the cinema screen as a 'fragile membrane with a multitude of currents pressing on it from behind'.[18] ∎

18 Chion (2006), p.159.

204

Still from The Human Centipede | BOUNTY FILMS

END TO END:
The Human Centipede

JACK SARGEANT

We do not have the ambition to list the countless possibilities of integration and disintegration according to which desire crafts the image of what is desired. We can, however, anticipate that these inter-anatomical dreams will break through to the surface of even the collective consciousness.
—Hans Bellmer[1]

The bracketed subtitle to Tom Six's 2009 *The Human Centipede* is *First Sequence*, but the film already has both the appearance and effect of a terminal document. Combining the body horror of David Cronenberg's *Shivers* (1975), *Rabid* (1977) and *Videodrome* (1983) and the annihilation of geographically estranged youth as envisioned in recent

FEATURING

Surgical nightmares
Grotesque creatures
Middle-class suburbia
Shit

1 Hans Bellmer, *Little Anatomy of the Physical Unconscious, or the Anatomy of the Image*, Jon Graham trans. (Dominion Press, 2004), p.41.

works such as Eli Roth's *Hostel* films (2005, 2007), *The Human Centipede* follows two beautiful American young women who are ensnared in a living hell while on holiday in what appears to be rural Germany. Trapped by Dr Heiter, a retired surgeon who once specialised in separating conjoined twins, they realise with growing terror that they will be incorporated into his secret pet project, the creation of the human centipede. The two women and an equally luckless male youth will be stitched together anus to mouth, forming the titular creature, a 12-limbed flesh construction that shares a single alimentary canal as it crawls around the surgeon's pristine home. The ensuing creation appears to have emerged from the same unconscious zones that inspired the artwork of surrealist affiliate Hans Bellmer and the sculptures of Jake and Dinos Chapman, biomorphic eruptions from the darkest fears of the id.

Cronenberg's *Shivers* and *Rabid* were about the individual body rebelling after scientific intervention (involving a 'beneficial' parasite and new 'miracle' surgery respectively), and they have been interpreted as metonyms for cancer and disease. *The Human Centipede* is a film about youth versus age. In a culture that venerates the freedom of youth and importance of beauty there is little more horrifying than the inevitability of the relentless progression towards decay. Worse even than death, the physical signs of ageing, the slow failure of the body and the loss of individual control, terrify us. The possibility for an increased longevity that leaves us utterly powerless may well become the true terror of the early 21st century, a decade that has seen the use of everything from Botox to anal bleaching in an attempt to halt the signs of old age and 'imperfection'.

While the youths who are brutally killed again and again in *Hostel* and similar movies have their lives snuffed out, the victims in *The Human Centipede* are not allowed to die; indeed even the pain of their surgery appears largely medicated. The fear, the absolute horror, of the film is predicated not on dying but on being condemned to live stitched onto, and slowly growing into, another person, becoming integrated into, as well as dependent on, the physical processes of a larger entity. Like old age the process disfigures, disgusts and disturbs far more than death; it suspends the three protagonists

in a zone of powerlessness that disables them and renders them physically abject.

The fear at play here is that of non-differentiation, it is not the terror of the eternal silent darkness of death, of non-existence, but of the loss of the physical limits of the self, the erasing of the boundaries that define the subject. As the pink and almost naked human centipede crawls, its limbs have to negotiate not only their own crippling surgery but also the new physical space of the 'down there' of the animal level. The eyes of two of the centipede's segments can only stare upwards or at the back of the segment in front of them, their visual sense radically restricted as their bodies are no longer their own.

repulsion is caused by the imagination of the audience picturing the unthinkable

The main conceit of the film is the shared alimentary canal. The central scene, which is perhaps the most difficult to watch, depicts its functioning. As the mouths of two subjects are grafted onto the rectum of the person in front of them they must subsist only on the excrement of that person, their biological survival dependent on a diet of shit. This process is only presented once in the film, with the surgeon leaning over the woman who forms the centipede's second segment and shouting 'feed' at her repeatedly, as the man who forms the front segment shits directly into her mouth, which is tightly sutured to his anus. There is no faecal matter visible at any point (the stitching of mouth to anus precludes this); instead repulsion is caused by the imagination of the audience picturing the unthinkable.

207

Recalling Pier Paolo Pasolini's *Salò or the 120 Days of Sodom* (*Salò o le 120 giornate di Sodoma*, 1975) the scene plays with the feelings of intense repulsion that scatology often provokes. Shit is waste, it belongs to the soil, to death (yet it itself is not death). Shit, to put it into a wider artistic context, fascinated Dali whose painting *The Lugubrious Game* featured a figure in shit-soiled clothing, a gesture that horrified André Breton and would divide the surrealists when Georges Bataille celebrated the work; in shit there is some secret truth, a collected experience that is repressed. As in Pasolini's film, the sequence positions youth at the mercy of age, literally forced to eat shit. In *Salò* this is a metaphor, according to the Italian

director, for capitalism. But beyond this, it is a moment of pure excess, in which Pasolini goes as far as possible, as if daring the audience to respond, so that one can neither condone nor condemn the sequence; it simply exists in a psychological quagmire steeped in fears and an utter primal disgust.

Pasolini's film draws upon the Marquis de Sade's most radical work *The 120 Days of Sodom* (*Les 120 journées de Sodome*) and there is a Sadean quality to *The Human Centipede*'s Heiter. While he does not appear to achieve sexual gratification from his creation he maintains a similarly complex understanding of the methods needed to achieve his desires as the protagonists of Sade's novel. In Heiter's explanation of the surgical procedure, in his selection of the order of the centipede's segments and in his subsequent behaviour, he shares with Sade's libertines the ability to fulfil his ambitions with blank acknowledgement of the humanity of his victims.

The narrative, such as there is one in *The Human Centipede*, has been condemned as having nowhere to go, with Peter Debruge in *Variety* stating that the film 'can't be bothered to expand upon its unpleasant premise'.[2] The film is remarkably, brutally, nihilistic, so in some respects this criticism is correct: the film, once it has created its grotesque masterpiece, has 'nowhere to go' – how could it? In contrast to the protagonists of *Hostel*, escape of any kind is not possible for these surgically joined youths. But this criticism presupposes that there should be a narrative progress, a readily identifiable meaning to a film, perhaps even a moral centre (of course, it could be argued that the 'meanings' ascribed to films such as *Hostel* are simple justifications for presenting violence as entertainment). Yet it is precisely the lack of meaning of Six's film – its very chaos – that makes its bleak horror so powerful.

At the heart of *The Human Centipede* there is a vertigo of despair at play. The sleek modernism of the surgeon's rural house, its

2 Peter Debruge, '*The Human Centipede: First Sequence*', *Variety*, www.variety. com/review/VE1117941318.html?categoryid=31&cs=1, 5 October 2009. In his review, Roger Ebert refused to award the film any stars (rogerebert.suntimes. com/apps/pbcs.dll/article?AID=/20100505/REVIEWS/100509982).

Still from The Human Centipede *(Bounty Films)*

clean interiors, the medical artworks hung on its walls and its well-manicured lawn, even the hygienic wraps that bind the subjects' wounds together, all conceal yet betray the repressed rot and contamination that lie just beneath the surface. There are echoes here of the secrets of Josef Fritzl's Austrian home; the safe middle-class suburbia of Western Europe hides many terrors. No reason exists for the scientist's experiments, there is no explanation or transparent meaning to the film, no comment on the operation or his work. It is a surgery that is pure creation, it exists simply to exist, just as in William Burroughs's novel *Naked Lunch* (1959), in which the equally 'mad' surgeon, Dr Benway, states:

209

> 'Now, boys, you won't see this operation performed very often and there's a reason for that... You see it has absolutely no medical value. No one knows what the purpose of it originally was or if it had a purpose at all. Personally I think it was a pure artistic creation from the beginning.'[3]

3 William S. Burroughs, *The Naked Lunch*, (John Calder, 1982), p.67.

This puts the audience in an unbearable position, forcing them to experience the disturbing antithesis of the image and the sound

The nihilism of *The Human Centipede* is not merely the director's; it belongs to the corruption of surgery itself, in the form of the meaningless nips and tucks that are constantly remodelling and negating the bodies of those in the West to make them as sleek and blemish-free as Heiter's home.

Tom Six's film is not concerned with the individuals, or even the scientist. Rather it is beholden to the creation of the human centipede itself, the emergence of a new entity in which all that is valued as human is annihilated into an endless grovelling, squirming creation straight from the id. The grotesque here is not defined through intertextual nods, post-modern references or sudden shocks; rather it emerges from the imagination of the director and the viewer, the basest, most darkly repressed fears and fantasies returning. Tellingly, David Cronenberg faced similarly hostile critical reactions with *Shivers*, which Robin Wood condemned as 'reactionary' and as 'premised on and motivated by sexual disgust'.[4] Wood could not envisage the possibility that Cronenberg may not be concerned with the humans so much as the parasites themselves. In *Shivers* they live so that they can cause orgiastic transformations. Cronenberg was not interested simply in defeating the monstrous other but in engaging with its wider ramifications.

Devoid of the aesthetic clutter of high-speed edits, the film is shot in cold, sterile tones and the dialogue is clipped. The soundtrack is an essential component of the horror in *The Human Centipede*: free of rock music, it is punctured instead by gurgled moans, whines and cries of abject suffering. These noises, coming as they often do from the two women, have a sexual undercurrent. This puts the audience in an unbearable position, forcing them to experience the disturbing antithesis of the image and the sound. These moans, which are all that the women are capable of voicing given the surgical prison in which they are trapped, sound sexual, but they are cries of terror under the crushing weight of imminent madness. Sound design has

210

4 Robin Wood, 'An Introduction to the American Horror Film', in Barry Keith Grant ed., *Planks of Reason* (Scarecrow Press, 1984), p.194.

rarely been so unpleasant, yet there are few screams or chainsaws and few jumps caused by sudden increases in volume.

Ultimately, what makes *The Human Centipede* work is its utter refusal to curtain its grim fascinations. It maintains a forensic gaze, watching in cold clinical detail, distanced from all. Only in the final scenes is this meticulous sterility of vision broken, when Heiter finally becomes a wriggling beast of his own, crawling and licking blood from the ground. *The Human Centipede* works precisely because it is disturbing and 'gruelling' for an audience to watch. It returns the horrific to horror.

The Human Centipede is available on DVD and Blu-ray from Bounty Films.

The best horror films push the audience into a new space, a zone both utterly unfamiliar yet instantly recognisable. *The Human Centipede* does this through its rejection of the usual boundaries of the genre and its meticulous engagement with the darkest zones of the id. Dissident surrealist Hans Bellmer understood that in sex and lust, in raw desire, bodies transmute, melding together and taking on new forms of beauty. His work scandalised, his sculptures and photographs, with their images of transformed and conjoined flesh, multi-limbed creations and sexually explicit transformations, sticking a finger deep into the sludge of the unconscious mind. If *The Human Centipede* goes similarly 'too far' then it has done its work. In contrast to the majority of recent horror films, which are too often dominated by the humorous and the intertextual, *The Human Centipede* has a true understanding of the grotesque and horrific that lurk in the human imagination. ∎

211

FINAL CUT:
Film critic on the verge

SIMON GUERRIER + PEARLYN QUAN

The same miserable crisis of faith in the last third of the movie.

The same miserable last-minute reprieve.

And my own role in this.

The same miserable effort to mine insight from cliché.

Nothing to be said but I say it anyway.

216

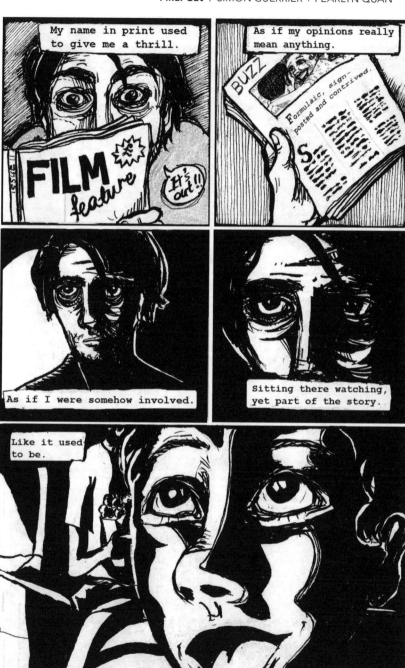

218

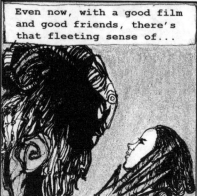

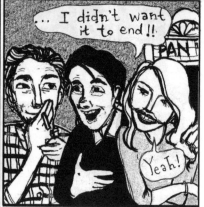

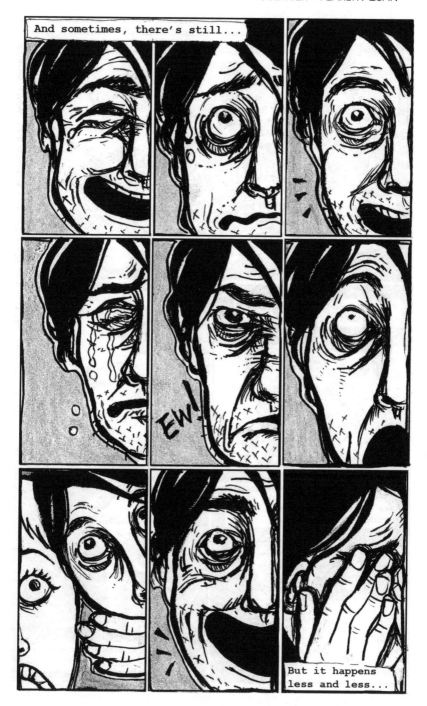

220

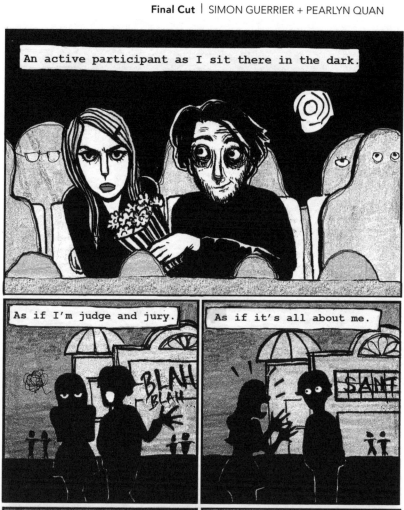

222

224

Still from Kings of the Road I AXIOM FILMS

THE END OF THE ROAD:
Driving to disenchantment

JASON WOOD

In archetypal terms, road movies entail the undertaking of a journey by one or more protagonists as they seek out adventure, redemption or escape from the constricting norms of society and its laws. A manifestation of our fascination with the road, and by extension the possibility of freedom, the road movie frequently reveals this possibility to be a myth that is, for the majority of its travellers, utterly unattainable. Dreams of escape quickly tarnish, hopes and aspirations for fresh starts in new towns

Motion

Mortality

Malaise

Melancholy

are vanquished by deadening reality. We can travel, but we can rarely escape, and soon even the sense of drift, an illusory state that promises much but ultimately delivers only stasis and deeper levels of alienation, can become commonplace and suffocating. Road movies frequently begin with a valiant search for self by an individual or individuals disenfranchised from society on social, economic, racial or sexual grounds – criminals feature heavily too – but the journey's end rarely brings peace or contentment, leading instead to further suffering and abject resignation at the crushing hopelessness of everyday life. As a disenchanted drifter in *Simple Men* (1992), Hal Hartley's road movie with one flat tyre, eloquently puts it, 'There is no such thing as adventure. There's no such thing as romance. There's only trouble and desire'.

The evolution of the road movie in American cinema – which is generally acknowledged as its originator – is closely aligned with the development of the motorcar itself and directors, including D.W. Griffith, utilising them to provide effective travelling shots. These travelling shots, later framed so as to include front and rear windscreens, would later become one of the key visual road movie motifs in terms of composition and style. Providing a window to the world and the earliest signs of automotive fetishism (later advanced to include low-angle travelling images of wheels and wing mirrors), these exterior and interior shots served multiple functions, primarily placing the spectator in the position of the character undertaking the journey. This could include breathtaking local scenery, or it could merely illustrate the numbing monotony of forward motion. Both are evidenced in Vincent Gallo's underappreciated *The Brown Bunny* (2003), which features an extended sequence of bugs hitting Gallo's front windscreen. Shot from the outside looking into the vehicle, the technique also conjures a sense of claustrophobia, telegraphing an enclosed environment with the possibility of introspection and rancour. This is particularly effective when you have two people in a confined space not getting along: the bickering couple in Godard's *Week End* (1967); the distant father and son in Ismaël Ferroukhi's *Le grand voyage* (2004); or the mismatched travelling duo thrown together by fate's cruel hand in John Hughes's *Planes, Trains &*

Automobiles (1987). The Hughes comedy aside (which somehow fashions a happy ending from the utter despair and loneliness of its John Candy character), the films above are all linked by the fact that their journey concludes with death. A relatively common final destination (the cliff-top plunge in 1991's *Thelma & Louise* being probably the most mainstream example), this is not perhaps the flight from reality that many of us have in mind when considering the genre's escapist tendencies.

Regarded as one of the pivotal road movies and precipitating a counter-culture backlash against old Hollywood, the recently departed Dennis Hopper's *Easy Rider* (1969), in which two anti-authoritarian bikers go in search of the real America but are unable to 'find it anywhere', cast an estimable shadow over the road movies that proliferated during the 1970s and 80s. Hopper's film concludes with the bikers being slain by a group of vicious rednecks; its downbeat dénouement and general slide to apathy and disappointment was to be keenly felt in both Richard Sarafian's *Vanishing Point* and Monte Hellman's *Two-Lane Blacktop* (both 1971), the two films that most obviously and immediately trailed in *Easy Rider*'s exhaust fumes. *Two-Lane Blacktop* has one of the most famous endings in film history, signing off with the image of the celluloid catching fire and fragmenting in the projection gate.

Similarly, Hellman and Sarafian, with their off-kilter, out-of-synch 'heroes', were instrumental in refuelling the road movie renaissance in American filmmaking that we experienced during the 1990s. Tapping into the genre's propensity for nihilistic cool and the iconography of cultural isolation, directors such as Jim Jarmusch, Gregg Araki and Gus Van Sant conceived of a new breed of existentialist traveller for whom the journey itself frequently outweighed the destination. Not all of the films made during this new purple period ended in extinction, but the majority did suggest ennui and general dissatisfaction. No matter how many miles one clocked up, the pervading feeling of melancholy could never be left behind.

It is, of course, essential to note that the road movie is by no means an exclusively American domain and has been historically

227

embraced by filmmakers from across the globe as a means of exploring national identity, individual and collective malaise and as a way of confronting social and political issues. Some key historical and contemporary landmarks from Europe include Cocteau's *Orphée* (1950), Bergman's *Wild Strawberries* (*Smultronstället*, 1957), Fellini's *La strada* (1954), Alain Tanner's *Messidor* (1979), Bertrand Blier's *Les valseuses* (1974), Antonioni's *The Passenger* (*Professione: reporter*, 1975), Cédric Khan's *Red Lights* (*Feux rouges*, 2004), Michael Winterbottom's *In This World* (2002) and Julie Bertucelli's *Since Otar Left* (*Depuis qu'Otar est parti...*, 2003). On a broader international scale we have George Miller's *Mad Max* series (1979-85), Fernando Solanas's *El viaje* (1992), Walter Salles's *The Motorcycle Diaries* (*Diarios de motocicleta*, 2004), Atom Egoyan's *Calendar* (1993), Takeshi Kitano's *Kikujiro* (1999), Carlos Sorin's *Bombón: El perro* (2004) and most recently Gerardo Naranjo's Godard meets *Gun Crazy* synthesis, *I'm Gonna Explode* (*Voy a explotar*, 2008).

a means of exploring the connection between motion and emotion

Of all the world cinema figures associated with the road movie format as a means of exploring the connection between motion and emotion, and as a way of analysing individual and national disenchantment, Wim Wenders particularly stands out. The nucleus of the New German Cinema movement of the mid-1970s, Wenders's professional career developed from his adaptation of Peter Handke's *The Goalkeeper's Fear of the Penalty* (*Die Angst des Tormanns beim Elfmeter*, 1972). The film follows a goalkeeper, Joseph Bloch, who lets a penalty kick past him without making any effort to save it. Sent off for arguing with the referee, Bloch trudges away without word, getting changed before heading into Vienna to pick up girls. Wandering by a local cinema (local cinemas becoming a recurring motif in Wenders's work), Bloch picks up a pretty cashier and the two spend the night together. After inexplicably strangling her in the morning, the seemingly unaffected Bloch leaves Vienna by bus to a Burgenland village on the Austro-Hungarian border. While the village is preoccupied by the disappearance of a mute schoolboy, Bloch spends his days flirting with his hotel maid and with a former girlfriend. Making little attempt to escape, even when a composite

drawing of his face circulates around the village, the emotionally estranged man simply waits for the net to tighten.

A deconstructed thriller in which no motive is given either for the crime, or more generally for Bloch's listlessness, the film gives the sense of a man who has grown too old for his vocation and whose inability to communicate (another abiding Wenders theme) and remoteness suggest an almost entire lack of human feelings. Bloch becomes caught up in his interest in all things American (there are various references to Coke and gum), and in one celebrated sequence he is captivated by the act of records mechanically dropping down in a jukebox. This moment also conveys the importance of music to Wenders and his own fascination with American culture and ephemera.

Kings of the Road is available on DVD from www. axiomfilms. co.uk.

As well as making unique contributions to road movie grammar (including a tendency to leave the camera focused on the space previously occupied by something long after it has passed into the distance) Wenders also sustained a dialogue with its very history. Perhaps more than anyone else, he fully embraced and appropriated the notion of the listless drifter, travelling with nowhere to go, and moving either to escape some awful emotional trauma from the past (the backbone of 1984's *Paris, Texas*) or moving purely for the sake of moving. More often than not, Wenders concluded his road movies with his confused and alienated characters trapped in a state of perpetual transit. This is certainly true of *Kings of the Road* (*Im Lauf der Zeit*, 1976), his most widely praised work.

The film began as a self-funded itinerary of small towns with ailing movie theatres on the border of East and West Germany, the director taking to the road with a handful of actors, a small crew and a few completed script pages. Wenders would pen the dialogue overnight, and if inspiration didn't flow, then the crew didn't shoot the next day. Originating with the premise of a self-sufficient projector repairer servicing rural cinemas under threat from the dominance of American cinema, *Kings of the Road* evolved into an analysis of the relationship that develops between the repairman, Bruno (Wenders regular Rüdiger Vogler), and a suicidal linguist, Robert, as they travel in Bruno's truck along the dusty border roads.

229

Lonely and introspective, the pair tentatively bond over their love of pop records, but are unable to totally escape their longing for the company of women. Representative of the Germany of the time, Bruno and Robert are uncertain about their place in the scheme of things, and worried about the future. By the end of their journey, which terminates at a deserted American border patrol hut, the pair conclude somewhat unconvincingly that 'in the course of time' (the film's German title) their lives may possibly take on some shape and significance. Robert leaves a goodbye note stating, 'Everything must change'; Bruno finally tears up his itinerary.

Combining the look and feel of a documentary – Wenders visited several cinemas and opens with an interview with a cinema owner – with the leisurely pacing of a John Ford Western, *Kings of the Road* typically eschews psychological motivation, suspense and dramatic tension. A lyrical work visually defined by Robby Müller's sumptuous black and white photography, the film's attentiveness to the capturing of real time passing on screen also reflects Wenders's admiration for the films of Yasujirô Ozu.

Many of the themes Wenders had pursued in his first five features find their culmination here. These include pop music ('My life was saved by rock and roll,' reads some graffiti), language, the dominance of American culture (the film is littered with US iconography and boasts the immortal line, 'The yanks have colonised our subconscious') and the failure of communication between men, and more importantly with women. Any interaction is almost silent and frequently achieved through gesture rather than dialogue. The male/female dichotomy finds particular purchase: Robert is estranged from his wife and children; Bruno claims to have 'never felt anything but loneliness in a woman.'

If Wenders was fascinated with the notion of perpetual drift, a fledgling filmmaker at the end of the 1970s went one further and fashioned a road movie in which the road literally runs out, leaving its alienated and alienating protagonist unable to continue. The debut feature of Chris Petit, *Radio On* (1980) remains one of the most striking and original debuts in British cinema.

Still from Kings of the Road *(Axion Films)*

Previously the film editor at *Time Out*, Petit claims to have seen nothing on the English screen that corresponded to a modern life that for him combined 'drift and boredom, *Alphaville*, J.G. Ballard and Kraftwerk'.[1] An admirer of *Two-Lane Blacktop* and *Bring Me the Head of Alfredo Garcia* (1974), Petit began to wonder why a British film could not explore the enduring theme of migration while presenting contemporary England as a cinematic landscape. He was similarly enthralled by the austere aesthetic of Bresson, Straub and Rossellini, but it was the films of Wim Wenders, with their jaded, conflicted heroes and endless autobahns, that indicated that a way of actually making films might be possible. Possibility became reality when the German director responded to Petit's overtures and became his executive producer. Petit had to audition for the privilege, and when asked by Wenders how he intended to shoot the

231

1 Chris Petit, preface to Jason Wood, *100 Road Movies* (BFI, 2007).

film, a pertinent question to put to someone who had never made one before, he responded quite simply, 'Black and white. 35mm'.[2] The answer obviously proved conclusive.

Minimalist in plot, *Radio On* follows a young man (a suitably remote David Beames) as he travels by car to Bristol to investigate the mysterious death of his brother. So far, so *Get Carter*. As the man drives he encounters figures as rootless as himself: a soldier deserting from duty in Northern Ireland, a German woman (Lisa Kreuzer, on loan from Wenders) looking for her lost child, and a rural rock'n'roll-loving garage mechanic (a pre-fame Sting) with a penchant for Eddie Cochran and dreams of stardom. Stunningly photographed in luminous monochrome by another Wenders regular, Robby Müller's assistant Martin Schäfer, the film offers a mythic and compelling vision of a British landscape stricken by economic decline and stalled between failed hopes of cultural and social change and the upheavals of Thatcherism.

it is a great jukebox movie

Petit, who has subsequently carved out a simultaneous career as a novelist, has eloquently written of his love of driving and music, citing the portable radio cassette as 'one of the great 20th-century inventions' and the in-car stereo as the means by which the 'dreary reality of Britain' could be 'transcended'.[3] Tapping into the connection between music and motion, *Radio On* incorporates the device of radio bulletins to foreground the political climate. It is a great jukebox movie, effectively utilising the new wave sounds of Bowie, Robert Fripp, Kraftwerk and Devo. Working with a meagre budget – the film was one of the first to be given financial backing from the BFI production board with matching funding coming from Germany – garrulous producer Keith Griffiths managed to persuade the then newly emerging Stiff Records to allow a number of their artists to be used on the soundtrack. Allegedly, only Elvis Costello demurred.

232

Signposting an entirely new direction for British cinema, albeit one sadly not taken up, *Radio On* ends in a way that is, in its own

2 Chris Petit, interview by Jason Wood, *Radio On* DVD (BFI, 2008).

3 Petit, preface to Wood (2007).

fashion, as iconic as anything else in European cinema. Having driven his retro Rover to a disused quarry edge, mechanical failure and the fact that there is no road left on which to continue leaves our traveller with little option than to abandon his vehicle – but not before inserting a Kraftwerk cassette and playing himself out of his own movie – and continue his wanderings by other means. It is possible to decipher the film's conclusion in two ways. First, we can imagine that the central protagonist, who we last see hopping aboard a train whose destination remains unknown, has wrestled back a sense of purpose and is returning to London and his former life. Alternatively, we can read it as evidence of a continued commitment to journeying without purpose, itinerary or end.

Co-directed by Robert Frank and Rudy Wurlitzer, *Candy Mountain* (1988) concludes on a similarly ambiguous note and, like the works of Wenders and Petit, assiduously undermines the mythology of the road while also re-asserting its enduring appeal and sense of the unknown. The link between travel and music is a further connecting thread. A co-production that begins in New York before meandering cross country and concluding in Canada, *Candy Mountain* is nonetheless described as a resolutely American film by its two well-matched collaborators. In many ways, it represents the arrival home of the road movie after its own wanderings across numerous continents and foreign shores.

An acclaimed photographer whose 1958 book *The Americans* depicted American iconography and the mythic allure of the road in a more downbeat light, Robert Frank segued into filmmaking, establishing his reputation with the Jack Kerouac-scripted Beat classic *Pull my Daisy* (1959) and the outlawed Stones doc *Cocksucker Blues* (1972). The writer of *Two-Lane Blacktop*, Rudy Wurlitzer further mined the tarnished mythology of America in Peckinpah's *Pat Garrett and Billy the Kid* (1973). His adaptation of Max Frisch's *Homo Faber* for director Volker Schlöndorff, released as the Sam Shepard-starring *Voyager* (1991), cemented his road movie credentials.

Candy Mountain tracks the dispiriting personal odyssey of ambitious but untalented New York musician Julius (Kevin

J. O'Connor), whose quest for glory leads him to feigning an association with Elmore Silk (Harris Yulin), the J.D. Salinger of guitar-making. Charged with luring the legendary craftsman from hiding and retirement, Julius initially contacts Elmore's brother Al (Tom Waits). Financially lighter (he is repeatedly sold cars that he either trades or crashes), Julius again takes to the highway and heads for the Canadian border and the remote home of Silk's former French lover, who re-directs him to a barren seaboard town. There, Julius finally tracks Silk down only to discover that in return for a lifetime of security and freedom he has signed an exclusive deal with a Japanese businesswoman.

Wurlitzer's script draws upon Frank's own background, specifically the dichotomy between art and commerce and the pressures of fame added to the practical imperative of satisfying the demands of the various international financiers. The pair also tapped into their desire to make a film about a journey from the centre of one culture to the margins of another. Pio Corradi's photography – redolent of Frank's own – imbues the shifting landscapes and their weird, cranky and frequently lonely populace with a timelessness and distinctly iconic quality. Corradi's absorbing attention to detail further heightens the pervading malaise. In a key moment, a toothless van driver warns the initially optimistic Julius that 'life ain't no candy mountain' before, like so many others, smartly ripping him off. Coordinated by Hal Willner, the music, provided by luminaries such as Arto Lindsay and Marc Ribot, is essential, intelligently foregrounding both character and action. In keeping with the film's endearing, counter-culture sensibility, the filmmakers cast from an esoteric pool of musicians and were repaid with accomplished and entertaining turns from the likes of Tom Waits, Dr John, David Johansen and Joe Strummer.

The film ends with Julius helplessly standing by as Silk destroys his remaining guitars; tired, broke and disillusioned, he attempts to hitch a ride home. Bowed but not quite beaten, our Kerouac-lite hero is back on the road, with just his dreams for company. ∎

234

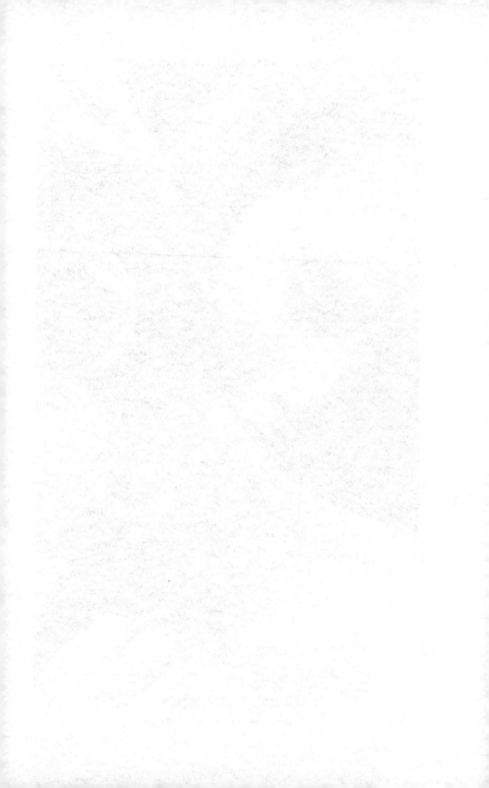

236

Still from Persona | PALISADES TARTAN

APOCALYPSE NOW:
Images of the end in the cinema of Ingmar Bergman

ADAM BINGHAM

After life comes death... the sentimental and fearful can seek solace in religion, while the weary or indifferent can commit suicide.
—From Ingmar Bergman's *Prison* (*Fängelse*, 1949)

The above line, spoken by a character at the very beginning of the film *Prison*, suggests something of the natural, inexorable presence of death within the work of Ingmar Bergman. Across the whole of his extensive filmography, images and themes of the end, of death and the apocalypse, proliferate and predominate. From his early romantic and familial dramas, through the symbolic, existential psychodramas that grace the period of his international breakthrough, and on to the intense,

FEATURING

Self

Truth

Fear

Death

subjectively rendered chamber narratives that characterise his final decade or so, Bergman repeatedly returned to stories that are (implicitly or otherwise) codified as apocalyptic. His is an oeuvre built around finality to the extent that, like the knight returning from the crusades in *The Seventh Seal* (*Det sjunde inseglet*, 1957), death hangs over and stalks its every move, haunting its domain like a shadow, an obstinate mirror image. The opposing forces of life and death are, in fact, almost symbiotic in nature, as though the one has need of the other and cannot exist apart from its dichotomous obverse image. For Bergman, to live means to court death, progression and time mean decay and decomposition; and those remorseless processes occupy a central place in his cinema.

For a director whose own existence appeared at times to be a protracted struggle against death (or at least against the fear thereof), and whose personal sense of spiritual emptiness was frequently manifest as physical ailment, the artistic preoccupation with questions of mortality should come as little surprise. What is perhaps more startling is the sheer multitude of forms that this questioning takes, the wealth and variety of images related to (figurative and literal) death and the apocalypse littered across Bergman's canon. There are variously personal, social, national, even cinematic signifiers of this perennial sense of disintegration and apocalypse; and most overt in this regard are those films made in the central period of the director's career. These works, chiefly *Persona* (1966) and the two trilogies it connects – *Through a Glass Darkly* (*Såsom i en spegel*, 1961), *Winter Light* (*Nattvardsgästerna*, 1963) and *The Silence* (*Tystnaden*, 1963) on the one hand, and on the other *Hour of the Wolf* (*Vargtimmen*, 1968), *Shame* (*Skammen*, 1968) and *The Passion of Anna* (*En Passion*, 1969) – are pervasively concerned with the end, visually, narratively and thematically. For the most part they do not, in contrast to *The Seventh Seal* or *Cries and Whispers* (*Viskningar och rop*, 1972), deal with actual, physical death. But they are nevertheless intent on exploring the effects of death on those not directly touched by its icy grip as much as on those in physical demise, and they offer a multivalent presentation of deaths and endings.

The most apposite starting point in this perspective is undoubtedly *Persona*. It is a key film in Bergman's oeuvre and a transitional piece that builds on several aspects of the director's preceding works and re-contextualises them in anticipation of subsequent films. In particular, it centres on the figure of an artist, and pares away the various insular settings of the first trilogy to arrive simply at two characters in an isolated house on a largely barren island location, characters that ultimately enter into a protracted interpersonal struggle of power, domination and humiliation (tellingly, the original title of the script that later became *Hour of the Wolf* was *The Cannibals*). Where the earlier tripartite is generally seen as centring on a figurative silence – the 'silence of God', to borrow the title of a 1969 critical study by Arthur Gibson – *Persona* is built around a literal lack of a voice. In this case, it is that of an actress who suddenly falls silent during a rehearsal of the play *Electra*, her refusal to speak leading her to be confined first to a sanatorium, and then, along with a young nurse assigned to help her convalescence, to a summer house on the beach.

The film closely contrasts the actress, Elizabet, and her nurse Alma. The latter talks and talks to the star, relating numerous details about her life (including a detailed description of an impromptu sexual experience she had with two boys and another girl just prior to her marriage), while her patient simply sits and listens to her without uttering a word in response. It is as though the actress absorbs the life of her companion, which is true insofar as Alma comes to believe it when she surreptitiously reads a letter about her in which Elizabet states that she finds the nurse amusing and likes studying her as she talks. At this turning point in the narrative (a direct echo of *Through a Glass Darkly*, in which the mentally ill protagonist seems to worsen after reading her father's diary telling of her incurability and his intention to document her condition), Alma's hitherto secure identity, an identity predicated on a complete acceptance of her circumscribed role as a woman within patriarchal society, begins inexorably to collapse.

Language in *Persona* is thus conceptualised as a form of death and personal finality, Alma literally pouring her life out verbally

for Elizabet and in the process losing her sense of self. It is this facet of the film that facilitates the famous exchange of personalities between the two women, as the nurse's interior disintegration leads her to assume the identity of her charge when the latter's blind husband arrives to 'see' his wife. This particular thematic, however, does not end with spoken and written communication. Language has a double meaning in *Persona*, not only human speech but the medium of filmmaking itself, the language of cinema. Bergman had previously dabbled in overt self-reflexivity, in *Prison* and in *All These Women* (*För att inte tala om alla dessa kvinnor*, 1964), but in *Persona* it is pushed to its limits. Indeed, in its deconstructive project it becomes something like self-negation, self-destruction, on Bergman's part: a veritable cinematic as well as personal apocalypse that is later underlined when a key moment in Alma's collapse is mirrored by the film burning up in the projector, literally disintegrating before our eyes as Alma herself will subsequently do.

Before this, however, narrative transparency is immediately obfuscated by Bergman. The very first image shows the arc lamps of a projector – a picture of the mechanical aspects of film viewing – and thereafter a series of ostensibly disparate images follow one another in quick succession: from male genitalia (almost subliminally) to a spider and shots of snowy waste in a desolate exterior landscape. This prologue of sorts then culminates when a young boy awakens on a table in a sparsely furnished location; perhaps an operating room; perhaps, given the boy seems to be naked save for a white sheet draped lengthwise over his body, a morgue. He sits up and reaches out, first apparently to the camera, but in fact towards what is revealed in a reverse angle shot to be a large screen on which can be seen a series of close-up images of the actresses (Bibi Andersson and Liv Ullmann) who will subsequently star in the film.

It is an oblique opening, one that is directly concerned (given the lack of any narrative context or cohesion – a narrative apocalypse) with the meaning and reading of images, and thus with a relationship between spectator and film defined by analytical distance as much as empathetic proximity. The audience is, like the young boy before the screen, placed in a position of figuratively

reaching out and groping towards the film from a point of instability and uncertainty, something that is subsequently represented in the narrative when Elizabet recoils in horror from pictures of the Vietnam War (in particular the iconic shot of the self-immolation of the native monk) on her hospital room television. She moves away from, rather than towards, the screen and its images, and this echo of

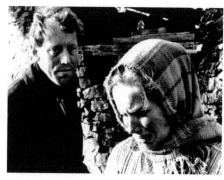

Still from Shame *(MGM)*

the opening frames *Persona*'s vision of the inherent power of the pictorial, and concomitantly of the ambiguity of vision (consider the blind husband and the famous shot showing one face composed of halves of Bibi Andersson and Liv Ullmann's faces).

However, these shots and symbols do not merely point to the end of cinema. They, in fact, carry a particular charge when contrasted with the recent films in Bergman's oeuvre. The image of the spider recalls the sexually invasive God that terrifies Karin at the end of *Through a Glass Darkly*; the snow recalls the setting of *Winter Light*; while the young boy is in fact the same actor (character?) who appeared in *The Silence*. In this perspective, there is an implicit sense that Bergman is drawing attention not just to the end of cinema but the end of his cinema, at least as it had come to be regarded in the near decade since the beginning of his authorial canonisation. This is further hinted at in the credits, in which the typically spare white on black Bergman type is diametrically transformed to become black writing on a pure white frame. It is a reversal, but also an exchange, a vision of fluidity that prefigures the central aspect of the narrative to follow.

If *Persona* recast those paradigms of Bergman's cinema that had largely dominated in the years since *The Seventh Seal*, then the earlier trilogy may be taken as the defining expression, the crystallisation, of this phase of his filmmaking. *Through a Glass Darkly*, *Winter Light* and *The Silence* are linked through a central

241

relationship between two key characters defined by apathy on one side and a craving for love on the other; and, as already noted, by the perceived key theme of God's silence, with an attendant exploration of how meaning can be found in a world where Christian faith has become untenable. Bergman himself expressed it thus:

'The theme of these three films is a "reduction" – in the metaphysical sense of that word. *Through a Glass Darkly* – certainty achieved. *Winter Light* – certainty unmasked. *The Silence* – God's silence – the negative impression.'[1]

The director does not expand on this rather cryptic elucidation. But with regard to images of the end it may be taken as a potentially revealing statement. One may ask: the certainty of what? What is achieved in *Through a Glass Darkly* that is then unmasked in *Winter Light*? And what exactly is 'the negative impression' of *The Silence*? The answer, at least in part, can be found in a reformulation of the thematic project of this trilogy. Rather than God's silence *per se*, the progression of each film can be said to examine the means by which men either explicitly or implicitly, consciously or unconsciously, fill in such a silence and void, such an end of faith and spirituality, and how they attempt to find meaning in their empty lives.

Or, more properly, how they fail to counter the void and find meaning. The characters in this tripartite can find certainty only in lovelessness, with the end of God and faith finding a correlative in the end of human contact and communication. From this perspective, it is significant that all three films end with talking and/ or language. *Through a Glass Darkly* concerns a fractious family unit comprised of a father, his son and mentally ill daughter and the latter's husband on holiday on a remote island. They all struggle with the daughter's ailments – her belief that voices speak to her of God's imminent arrival – and with the siblings' collective animosity towards their novelist father, who they feel has abandoned them to concentrate on his work in the wake of their mother's death. The

1 Peter Cowie, *Ingmar Bergman: A Critical Biography* (Charles Scribner's Sons, 1982), p.197.

first image of the film, of the four protagonists walking ashore from the sea, carries echoes of *The Seventh Seal* in connoting isolation, of characters welling up as if from nowhere, from the depths of the ocean. The siblings initially try to connect with their father and earn his admiration on his terms – that is, in the way of art, a short play written by the son. But their attempts to reach out to him and one another are continually frustrated, leading to a rigorous sense of alienation in which the specific needs of each begin to sow the seeds of their own collapse. In particular, here, is the ultimately incestuous relationship between the brother and sister – when the former's burgeoning sexuality and the latter's need for human contact find confused expression in their physical union.

empty words that no longer have any meaning but which must still be promulgated

The son is a significant figure in the drama. He feels especially estranged from his father, and at the end, following his sister's mental collapse, the end of her sanity, he speaks with his parent and is told by him that God resides in love, their familial love. To which he replies in quiet ecstasy, framed before the immensity of the sea outside his window (a gulf ready to swallow him back up as it seemed to spit him out at the beginning): 'Father has spoken to me.' It is a damning façade of a happy ending, one in which the mental disintegration of the daughter is cannibalised by her immediate family as a perceived remedy for their estrangement and a facilitation for their tenuous union. It is a mere pretence, a self-delusion, and against it the daughter's insanity begins to seem less of a medical illness than an effect of familial, perhaps social conditioning.

243

Winter Light further underlines this notion of love and deception. It concerns a village pastor's crisis of faith and fraught relationship with a local schoolmistress named Märta, who professes to love him. This is predicated on the implicit notion of a corollary between human and divine love, the pastor having lost his wife and, as a result, his faith, and the schoolmistress in desperation conflating a need for God's presence with confused love for His conduit on Earth. The film ends as it began, with a sermon, with empty words that no longer have any meaning but which must still be promulgated, something that then segues into the final film of this trilogy; which, given the title of *The Silence*, is unsurprisingly centred around God

as an even more remote figure, indeed an almost complete absence. The antagonistic central relationship in this film is between two sisters, who, along with the young son of one, find themselves ensconced in a hotel in a strange country that seems to be at war. One of the siblings is a translator and is succumbing to a terminal illness; the other, away from her husband, seeks random sensual fulfilment with a café waiter. The film dispenses with God almost altogether (the translator prays to be able to die at home, but one senses it is not the prayer of a believer, rather a last recourse, a plea in desperation), and in His stead, in the absence of spirituality, Bergman concentrates on a potent, emphatic physicality. He juxtaposes two bodies, one decaying and one craving, one entering death and the other searching desperately for life, for a feeling of aliveness. The symbolic position of the young boy caught between these polarised states then becomes one of potentiality, of the possible hope for growth and renewal: a tentative positivity amid a family, and by extension a society, seemingly rushing into oblivion.

While recapitulating these themes, *Persona* also looks forward to Bergman's subsequent trilogy of *Hour of the Wolf, Shame* and *The Passion of Anna*, more particularly in its focus on personal breakdown and disintegration. In these three films, a fracturing, transforming psyche both presages and is connected to a crumbling relationship between a husband and wife that ultimately disintegrates beyond repair. *Hour of the Wolf*, like *Persona*, immediately brings the practical aspects of the medium of filmmaking to the forefront: over the credits the director and his crew can be heard on set preparing to shoot. The film then proceeds to stress this self-reflexivity with a very pronounced tension between, on the one hand, a psychological horror film in which the husband, a painter, succumbs to his inner demons (which are graphically visualised as the fiendish occupants of a castle), and on the other a quasi-discursive record based on the husband's diary, given to the film crew by his wife following his disappearance. Where the deconstructive project of *Persona* traced, like Godard's *Week End* (1967), a *fin du cinéma*, and an end of Bergman's cinema in particular, *Hour of the Wolf*'s self-reflexivity lies in its use of these two ostensibly incompatible modes to reflect

the contrastive states of the male protagonist's existence: that is, his actual life with his wife and the interior world of overt fear and desire to which he succumbs.

Shame is perhaps the most complete and thorough of any Bergman film with regard to images of the end, focusing as it does on a couple torn apart when an ongoing civil war erupts into their lives. Alongside its portrait of a fracturing marriage and attendant exploration of personality disintegration lies a vision of conflict, of a social, perhaps national, apocalypse, that investigates the extent to which external incidents shape human behaviour and identity. Although Bergman was criticised for what was seen in some quarters as a questionable opportunism in presenting an abstract, 'ideologically vague' war as simply an objective correlative to domestic, marital antagonism,[2] in fact *Shame* offers a vision of warfare as it is experienced by many of those caught in its midst. In particular, it depicts two people directly affected by events entirely beyond their control and understanding, events whose origin they do not know and the reasoning for which they can barely conceive of.

Against this, however, is the fact that two of the couple's close friends emerge as leaders on either side of the fighting, thus complicating the narrative by inferring that the protagonists remain perhaps wilfully ignorant of the events raging all around them. Subsequently, the pervasiveness of Bergman's vision of finality begins to emerge through the characters, whose personalities don't so much disintegrate as is the case with the other films made in the wake of *Persona*, but rather change and transform. The proximity of the conflict irrevocably alters the behaviour of both man and wife: she loses her former strength and resilience; he overcomes his initial fright and sensitivity to become a ruthless presence, eventually shooting his supposed friend, among other acts of violence that the film implicitly challenges us to judge as either justified or otherwise (the man does learn of his wife's casual infidelity with their friend). In other words, does the war alter and thus create this man, or merely

245

2 Robin Wood, *Sexual Politics and Narrative Film: Hollywood and Beyond* (Columbia University Press, 1998), p.249.

facilitate the release of latent potentialities within him? Does it give free rein to what was dormant or twist and fundamentally alter his nature? In short, to what extent is there an essential personal identity that remains inherent and true? Or conversely how much of one's selfhood is the result of a constant, ongoing process, a negotiation and dialogue with external precepts?

does the end of the world result in the end of the self, or vice versa?

This is reinforced towards the end of *Shame* when the couple are cast adrift at sea in what is a literal visualisation of the post-apocalypse. It depicts the last remaining vestiges of civilisation, and Bergman creates a dreamlike atmosphere of temporal elision and spatial instability that contrasts markedly with the long takes and frequently frontal, stylised and theatrical compositions that characterise the scenes in the couple's home. It is a change of register that rhymes with the woman's relating of a dream, and has the effect not only of denoting a sense of confusion and collapse but further connoting an internalisation of the cataclysmic events in the narrative. The pressing question raised in *Shame* thus becomes: does the end of the world result in the end of the self, or vice versa?

The final film in the trilogy, *The Passion of Anna*, is best viewed as a summation and recapitulation of Bergman's project since *Persona*. Like those films, it concerns a troubled relationship, although here it is one that forms and subsequently ends over the course of the narrative, rather than one already in its final throes when the film

246

begins. Andreas is divorced, Anna a widow following the death of her husband (and son) in a car crash, and their troubled marriage is the central focus of the film, with the relationship between another couple figuring as a prominent structural counterpoint.

The Passion of Anna did not immediately follow *Shame* as that film had followed *Hour of the Wolf*,[3] and as a result Bergman seemed to come to it with the clear project of extending the

3 The interim film, *The Rite* (*Riten*, 1969), makes a fascinating companion piece to this particular trilogy. It similarly concerns artists, here a troupe of three cabaret entertainers under official investigation on charges of obscenity, and offsets an emphasis on physical decay (the investigator in particular is struggling with his dying, rotting body) with an exploration of the limits of personal freedom and individuality in relation to the symbiotic interaction of performance and selfhood.

parameters of the earlier films but without knowing fully how to achieve this. This ambiguity was made manifest in the director's methodology: he discarded his usual strict observance of the screenplay as written in favour of protracted re-writing, re-working, improvisation and experimentation. For instance, there are four short narrative inserts in the film in which

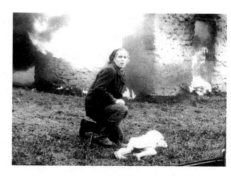

Still from Shame *(MGM)*

the actors discuss their views of the characters they are playing. These were not in the original script, but arose through discussions among the cast, and Bergman remained undecided throughout the shooting and editing as to whether or not he should include them in the final cut.

The Passion of Anna thus offered another instance of an end with regard to Bergman himself, an end to his hitherto firmly held working practices and, potentially, his confidence in and contentment with his brand of cinema. The film crystallises something of this uncertainty, which is specific to its modernist inquiry into the end of objectivity and truth (distinguishing it from the likes of *Rashōmon* [1950] and *Last Year at Marienbad* [*L'année dernière à Marienbad*, 1961]) as attendant on its portrait of the collapse of a marriage and the male psyche.

247

Bergman achieves this by establishing a documentary mode of address that is then subverted and frustrated. Shooting in colour for only the second time in his career, he initially presents his protagonist with a naturalistic, quotidian scene of domestic endeavour (house repair) and employs an officious voice-over (by Bergman himself) to fill in the salient details of his life. The setting remains indeterminate, although the film does not appear to be a discursive record of life on an isolated, rural island as in the previous works. There is an anomalous moment in which Andreas looks to the distance and appears to see three distinct suns, the 'truth' of which is never clarified or elucidated. It could be a natural phenomenon

caused by the light of the setting sun on the horizon, or it could be the indication of a distorted point of view, a mental breakdown; we remain unsure. All we can be certain of, here as in the remainder of the film, is the purely phenomenological, the specific details of action and behaviour; the rest is ambiguous and we must decide for ourselves.

This point is underlined by the aforementioned inserts of the four main actors discussing their characters. Replete with introductory clapperboards, these would seem to be documentary scenes. But whatever the validity of the performers' various perspectives, these are staged moments, the meaning of which is to highlight precisely the fact that only individual points of view and impressions are on offer, not irrefutable facts. This frustration of truth is also seen in the film's prominent sub-plot concerning the mysterious slaughtering of animals, the answer to which is never conclusively provided in the narrative.

At the end of *The Passion of Anna*, the film disintegrates at the same time as its protagonist, zooming in on Andreas left alone in a barren landscape until the image begins to blur and decompose. The voice-over returns to intone, 'This time his name was Andreas Winkelman', as though the fate of his protagonist reflects directly that of all Bergman's characters, indeed arguably all men in general given the state of contemporary malaise identified by the director. It is one of the most potent and far-reaching visions of the end in Bergman's body of work, and it remains as damning as any the cinema has given us. ■

DECASIA:
This film will self-destruct

TINA PARK

FEATURING

Spectres

Spinners

Nuns

Dervishes

251

252

Between 1895 and 1952, films were shot on cellulose nitrate, also known as celluloid, also known as guncotton. The silver in the nitrate makes whites intensely luminous and blacks rich and velvety.

Nitrate film is fragile and mortal. It can burst into flames. Or it may crumble to dust. It may even react with the metal can in which it is stored. The alchemical transformation of the filmic matter is ongoing.

Fifty years after nitrate film was buried, Bill Morrison resurrected some of its rotting corpses. He called his spectral ballet *Decasia*.

There are iridescent lines in the darkness, a marbling of the surface, a puckering, the image like magnified pores or burnt paper.

Phantoms appear, barely visible, through the flowery patterns and effervescent emulsions of putrefaction. New forms come out of the dying old ones.

A butterfly flutters against the strange map of a decomposing land.

253

254 Waves of corruption A Bedouin caravan A dervish whirls,
 crash against the moves slowly along stubbornly oblivious
 rocks. A pier, almost a speckled desert, a to the insubstantial
 indistinguishable, silhouette on a camel hands unravelling
 is engulfed in threatened by the next to him.
 fluctuating shadows. encroaching darkness.
 Ruins, the columns
 of an ancient
 temple perhaps.

Nuns stand in chiaroscuro, perfectly immobile, like black ghosts in the shifting light watching white-clad children walk through their shadowy world. A little girl turns around. She has seen us.

A baby is born in negative. Darkness is light, light is darkness. Human endeavours are doomed to ruin, but mankind persists in bringing light out of darkness.

Otherworldly spinners spin our fates on their translucent wheels.

255

256

A beauty smiles at herself, unaware that her skin is speckled with the black spots of decay. A swarm of chemical insects attacks a young ingénue. Black bubbles come out of dancers on fire. Couples embrace and dissolve.

Heads are stretched and deformed. Some go up in smoke. Headless bodies carry on walking as if nothing has happened.

A young woman made only of pulsating light laughs as she peeks through a door. What can she see now with those gelatinous, disembodied eyes?

A heroic boxer takes up the fight, aiming vain punches at a shimmering column of corrosion. Men emerge from a dark tunnel carrying the wounded and the dead into a world that is falling apart.

A lone plane flies through a sky of unstable greyness. Tiny parachutes are still hoping to make it all the way down to an earth they can no longer see.

A foggy city is annihilated by a sinister black shadow, a few Edwardian survivors intermittently peeking through its deadly embrace.

258 Ghosts walk into the river to be baptised and born again. A garden is corrupted, but isn't that the eternal story? The gardener keeps working.

The sun has disappeared behind the black desert now. The caravan has gone back.

The dervish is still whirling.

All stills from Decasia (Bill Morrison) – www.decasia.com

Biographies

Editor
Virginie Sélavy is the author of a thesis on Hollis Frampton's *Zorns Lemma*. She has written on film for *The Guardian*, *Sight & Sound*, *What's On*, *Cineaste* and *Frieze*. She founded the *Electric Sheep* website in 2007 and edited the *Electric Sheep* print magazine from 2007 to 2009.

Art Director
Emerald Mosley is a freelance print and new media designer whose clients include Carlton, Disney, BBC, British Council, Sotheby's & UKTV. Working with Virginie Sélavy, she designed and built the *Electric Sheep* website in 2007 and developed the *Electric Sheep* identity by designing the print magazine from 2007 to 2009.

Assistant Editors
Sarah Cronin earned a degree in Communication Studies at Montreal's Concordia University before moving to London to work in publishing.

Alex Fitch contributes to Resonance FM's film show *I'm ready for my close-up* and comics show *Strip!* which is podcast as *Panel Borders*. He has been nominated for an Eagle Award for his services to comic books and is working on his first graphic novel. He co-organises *Electric Sheep* screenings.

Sub Editors
Richard Bancroft is a proof-reader and web editor who has worked on several books, mainly for *Strange Attractor*. He has an abiding love for old horror and exploitation films.

Alexander Godfrey once worked on a soap magazine and ironically still feels dirty. After finishing his degree in film he now works for *The Times*.

Eleanor McKeown researches still images by day and writes about moving ones at night, following her interest in the magic of early film technologies, inventive cinematography and imaginative animation.

Alexander Pashby has worked as a script reader in Hollywood and London and is a former assistant editor of LOVEFiLM.com. He is currently freelancing and his reviews and interviews can be found in *Little White Lies* as well as *Electric Sheep*.

Writers

John Berra is Professor of Film Studies at Nanjing University. He is the author of *Declarations of Independence: American Cinema and the Partiality of Independent Production* and the editor of the *Directory of World Cinema: American Independent* and the *Directory of World Cinema: Japan*.

Adam Bingham completed his thesis, *Kitano Takeshi: Authorship, Genre and Stardom in Japanese Cinema* in 2008. He has written for *CineAction, Cineaste, Sight & Sound, Senses of Cinema, Asian Cinema* and *Screen*. His particular areas of interest are Asian and Eastern European cinema.

Mark Bould is Reader in Film and Literature at the University of the West of England and co-editor of *Science Fiction Film and Television*. His recent books include *The Cinema of John Sayles, The Routledge Companion to Science Fiction* and *Neo-Noir*.

James Evans is an Anglo-Canadian writer for *Electric Sheep, Little White Lies* and *Cinema Scope*. He has contributed chapters to books, most recently *Under Fire: A Century of War Movies* and *Jerzy Skolimowski* for the Jeonju International Film Festival. He lectures at the University of Brighton and the University of the Arts, London.

Ian Francis is a film curator and writer. He is also a founding director of mobile exhibition outfit 7 Inch Cinema and the Flatpack

Festival, which takes over venues across Birmingham each March. He has written on early cinema and animation for publications including *Little White Lies* and *Electric Sheep*.

Simon Guerrier has written novels, short stories, comic strips and audio plays for *Doctor Who*, *Being Human*, *Primeval*, *Robin Hood*, *Blake's 7* and *Sapphire and Steel*. He lives in London with a bright wife and a dim cat.

Max Hattler is a German experimental animator and media artist based in London. His films have screened in hundreds of festivals and have received many awards. He has made music videos for bands including Basement Jaxx and The Egg. He is represented worldwide by Partizan. www.maxhattler.com

Jim Harper is a writer and film critic specialising in cult and horror cinema from around the globe. He is the author of *Legacy of Blood: A Comprehensive Guide to Slasher Movies* and *Flowers from Hell: The Modern Japanese Horror Film*.

Pamela Jahn is a Berlin-born, London-based film programmer, writer and assistant editor of *Electric Sheep*. She currently works at the Institute of Contemporary Arts (ICA) where she has programmed various seasons and co-edited the ICA's 60th anniversary book *How Soon Is Now*. She co-organises *Electric Sheep* screenings.

Greg Klymkiw has seen over 30,000 feature films. A film critic, screenwriter and producer, he's produced the iconoclastic work of Guy Maddin (*Archangel*, *Careful*) and among many others, Cynthia Roberts (*The Last Supper*, *Bubbles Galore*). Since 1998, as Senior Creative Consultant, he's taught filmmaking at Norman Jewison's Canadian Film Centre.

Frances Morgan is a writer and musician based in London. The former editor and publisher of *Plan B* magazine, she has written about music, sonic art, books and film for *Frieze*, *The Quietus*, *Loops*, *Terrorizer* and *New Statesman*.

Tina Park is a writer from Hong Kong. She has written about

Asian cinema and organised an underground film club in Hong Kong from 2006 to 2007.

James Rose is predominately concerned with interpretations of contemporary horror and science fiction cinema and television. He has written a number of books and contributed chapters to a range of scholarly collections alongside writing critical texts for a range of national and international journals.

Jack Sargeant is the author of numerous articles, essays, screeds and books focusing on underground, cult and independent cinema. He is Programme Director for the Revelation Film Festival and has co-curated the film series for the Sydney Biennale. He enjoys searching out the nether regions of cinema culture and is currently working on his Ph.D.

Toby Weidmann is a film and video journalist who has edited two video industry trade magazines, *timecode* and *RRP Magazine*, as well as written regularly for video games trade publications *X Magazine*, *CTW* and *In Stock*. Continuing to freelance for various film websites, he now works for Metrodome Distribution.

Jason Wood is the director of programming for Curzon cinemas and the author of several books on cinema, including *The Faber Book of Mexican Cinema* and *100 Road Movies*. His writing also appears in *Sight & Sound* and *Little White Lies*.

Nicola Woodham has written broadly on Nigerian evangelist horror films and is contributing to *Screening the Undead: Vampires and Zombies in Film and TV*, out in 2011. She spends the rest of her time tracing animistic practices in morbidly dull, suburban West London locations for her short film *Empty Orchestra*.

Illustrators & Photographers

Sean Azzopardi is a London-based cartoonist/illustrator and a self-publisher of books that include *Twelve Hour Shift*, *Ed* and *Necessary Monsters* (with writer Daniel Merlin Goodbrey). phatcatz.org.uk

Tom Humberstone is an Eagle award-winning comic artist, illustrator and publisher responsible for *Art School Scum*, *My Fellow Americans*, *Solipsistic Pop* and *How To Date a Girl in Ten Days*. He draws a regular web comic titled *Worth Recording* and helps run comic events with the We Are Words + Pictures collective. www.tomhumberstone.com

Lisa Claire Magee has recently graduated from the North Wales School of Art in Illustration for Children's Publishing although her work normally encompasses more adult themes. She is inspired by religion and philosophy and enjoys trying to turn the dark and the macabre into something beautiful and interesting. www.glitterforguns.co.uk

Simon Norfolk is a photographer who was born in Lagos, Nigeria, and grew up in England. His landscape series *Afghan: Chronotopia* was produced during the Afghan war in 2001 and has been exhibited internationally, winning numerous awards. His work appears regularly in *The New York Times* magazine and *Guardian Weekend*. www.simonnorfolk.com

Pearlyn Quan moved from Singapore to London and consequently had various random encounters with Indian ink, which convinced her she was on the right track. She holds Robert Crumb, Yoshihiro Tatsumi, Renee French and Charles Burns personally responsible for revealing to her the joys of sex, violence, blood and gore in black and white. poisonpencomics.wordpress.com

Mark Stafford is a cartoonist/illustrator/ink monkey based in Brixton. He is the cartoonist in residence for the marvellous Cartoon Museum in Bloomsbury, and co-creator, with Bryan Talbot, of the damn fine *Cherubs!* graphic novel. He writes about cinema for *Electric Sheep* and *Vertigo*. www.hocus-baloney.com

James Stringer can be found at www.james-stringer.tumblr.com.

'If that happened, we wouldn't stand a chance.' | PEARLYN QUAN

THE END